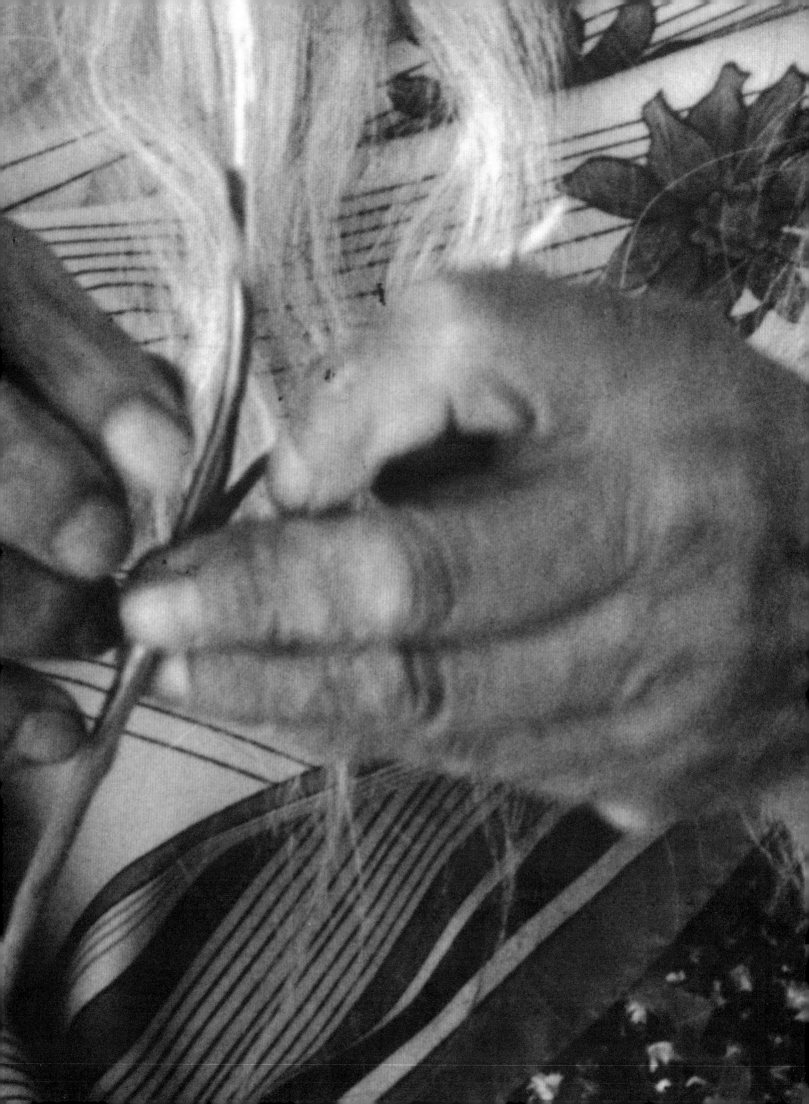

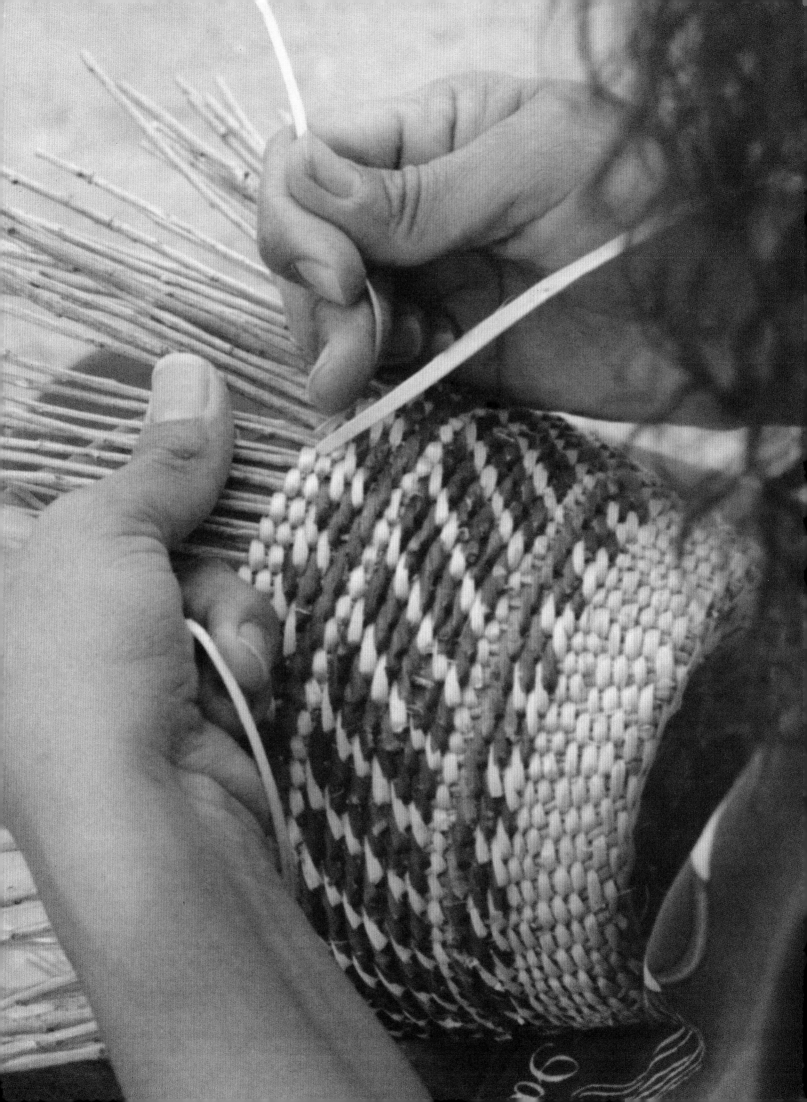

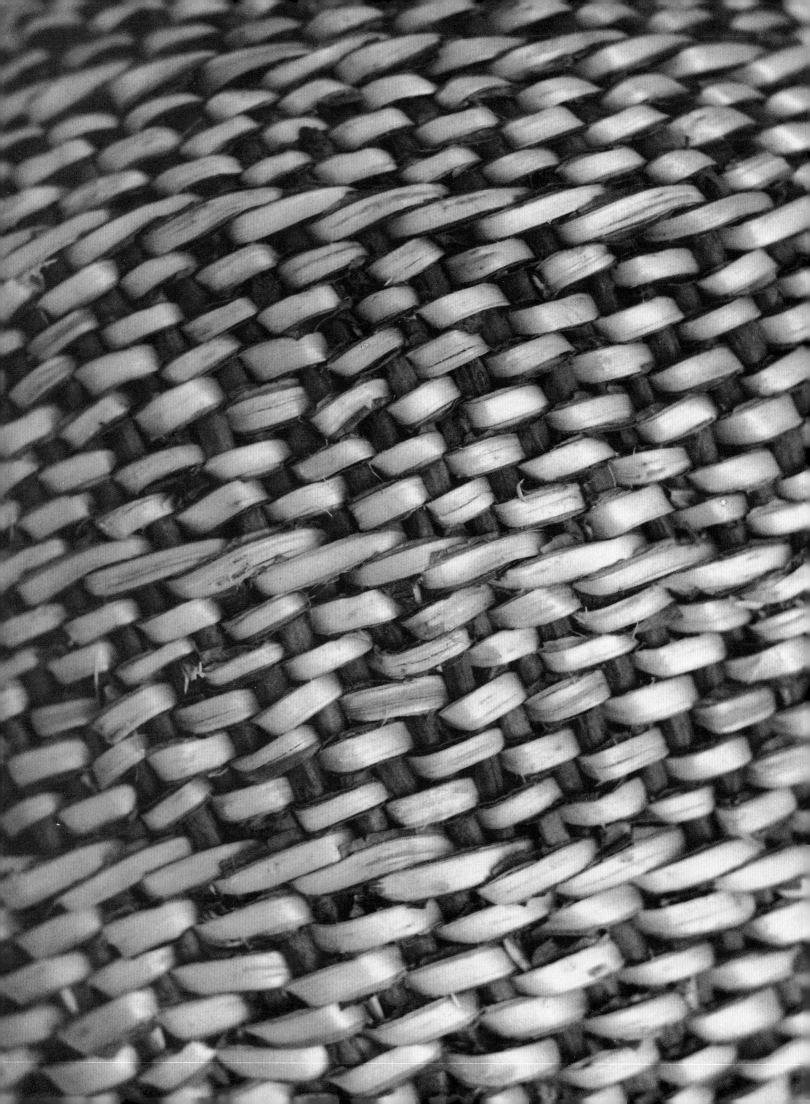

Indian Basketmakers

OF THE SOUTHWEST

⊕

THE LIVING ART

AND FINE

TRADITION

BY LARRY DALRYMPLE

WITH A FOREWORD BY SUSAN BROWN MCGREEVY

DOCUMENTARY PHOTOGRAPHY BY LARRY DALRYMPLE

STUDIO PHOTOGRAPHY BY BLAIR CLARK

MUSEUM OF NEW MEXICO PRESS SANTA FE

THIS BOOK IS DEDICATED TO THE BASKETMAKERS I HAVE KNOWN.

PROJECT EDITOR: Mary Wachs
ART DIRECTOR: David Skolkin
DESIGN: Carol Haralson Design
COMPOSITION: Set in Minion with Mason Sans display
CARTOGRAPHY AND ILLUSTRATION: Deborah Reade

Manufactured in China
10 9 8 7 6 5 4 3 2

Library of Congress Cataloging-in-Publication Data

Dalrymple, Larry
Indian basketmakers of the Southwest : the living art and
fine tradition / by Larry Dalrymple ; with a foreword by Susan Brown
McGreevy ; documentary photographs by the author ; studio photographs
by Blair Clark.
cm.
Includes bibliographical references and index.
ISBN 0-89013-338-7 (pbk.)
Indian baskets—Southwest, New. I. Title.
E78.S7D29 2000
746.41 '2 '0899 70794—dc21 00-39182 CIP

Photographs: i: (cattails split and dried in preparation for making an
O'odham willow coiled basket); ii (see 24); iv (see 42); vi (see 123);
ix (see 16); x (see 75).

MUSEUM OF NEW MEXICO PRESS

POST OFFICE BOX 2087

SANTA FE, NEW MEXICO 87504

THERE SEEM TO BE A NUMBER OF INDIVIDUALS WHO, intentionally or not, perpetuate the conventional wisdom that contemporary American Indian basketry has nothing of merit or interest to offer. It is my fervent hope that Larry Dalrymple's book *Indian Basketmakers of the Southwest,* along with its companion volume *Indian Basketmakers of California and the Great Basin,* will help dispel such wrongheaded notions. In fact, there is much to celebrate about baskets and basketmakers today: diversity, invention, originality, creativity, and skill come readily to mind.

The literature concerning American Indian basketry tends to support the idea that late nineteenth- early-twentieth-century baskets approached the zenith of achievable perfection. One of the most tenaciously held fictions emanates from the perspective of the purist, namely, that these baskets were Indian-made for Indian use and thus uncontaminated by influences from the outside world. While it is certainly true that many baskets from this period were created for everyday use, in a sense they were already commodified, traded between Native American groups and also to Spanish and American settlers. Some early utilitarian baskets were undecorated while others had geometric designs.

By the early part of the twentieth century, the availability of factorymade vessels made it unnecessary for Native Americans to continue to produce baskets for everyday use. Still, baskets continued to be made, some in response to ceremonial demand, some in response to collector and tourist markets. It was during this period that innovative figurative designs of animals and people began to appear, most notably on Western Apache and O'odham (Pima and Papago) baskets. Books and articles written by a number of authorities hail these decorative developments as a new and exciting artistic trend, yet at the same time most authorities seem to suggest that the productive period of southwestern Indian basket making ended about 1930 or 1940. Indeed, in the case of Navajo basket making, Washington Matthews wrote, as early as 1894, that "the art of basket making is little cultivated among the Navajos." He was wrong. While this may have been the case in the area of Matthews's research (the southeastern portion of the reservation), there were many active basketmakers in the northwestern region.

However, there is at least one valid reason that basketry publications have neglected to document mid- and late-twentieth-century basket-making developments, as there was a serious decline in the quality of baskets made by many groups in this period. Indeed, as Dalrymple observes, basket making has become obsolete in certain tribes, and some traditional techniques are no longer practiced in others. During the last decades of the century, though, there has been an electrifying basketry renaissance across much of the Southwest, an explosive burst of creativity and innovation that lamentably has not been documented but for a few notable exceptions, Whiteford's *Southwestern Indian Baskets* (1988) and Teiwes's superb account of Hopi basket weaving (1996) chief among them.

Dalrymple's book goes a long way to redress previous lacunae. Through his words and photographs, we learn about current trends in basketry design, materials, and techniques.

He accentuates the diversity of contemporary baskets in a visual journey that educates the eye and enriches the mind. He has integrated information garnered from extensive reading with insights acquired through his friendships and working relationships with the basketmakers. It is the personal dimension that creates the book's distinctive personality. The basketweavers' narratives, combined with the photographs of their work, bring their special world into focus. We learn about their struggles and triumphs, about what it means to be a basketmaker in the modern world. We learn that today's basketmakers lead lives that are as diverse as their designs. Some are young but most are middle-aged or older. Some live in remote rural areas, others in or near towns. While basket making traditionally has been a woman's art, today there are numerous male basketmakers. We learn who their teachers were and to whom they are passing on their knowledge.

Knowledge of the plant world, and the labor-intensive job of collecting and processing basketry materials, forms a common denominator. Although market activity has been a major factor in the current basketry renaissance, economic incentives alone do not account for the originality and versatility of today's basketmakers. Above all, it is the creative impulse that drives the artists. Designs are derived from a variety of sources: dreams, the landscape, photographs, books and magazines, and visits to museums and galleries. These ideas are filtered through the imagination, life experiences, and cultural values of each basketmaker.

Dalrymple's personal relationships with the basketmakers emerged as a result of his collecting activities. Every collection is an idiosyncratic assemblage that reflects the collector's personal tastes and interests. Dalrymple has not tried to acquire masterpieces (although in some instances he coincidentally has done so). His collection rather expresses his interest in continuity and change in basketry traditions, in techniques and materials, and, most importantly, in the basketmakers themselves. Thus, his baskets are more than beautiful or interesting objects; they contain the wisdom, creative energy, dreams, and aspirations of a unique group of artists. In many respects, the book represents a collaboration between the artists and the collector in a synthesis of Native talents and collector sensibilities.

Thus, the Dalrymple collection, and resulting publication, is an expression of one man's deep involvement with the lives of contemporary southwestern Indian basketmakers. His respect for them and appreciation of their creativity are salient features of this admirable book. For those who have long nurtured the archaic view that there is nothing worthwhile about modern Indian baskets, this book and its companion volume should jump-start a conversion experience.

SUSAN BROWN MCGREEVY

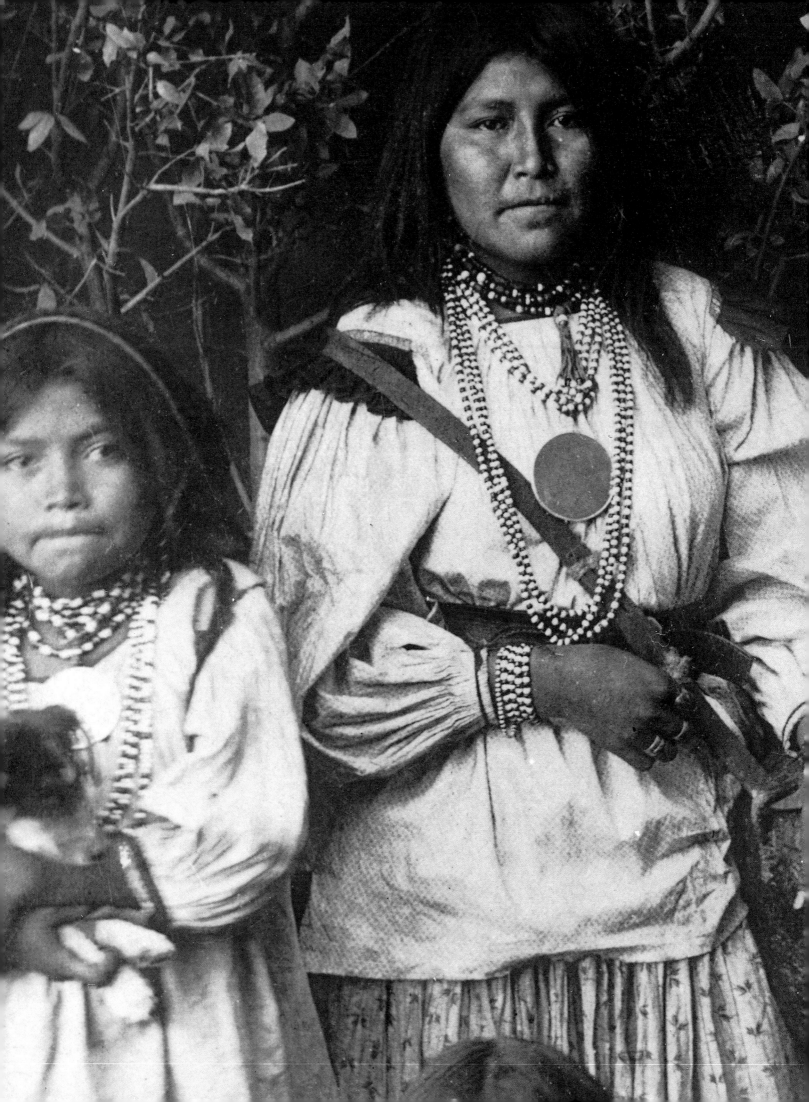

BASKET MAKING IN THE SOUTHWEST DATES BACK thousands of years to prehistoric peoples who occupied the region long before the arrival of many of the tribes we presently associate with it. The Anasazi of the Four Corners region, ancestors to the modern Pueblo people of the Rio Grande Valley, produced baskets so exceptional that archaeologists in the 1920s named the culture "Basketmaker" in recognition of their artistry.

Among early indigenous peoples, baskets played a pivotal role. They were used for cooking and for serving and storing food, to carry and transport goods, to gather and prepare seeds and berries, for trapping and fishing, and for ceremonial purposes. As prehistoric peoples settled into farming-based cultures, pottery making began to develop that in large measure supplanted the earlier reliance on basketry. At the same time, growing cultural sophistication overall was evident in basket making as well, which continued for both ceremonial and utilitarian uses well into the historic period and the advent of the Europeans.

Basket making as a continuously practiced traditional craft wasn't significantly interrupted until the nineteenth century and the opening of the region to the surrounding influences of the United States. The inverse was also true. The arrival of the railroad into the Southwest in the last decades of the 1800s brought tourism, which stimulated interest in the revival of native arts. This resulted in the reemergence of traditional basketmakers as well as innovators who envisioned new applications for their skills and could adapt with great ingenuity. These creative and talented women and men were the Jicarilla Apache weavers who made lidded cloth hampers and fishing creels for non-Indian consumption. They were the Ute and San Juan Paiute weavers who saw the Navajo's need for the sacred *ts'aa'* (wedding basket) and learned to make them according to Navajo specifications. They were those weavers who were able to make the transition from producing pieces made for domestic use or trade to those made for sale. They were the Tohono O'odham weavers who saw the willows die along the dry streambeds and replaced their use with that of yucca.

Materials used for basket making have always depended on availability. Those most frequently used in the Southwest today are sumac, willow, cottonwood, and yucca, but weavers frequently have to substitute one material for another because of the impact of harsh winters or drought or availability. Thus, for example, we see Western Apache, Yavapai, and Havasupai weavers sometimes using cottonwood in their coilwork while at other times relying on willow. Never static, basketry has always been a creative and changing craft, and this is as true today as it was in the past.

However, the basketry tradition has disappeared among many tribes in the Southwest, and among others certain types are no longer made. The beautiful coiled trays and ollas of the Western Apache and the Yavapai and the boldly colored work baskets of the Jicarilla Apache are no longer made. Yucca sifters and red willow baskets are only being produced by a handful of weavers in the New Mexico pueblos. The many problems related to weaving, from gathering materials to finding the time to prepare and use them, make it difficult for weavers of the late twentieth century to continue the tradition.

As the new century approaches, American society faces many problems: crime, poverty, drug abuse, racial inequality, and technological change. Native Americans are experiencing these same problems along with an additional one—adjustment to a non-Indian world. This adjustment has been complicated by past governmental intervention in their affairs and threats to their cultural traditions. For example, one policy that was very destructive to Indian culture was, without parental approval, sending Indian children away at an early age to boarding school, where they were then discouraged from or even punished for speaking their native languages, a strategy intended to replace Indian culture with a Christian–European ethic. The unfortunate result was the loss of many Native American traditions and values, including some arts and crafts.

The prospect for the continuance of basket making among several groups in the Southwest is very bleak. In the 1990s, among the Hualapai, Yavapai, Ute, and Rio Grande Pueblo of New Mexico, the art is in a very precarious state. The Yavapai have only one weaver, who because of age seldom weaves, while the Hualapai have only three. Among the Rio Grande Pueblo people there are a couple of weavers at Santa Clara Pueblo, one at San Juan Pueblo, and one at Taos Pueblo who continue to make willow baskets. A woman from Jemez Pueblo is the only Pueblo basketmaker who still makes yucca sifters.

In Arizona there are a few Havasupai women and one man who are excellent weavers. The Jicarilla Apache Tribe supports a weaving program that has proved to be very successful and provides employment for a dozen women. On the San Carlos Reservation, several dozen Western Apache women, many of whom belong to the Henry family (see genealogy chart), make twined burden baskets. In addition, there are a number of weavers at Cibecue on the White Mountain Reservation who also make some burden baskets, large ceremonial baskets, and a water jug or vase-shaped basket they refer to as a *tus'*.

The small, very active group of San Juan Paiute weavers on the Navajo Reservation make excellent baskets that closely resemble those made by the Navajo.

Fortunately, Navajo basket making has undergone a renaissance in the last twenty years, with the members of four families producing many of the pieces (see genealogy chart). While their output does not begin to equal the productivity of the Tohono O'odham, it is prodigious.

Currently, basket making among the Tohono O'odham and Hopi is the most prolific among any of the other tribes in the Southwest. The Tohono O'odham have developed a system of trade that is profitable for weavers and relatively inexpensive for collectors. Because the Hopi still use baskets in many of their ceremonies and as paybacks (payment), they produce them with considerable frequency for use in the Hopi community.

I

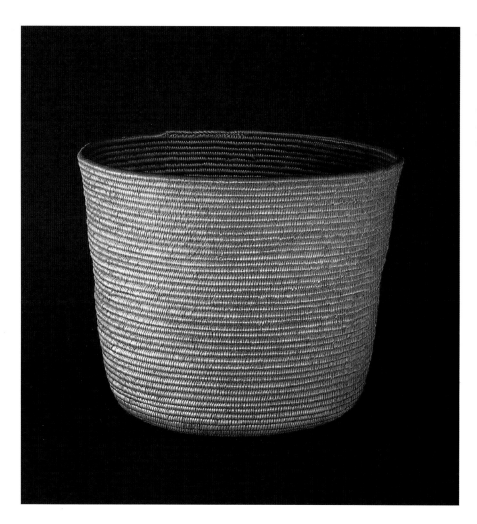

2

The idea for this book came from my own collection of some 250 contemporary baskets begun in 1978. More important than the baskets, however, was the information the basketmakers were willing to share with me. During the past twenty years, I have come to know most of the women and the few men who are pictured here with their creations. They all have a passion for their work and for the preservation of the art.

The tribes and their basketmakers discussed in this volume are: the Yavapai, Havasupai, Hualapai, Western Apache, Jicarilla Apache, Ute, San Juan Paiute, Navajo, Akimel O'odham, Tohono O'odham, Hopi, and the Pueblo. The chapters are organized to reflect the visual and structural similarities seen in contemporary baskets rather than according to anthropological criteria. Therefore, the Ute, San Juan Paiute, and Navajo are combined in a single chapter, as are the Akimel O'odham with the Tohono O'odham and the Hopi with the Pueblo of New Mexico.

Each chapter contains a brief ethnographic history of every tribe, explaining the changes that have occurred in basketry. When possible, one or two historical weavers from each tribe whose work is significant are discussed. This has not always been possible because the identity of many weavers was never recorded. With very few exceptions, it has only been in recent years that buyers and collectors have begun recording the names of the artists.

Each chapter also includes a section on materials and construction. While I have discussed the styles historically made, the discourse on materials has been confined to the context of baskets presently made.

Finally, the last section of each chapter portrays basketmakers whose work I have collected over the last twenty years. A brief biography of these women and men is included along with their comments on gathering and processing materials, creating designs, and weaving baskets.

The documentary photographs included in this book were taken by me unless otherwise noted. Blair Clark photographed my collection. Baskets presented here are from my collection or the collections of friends and acquaintances, who generously allowed me to photograph them. The Museum of Indian Arts and Culture in Santa Fe provided access to pieces in its fine collection.

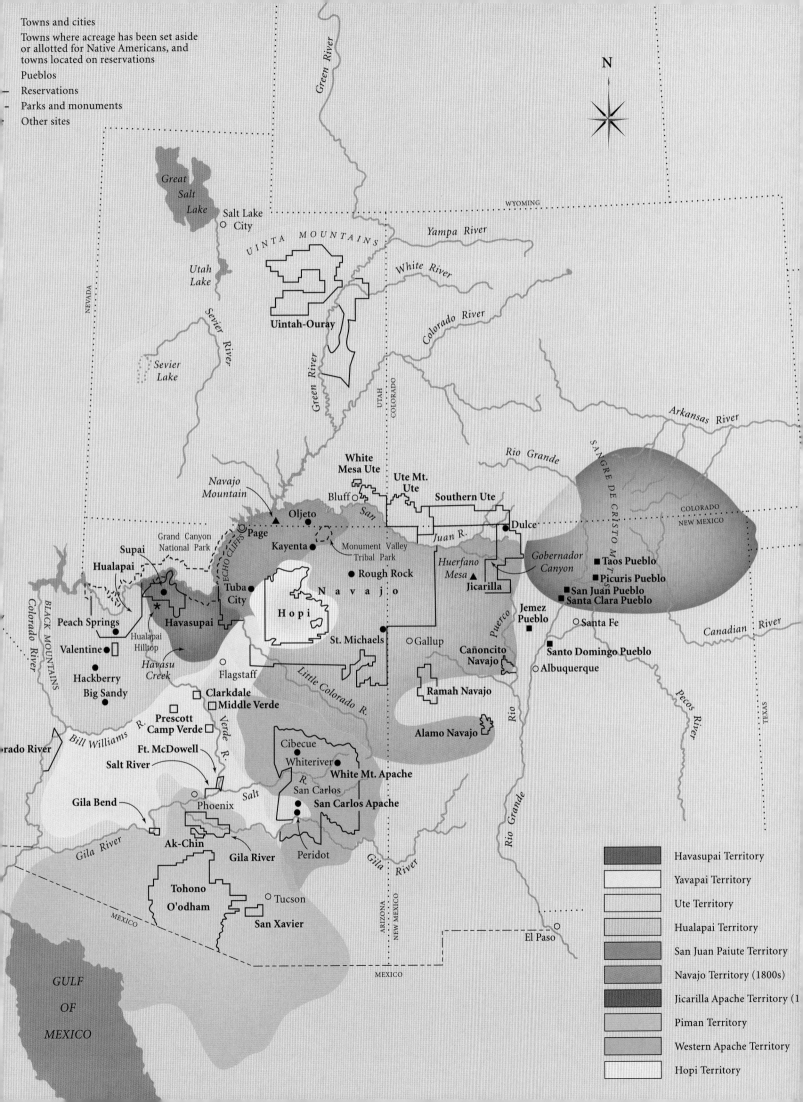

Towns and cities
Towns where acreage has been set aside
or allotted for Native Americans, and
towns located on reservations
Pueblos
Reservations
Parks and monuments
Other sites

N

Green River

WYOMING

Great Salt Lake

Salt Lake City

U I N T A M O U N T A I N S

Yampa River

Utah Lake

White River

Uintah-Ouray

Sevier River

Colorado River

Sevier Lake

NEVADA

Green River

UTAH
COLORADO

Arkansas River

Rio Grande

SANGRE DE CRISTO MTS

White Mesa Ute

Navajo Mountain

Bluff

Ute Mt. Ute

Southern Ute

COLORADO
NEW MEXICO

Oljeto

San

Dulce

Gobernador Canyon

■ **Taos Pueblo**

Grand Canyon National Park

Page

Kayenta

Monument Valley Tribal Park

Juan R.

Huerfano Mesa ▲

Jicarilla

■ **Picuris Pueblo**

ECHO CLIFFS

Supai

N a v a j o

Rough Rock

■ **San Juan Pueblo**
■ **Santa Clara Pueblo**

Hualapai

Tuba City

H o p i

Canadian River

BLACK MOUNTAINS

Havasupai

St. Michaels

Gallup

Cañoncito Navajo

Jemez Pueblo ■

○ Santa Fe

Peach Springs

Puerco

Hualapai Hilltop

Valentine ●

Santo Domingo Pueblo ●

Colorado River

Havasu Creek

Flagstaff

Little Colorado R.

○ Albuquerque

Hackberry

Ramah Navajo

Pecos River

Big Sandy ●

Clarkdale
Middle Verde

Rio

TEXAS

Prescott
Camp Verde

Alamo Navajo

rado River

Bill Williams R.

Ft. McDowell

Verde R.

Cibecue

Salt River

Whiteriver

White Mt. Apache

Rio Grande

Gila Bend

Phoenix

Salt

R.
San Carlos

San Carlos Apache

Gila River

Ak-Chin

Gila River

Peridot

Tohono O'odham

○ Tucson

Gila River

ARIZONA
NEW MEXICO

San Xavier

MEXICO

El Paso ○

MEXICO

GULF OF MEXICO

Havasupai Territory
Yavapai Territory
Ute Territory
Hualapai Territory
San Juan Paiute Territory
Navajo Territory (1800s)
Jicarilla Apache Territory (1
Piman Territory
Western Apache Territory
Hopi Territory

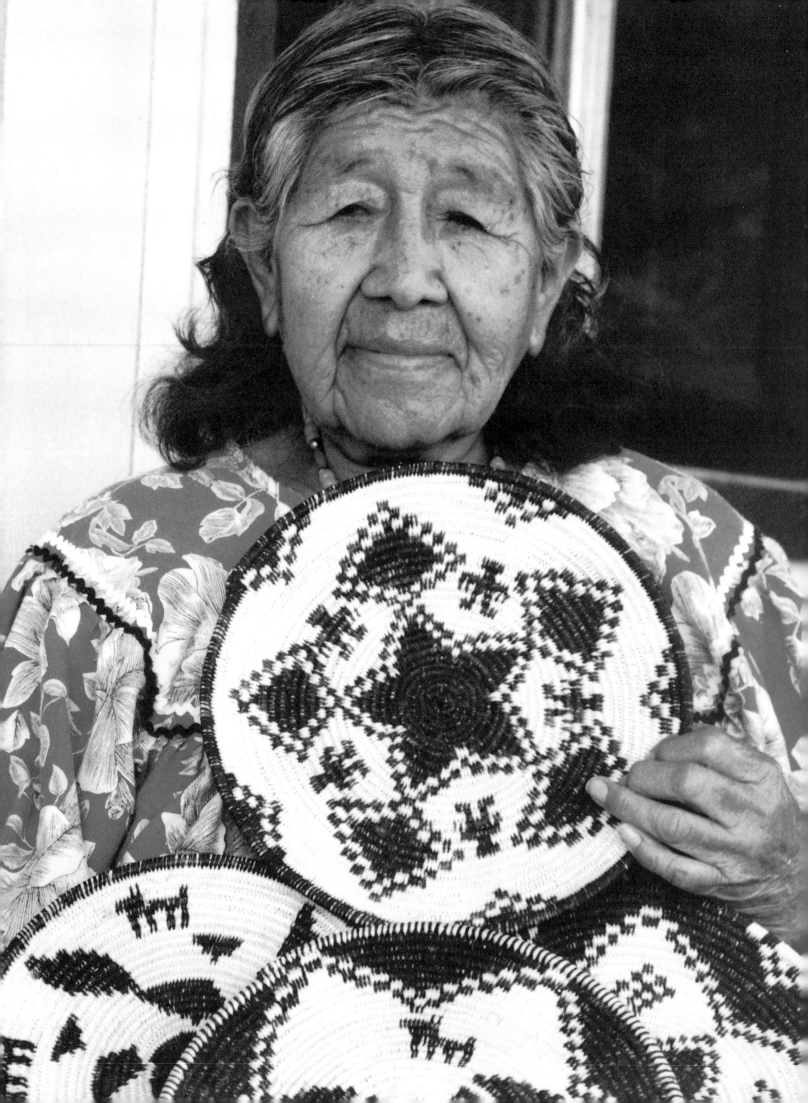

THE PROPOSED CHRONOLOGY FOR THE PAI PEOPLE (Yavapai, Havasupai, and Hualapai) dates their migration into Arizona at approximately A.D. 800. Coming from an area west of the Mojave Desert in present-day California, they were probably displaced by the advancements of Numic and Yokuts peoples and forced to migrate to a new homeland. A major obstacle confronting them was crossing the Mojave Desert, but after arriving in the upland regions of Arizona, they found few people, with the exception of some scattered farming communities of the Sinagua.

They brought with them five types of twined baskets that were essential to their way of life. These included: cone-shaped seed carriers; water jugs with a pointed bottom; circular parching and winnowing trays; cooking baskets; and small gathering jars with an opening just large enough to place the hand inside and a strap attached around the rim. The weaving materials they used had to be adjusted according to the availability of plants in their new environment. For example, one of their traditional practices was coating winnowing and parching trays with a vegetal mixture to fill the cracks. When they were in California, a glutinous material from roasted soaproot bulbs had been used, while in the Southwest this sealer was made from peach pulp.

Eventually, the Pai people were divided into three groups, with the Havasupai and Hualapai settling in upland regions and the Yavapai continuing to hunt and forage over an expansive area that included much of central Arizona. Through contact with the Sinaguan peoples, the Yavapai were introduced to the technique of coiling baskets and in turn probably passed on the method to the Havasupai as late as the second half of the nineteenth century. Moreover, it is likely that the Yavapai also introduced the coiling technique to the Western Apache during historic time when they were placed together on the San Carlos Reservation—a theory that Bert Robinson proposed in the 1960s based on conversations he had with weavers on the San Carlos Reservation. (This information is based on conversations with Lawrence Dawson at his home in Cottonwood, Arizona, September 14–15, 1998.)

⊕ **HISTORY** Yavapai territory originally covered a large portion of the state of Arizona, including all the central and western part. It was bounded on the west by the Colorado River, on the south by the Gila River, on the north by Havasupai and Hualapai territory, and on the east by Western Apache territory.

5

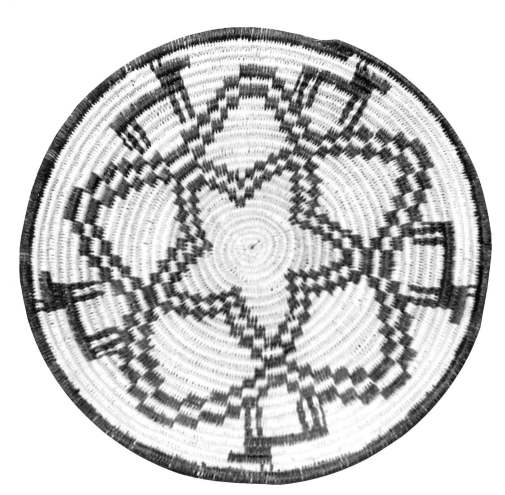

COILED TRAY BY YAVAPAI WEAVER KATE AUSTIN, MADE CA. 1970. NOTICE THE TREATMENT OF THE TAIL ON THE HORSES. DIA. 13", H. 1". COLLECTION OF JOYCE AND MELVIN MONTGOMERY.

FACING PAGE: YAVAPAI WEAVER LOLA DICKSON WITH SOME OF HER WORK, FEBRUARY 16, 1992. SHE USES COTTONWOOD FOR THE FOUNDATION AND THE SEWING STRANDS IN ALL HER BASKETS AND EMPLOYS DEVIL'S CLAW FOR THE DESIGNS.

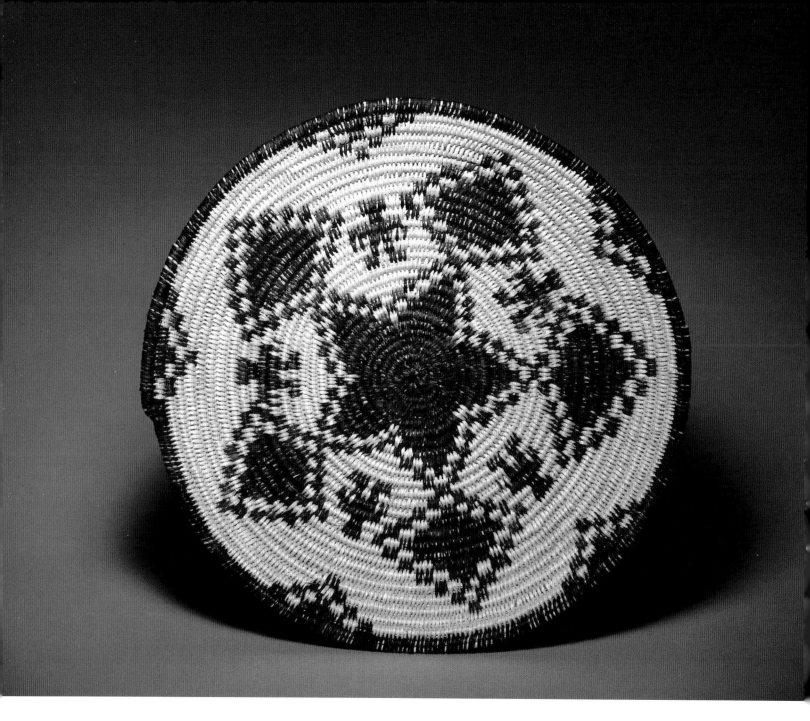

This vast area included desert, mountain, and transitional zone environments and thus many varieties of vegetation, ranging from cactus and palo verde on the lower elevations of the Sonoran Desert to chaparral, juniper, oak, and pine at higher elevations. Hostilities existed between the Yavapai and several of their neighbors: the Havasupai and Hualapai to the north and west and the Tohono O'odham, Akimel O'odham, and Maricopa to the south. They were, however, friends and sometimes allies with their Western Apache neighbors to the east.

Although the Yavapai and the Western Apache peoples are not linguistically related, their cultures have many similarities, including their basketry. These cultural affinities have caused considerable confusion with recognition of the Yavapai by the United States government as a separate ethnic group from the Apache. As a result, they have been designated Mohave–Apache, Tonto–Apache, and Yuma–Apache—appellations that have all added to the confusion of their cultural identity and caused problems in identifying their material culture.

In the 1860s, before gold was discovered on their lands, the Yavapai had experienced only temporary exposure to Euro-Americans. However, within the next few years, their territory was overrun with gold seekers. Towns grew up overnight, and their traditional hunting, gathering, and farming areas were overtaken by the newcomers.

In 1865, some Yavapai were removed to the Colorado River Indian Reservation, which they shared with other tribes. Others were encouraged to settle near the military post at Fort McDowell east of present-day Phoenix. While these relocation efforts were partially attempts to protect the Yavapai from aggressive Anglos, in reality they encouraged Anglo settlement of Indian lands. In any case, both locations proved unsuccessful to the Yavapai, and many

returned to their traditional homelands. In 1871, the Rio Verde Reservation was established, and General George Crook ordered all "roving Apache" to be relocated there (Schroeder 1974, 93). Responding to the order, the military attempted to round up a band of Yavapai that had taken refuge in a cave above the Salt River. The tragic result was the mass killing of men, women, and children in what later became known as the Skeleton Cave Massacre.

By 1875, the Yavapai were again forced to move, this time to the San Carlos Apache Reservation outside their original territory. For the next twenty-five years, the majority of them remained on the reservation, where some intermarried with the Western Apache. Among scholars and those interested in basketry, there is considerable conjecture about which tribe influenced the other concerning the designs on coiled baskets and their construction during the period they lived together at San Carlos. There is no definite way to distinguish between the two, and an additional problem is that many basketmakers are of mixed descent of Yavapai and Western Apache.

When the Yavapai left San Carlos, they returned to places they had previously lived and where they could find work, eventually settling in four areas throughout Arizona: the vacated military base at Fort McDowell, where they were given a reservation in 1904; the small community of Clarkdale, where they were given 60 acres in 1969; Camp Verde, where they received forty acres in 1910 and an additional 448 acres in 1916 at Middle Verde; and at Prescott, where in 1935 they were given seventy-five acres, later increased to 1,395.

The frequent moves forced on the Yavapai plus the hostilities between the Anglos and all Apache (which included the Yavapai) had a devastating effect on their traditions. It is surprising that coiled basket making survived this period of transition since so much of the Yavapai culture was lost. The confusion surrounding the Yavapai's ethnicity and the similarity between Apache and Yavapai coiled baskets encouraged the use of the word *Apache* to identify both tribes' pieces.

Clara Tanner has attempted to develop criteria for identifying Yavapai baskets, arguing that although the size, stitch, coil count, and materials used are the same as Apache baskets, the designs reflect a difference. According to Tanner, Yavapai weavers favor concentric bands and less clutter by small independent elements; use of heavier lines; more frequent use of large areas of black; and fewer variations of elements in a single basket (Tanner 1983, 182).

While it seems certain that the Yavapai learned the coiling method after their arrival in the Southwest, they brought with them the much older tradition of twining baskets. These included cone-shaped carrying pieces, pointed-bottom water jugs, circular winnowing trays, cooking baskets, and large-mouthed jugs with strap handles. The few twined pieces that remain and have been identified are found in museum collections.

⊕ MATERIALS AND CONSTRUCTION

Yavapai coiled baskets generally have a white background with a black design or a black background with a white design. The only materials presently used are willow, cottonwood, and devil's claw.

7

FACING PAGE: ONE OF LOLA DICKSON'S FINEST PIECES; NOTE THE SYMMETRY OF THE DESIGN, WHICH IS ORGANIZED USING COMBINATIONS OF FIVE. MADE IN 1987. DIA. 10", H. 1".

THREE-ROD COILED TRAY BY YAVAPAI WEAVER LILLIAN SHENAH, WITH FOUNDATION AND SEWING SPLINTS MADE OF COTTONWOOD. MADE IN 1983. DIA. 10 1/3", H. 2". COLLECTION OF THE MUSEUM OF INDIAN ARTS AND CULTURE/ LABORATORY OF ANTHROPOLOGY.

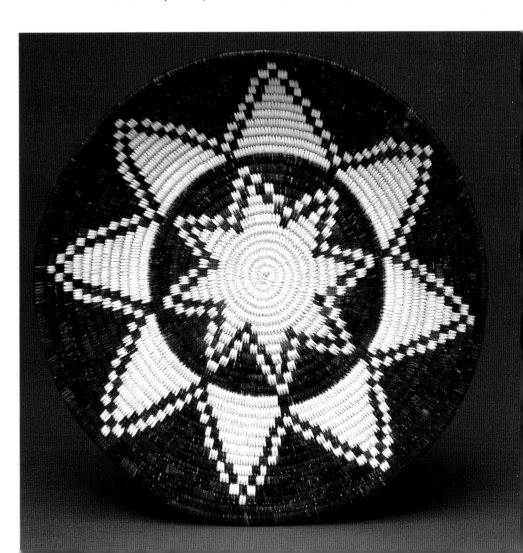

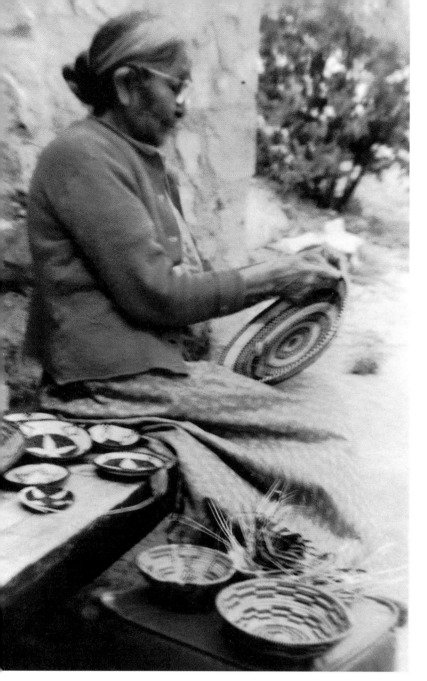

Either cottonwood or willow is employed for the three foundation rods. The willow is gathered in late fall, while cottonwood is preferably harvested in early spring. Both can be collected at other times and frequently are, but the quality is not optimal. Long first-year branches without offshoots are selected. They are then stripped of bark and sorted into bundles according to size before being stored. When making a basket, the weaver selects two smaller sticks and one larger one; the placement of the larger stick in relationship to the two smaller ones helps shape the foundation of the basket. Cottonwood or willow is also used for the sewing strands, which are wrapped around the three rods and sewn to the bundle beneath. To prepare the sewing strands, the weaver first makes two small cuts on the end of the willow, then, holding the midsection of the willow between the teeth and with both hands (one on each side), pulls down, splitting the branch in thirds. If the branches are collected at undesirable times, it is difficult to keep the strands equal in size. Thus, weavers can often be seen along the roadside cutting and peeling branches to test their readiness for harvesting. Devil's claw, the other material used for sewing, is usually domestically grown and the clawlike pod split into strands for use in creating the black design. All of these materials are soaked in water to make them pliable.

⊕ WEAVERS AND THEIR BASKETS

One of the best-known Yavapai weavers was Viola Jimulla (1878–1966), who was born on the San Carlos Apache Reservation, where she learned to weave as a small girl. She lived most of her adult life at the Yavapai Indian Reservation near Prescott, where she married and raised a family. She continued to make baskets until her death.

ABOVE: YAVAPAI BASKETMAKER VIOLA JIMULLA WORKING ON HER LAST BASKET, JUNE 8, 1965. PHOTOGRAPH COURTESY OF THE SHARLOT HALL MUSEUM.

RIGHT: COILED START OF A BASKET BY LOLA DICKSON. NOTICE THE THREE FOUNDATION RODS. THE TWO DEVIL'S CLAW PODS WILL BE SOAKED IN WATER AND SPLIT BEFORE BEING USED FOR SEWING STRANDS LIKE THOSE IN THE COIL START. THE AWL IS USED TO PIERCE THE PREVIOUS COIL TO SLIDE THE SEWING STRAND THROUGH.

FACING PAGE: BASKET BY YAVAPAI WEAVER EFFIE STARR, MADE FOR THE SHARLOT HALL MUSEUM IN 1978. THE TRAY IS MADE OF WILLOW AND DEVIL'S CLAW. DIA. 11 3/8", H. 1 5/8". PHOTOGRAPH COURTESY OF THE SHARLOT HALL MUSEUM.

Viola made large and small coiled vase-shaped ollas, trays, and bowls. One of the early ollas she made was so large that it would not fit through the door of her house. Consequently, the doorway had to be enlarged before it could be removed and sold for $90.

During the Depression Viola conducted a Works Progress Administration (WPA) class on basket weaving at Camp Yavapai. A photograph taken in 1935 shows her and six of her students with baskets they made. According to Franklin Barnett, these Prescott weavers made many baskets in the ensuing years. Some pieces were even selected to be sent back east to Washington, D.C. (Barnett 1968, 34–35). However, in another photograph taken in 1946 entitled "The Last Prescott Yavapai Basket Weavers," only three elderly women are shown: Annie James, Rose Charles, and Viola Jimulla. Further research may reveal what brought about the rather abrupt decline in the number of basketmakers. In 1986, Effie Starr (1909–1988?) was reported to be the only remaining basketmaker on the Prescott reservation (Whiteford 1988, 101).

In recent years the only active Yavapai weavers have resided at Fort McDowell. During the 1960s and 1970s, several women were weaving there, including Kate Austin, Josephine Harrison, Jocelyn Hunnicut (Whiteford 1988, 99), Lillian Shenah, Bessie Mike, Nina Smith, and Lola Dickson.

Lola Dickson is the only basketmaker left at Fort McDowell and possibly the only one still weaving in any of the Yavapai communities.

Lola comes from a long line of basketmakers; her sister, Nina Smith, was a weaver at Fort McDowell, as was her cousin, Mabel Osife, and her mother and grandmother. Lola was born on the Fort McDowell Indian Reservation near Phoenix, to Ralph and Lucy King. Before settling at Fort McDowell, she moved with her extended family to a number of different locations, such as Clarksburg and Prescott, where work could be found in the mines and smelters or on farms and ranches. Traveling by horse and wagon, they stayed with friends and relatives.

Lola's mother and grandmother both made coiled baskets and twined burden baskets. She recalls as a small girl seeing twined pieces around the household and using them, but it was not until she was in her twenties that she learned from her mother to weave coiled baskets. Lola remembers with delight how both of them laughed at her early basket-making skills. Her first basket was undone and restarted many times before finally being completed and sold for about a dollar.

Lola makes plaques and round and oval bowls but has never made an olla or done twinework. During the past sixty years, she has only woven intermittently while being married and raising a family of three boys and one girl. She has taught her daughter, Tisha, to weave and hopes she will someday carry on the tradition. Lola makes between ten and twenty baskets a year, weaving outside during the summer months because she can see better in the natural light. She uses cottonwood and devil's claw on all her baskets, obtaining some of these materials from Kathrine Brown on the San Carlos Apache Reservation. Her baskets are sought after by various buyers and collectors, and several people regularly stop by her house in hopes she will have a basket for sale.

The four baskets in the book made by Lola (page 4) have twelve stitches to the inch and were made between 1987 and 1992. Lola usually, though not always, starts and finishes her baskets with devil's claw, a characteristic that has often been used to identify Yavapai baskets. (It is not a rule for Lola but more often than not proves to be the case.) One unfinished basket (page 10) does not have the completed devil's claw rim but instead has five light designs separating the dark spaces. If this basket had been completed, a rim with ticking might have been used. Another basket (page 11) is ticked with black and white on the rim, which is a technique frequently used when large areas of black are placed next to the outer edge of the basket. While baskets made by Lola have many isolated elements, the designs appear very structured. When studying one of Lola's unfinished baskets it is easy to see what design elements are lacking in order to complete the pattern. This organized characteristic is what Clara Lee Tanner used to distinguish Yavapai from Apache baskets. The last basket (page 11) has an experimental design uncharacteristic of Lola's work. Each element floats in isolation, lacking the usual symmetry. Experimentation with patterns like this one allows the weaver to continually explore possibilities within the limitations of her work.

There appears to be very little, if any, future for Yavapai basket making. Because of advancing age, Lola produces very few pieces. The Fort McDowell population is small, and the community has found new wealth with the success of its casino. I know of only one Yavapai woman, Lola's daughter, who has knowledge about basket making. Despite the bleak outlook, however, some other Yavapai basketmakers may appear on the scene, though it is doubtful their basketry will survive for very long without a concerted effort to preserve it.

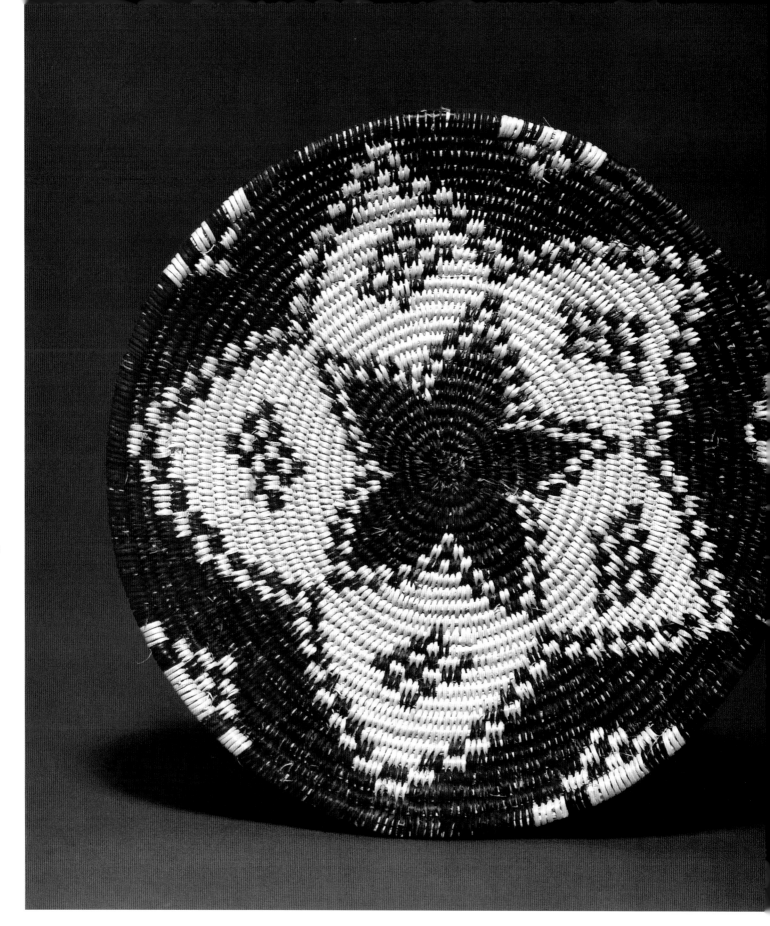

AN UNFINISHED TRAY MADE IN 1990 BY LOLA DICKSON; SHE HAD
INTENDED TO ADD SEVERAL MORE ROWS. WHEN ASKED IF SHE WOULD
FINISH THE RIM LIKE THE ONE OPPOSITE (TOP), SHE SAID SHE WOULD
DECIDE WHEN THE OTHER ROWS WERE FINISHED. DIA. 9 1/2", H. 1".

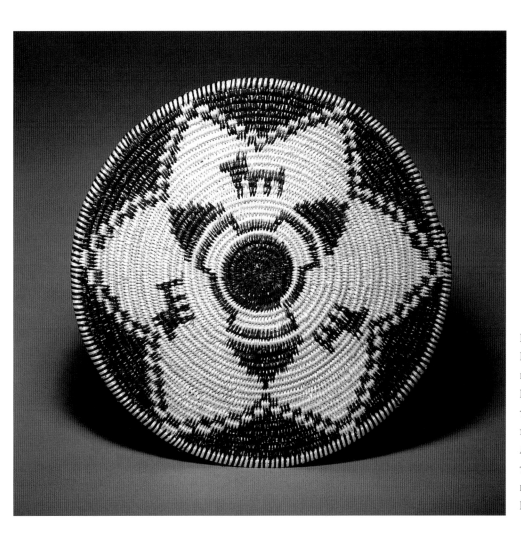

Flat plaque by Lola Dickson measuring 1/2" in height. Most of Dickson's baskets are tray-shaped and at least 1" high. She used black-and-white ticking on the rim to frame the design on this 1992 piece. Dia. 10 1/2", H. 1/2".

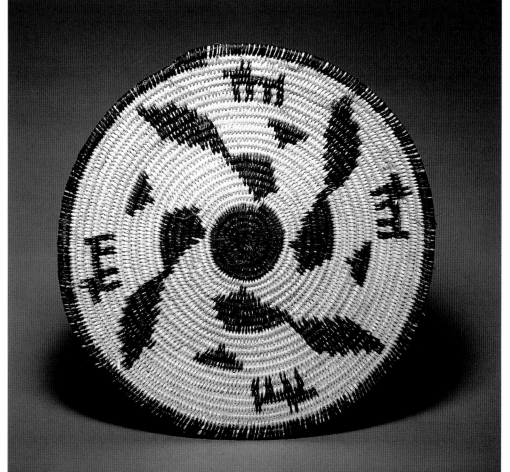

Lola Dickson experimented with a new design in this tray made in 1990. Dia. 9 1/2", H. 1".

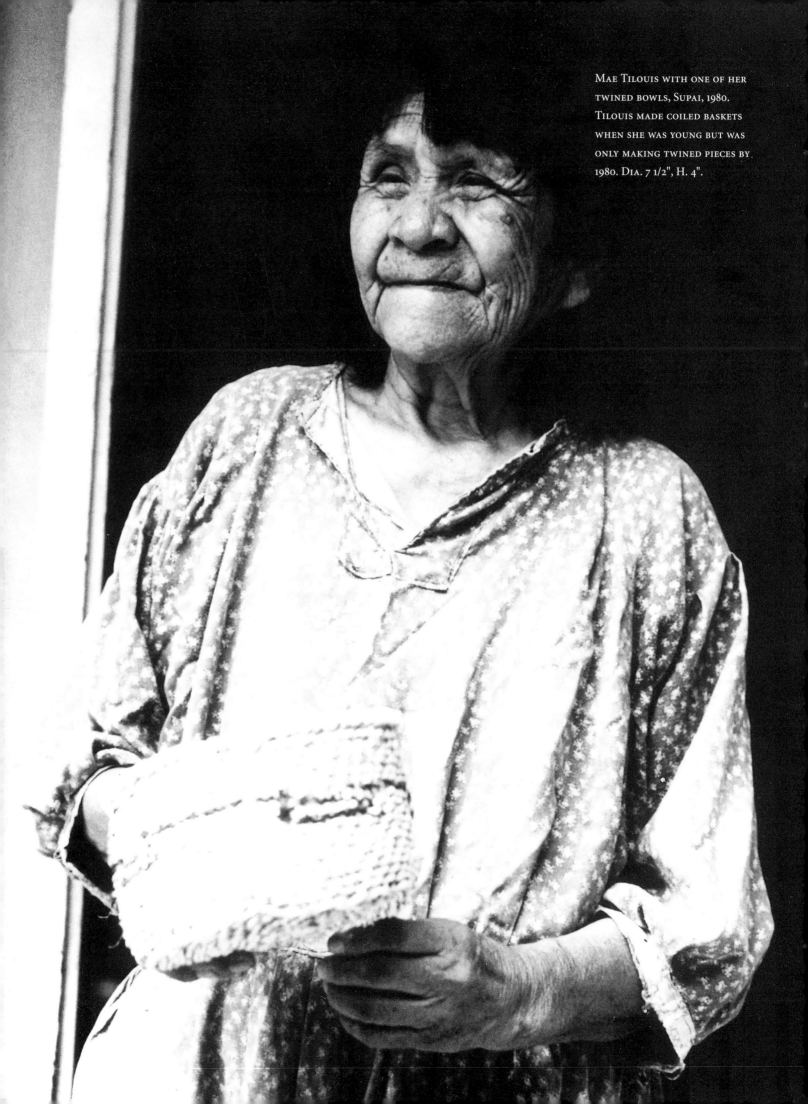

MAE TILOUIS WITH ONE OF HER
TWINED BOWLS, SUPAI, 1980.
TILOUIS MADE COILED BASKETS
WHEN SHE WAS YOUNG BUT WAS
ONLY MAKING TWINED PIECES BY
1980. DIA. 7 1/2", H. 4".

IN HISTORICAL TIMES THE VAST MAJORITY of the baskets made by the Havasupai were twined trays, bowls, burden baskets, and water jugs. They were used for winnowing and parching corn, seeds, and pine nuts; for carrying firewood and household goods; and for storing, cooking, and serving food. Coiled baskets were also employed for some utilitarian purposes but to a lesser extent; they were, however, important trade items with the Hopi since a number of them have been collected on the Hopi mesas.

⊕ HISTORY The Havasupai occupy a small geographical area of northwestern Arizona south of the Colorado River. They farm small irrigated plots of corn, squash, beans, melons, and fruits among thick stands of cottonwood and willows along Havasu Creek. Havasu Canyon, through which the creek flows, is several thousand feet below the adjacent Coconino Plateau. Seeking protection from enemies, they originally moved from the plateau into the canyon, which provided a continual source of water. As the outside threat abated, their life-style changed to focus on farming in the canyon during the summer months and hunting and gathering on the plateau during the winter months.

Because of their isolation, the arrival of Euro-Americans had less impact on Havasupai than on the neighboring Hualapai and Yavapai peoples. Eventually, however, due to the growing pressure from ranchers and the National Park Service during the late nineteenth and early twentieth centuries they became permanently confined to their canyon location. It was not until 1974 that they were able to add 160,000 acres of the Coconino Plateau to their small reservation. Additionally, they were given the use of 95,000 acres of Grand Canyon National Park for grazing animals and as residence for many Havasupai who camp there to harvest pine nuts and to escape the damp climate of the canyon during the fall and winter months.

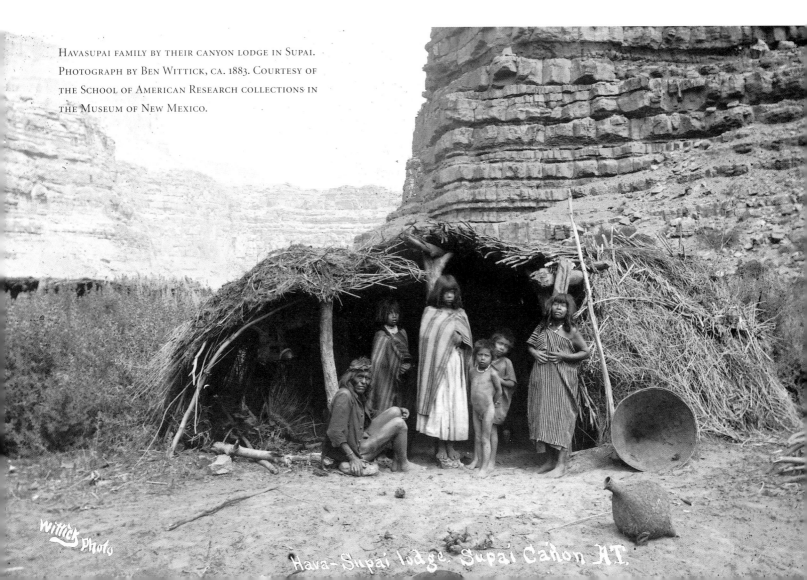

HAVASUPAI FAMILY BY THEIR CANYON LODGE IN SUPAI.
PHOTOGRAPH BY BEN WITTICK, CA. 1883. COURTESY OF
THE SCHOOL OF AMERICAN RESEARCH COLLECTIONS IN
THE MUSEUM OF NEW MEXICO.

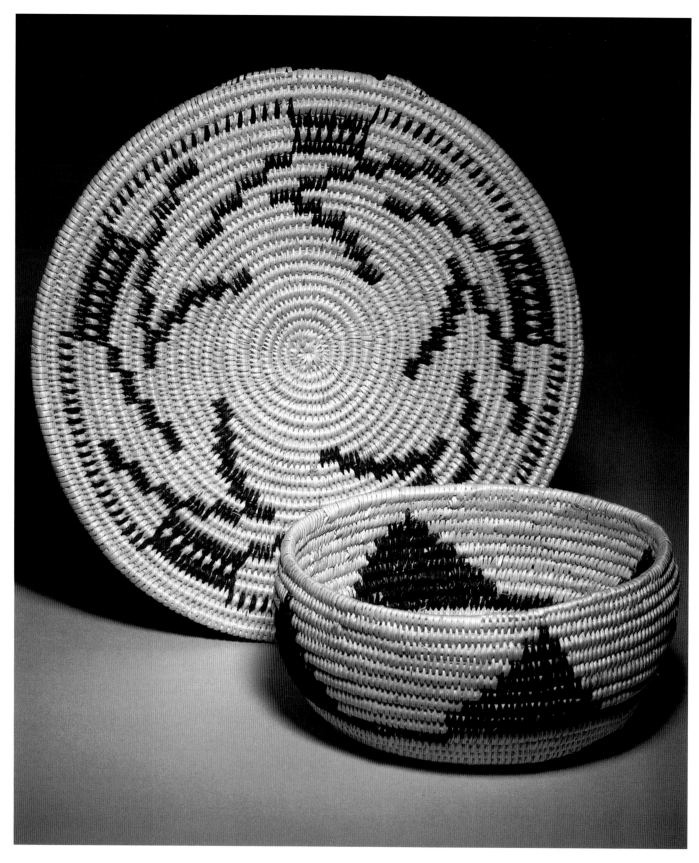

ABOVE: COILED BOWL AND PLAQUE BY FLORENCE MARSHALL, MADE IN 1982. (FROM LEFT) PLAQUE, DIA. 10 1/2"; BOWL WITH MOUNT SINYELLA DESIGN, DIA. 7", H. 3".

FACING PAGE: COILED PLAQUE BY SARAH NODMAN COOK, MADE IN SPRING 1988. IT WAS THE FIRST BASKET SHE HAD MADE IN SEVERAL YEARS. DIA. 11 1/2".

The isolated location of Havasu Canyon, in which the Havasupai reside, has been an important factor in the preservation of their basketry. Two trails—one twenty-six miles long and the other eight miles long—are the only access into the canyon except for helicopter service from Hualapai Hilltop and the Grand Canyon. All visitors and people delivering goods and offering services get to Supai village on the eight-mile trail by walking or riding horses and mules. The resulting minimal contact with the outside world has made baskets a necessity in every home until recent years, thus preserving Havasupai basket making.

At one time, the Havasupai and Hualapai were part of the same culture, and thus many aspects of their cultures are similar, including their basketry. The methods of construction and use of designs are the same, although the materials they use may differ because of availability. According to McKee and Herold in their book, *Havasupai Baskets and Their Makers: 1930–1940*, Havasupai basketry has gone through several transitional periods. Coiled baskets were seldom if ever produced before 1870 but began to appear after this date. This surge in production of coiled baskets was the result of several developments: the introduction of the commercial awl; the use of devil's claw for creating designs; the influence of Yavapai weaving; the encouragement of schoolteachers; and the increased demand for baskets from both Hopi and Anglos.

In the early 1900s, aniline dyes were briefly used by the Havasupai in basket patterns, but soon devil's claw again became the preferred material for executing designs. While twined baskets were still made with great frequency for use in the home, the production of coiled baskets continued to increase. Between 1910 and

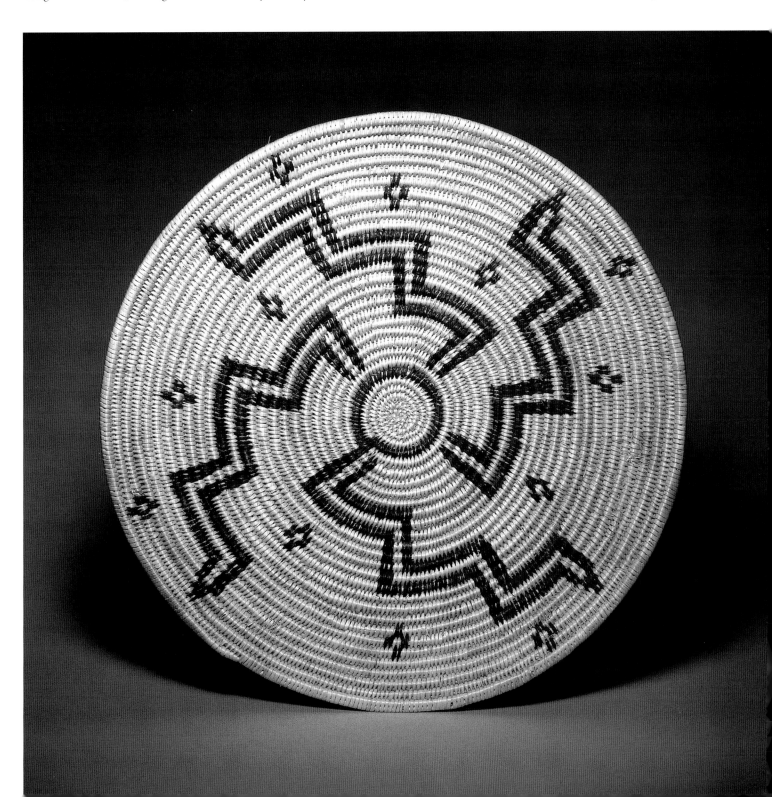

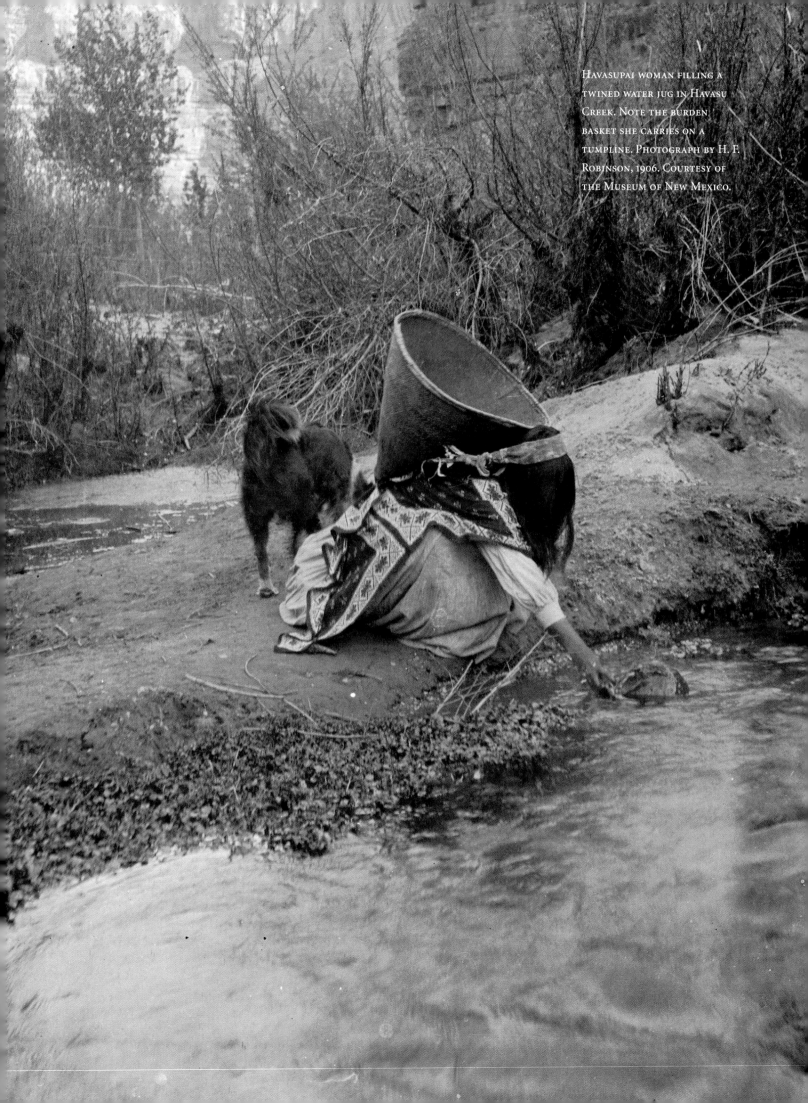

HAVASUPAI WOMAN FILLING A
TWINED WATER JUG IN HAVASU
CREEK. NOTE THE BURDEN
BASKET SHE CARRIES ON A
TUMPLINE. PHOTOGRAPH BY H. F.
ROBINSON, 1906. COURTESY OF
THE MUSEUM OF NEW MEXICO.

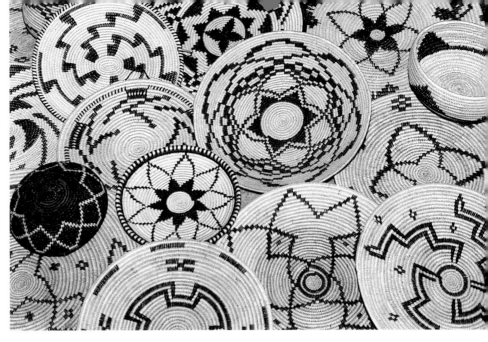

HAVASUPAI BASKETS MADE BETWEEN 1980 AND 1993 REPRESENTING THE WORK OF SIX WOMEN AND ONE MAN.

SARAH NODMAN COOK POSES WITH RECENTLY MADE BASKETS AT HER HOME IN PEACH SPRINGS, AUGUST 7, 1989, SHORTLY BEFORE HER DEATH. (FROM LEFT) FRET DESIGN, DIA. 10 3/4"; BOWL, DIA. 7 1/4", H. 4 1/4"; FIVE-POINTED STAR, DIA. 10 3/4".

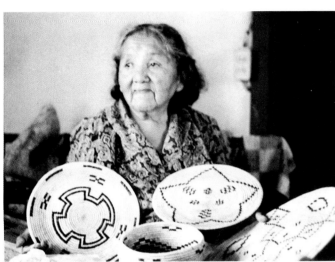

1930 basket making leveled off. The growing popularity of the Grand Canyon as a tourist destination resulted in jobs for many Havasupai, and consequently the economy became increasingly based on cash rather than barter. Subsequently, baskets made for tourist consumption replaced those produced for trade with the Hopi.

The apogee of Havasupai basket making occurred between 1929 and 1940. Weavers made their baskets for sale, perfecting the quality of their work while expanding the range of forms and sizes (McKee et al. 1975, 6). It was during this period that Barbara and Edwin McKee, who lived and worked at the South Rim of the Grand Canyon, gathered the 184 baskets showcased in *Havasupai Baskets and Their Makers: 1930–1940.*

By the 1950s, the decline in Havasupai basket making became apparent, probably caused by the belated impact of the Depression and wartime economy during World War II. In the ensuing years, considerable changes took place at Supai: electricity was brought to the village, mail service by mule train was established, and new housing was provided.

In the 1970s, the unspoiled natural beauty of Havasu Canyon and its remote location began to attract hikers and outdoor enthusiasts. Consequently, a campground was developed near Havasu Falls, one mile below Supai. A small dormitory provided beds and cooking facilities for visitors, and a restaurant established in the central plaza served Indian fry bread, sandwiches, and homemade pie. Tourists also had the option of hiking or riding horses into Havasu Canyon with a Havasupai guide. Soon these tourists began to purchase small twined and coiled bowls as souvenirs of their sojourn in the area. This demand has encouraged a number of older women to resume weaving, even though most of the pieces produced for the tourist trade are inferior in quality to those made in the 1930s.

In the 1980s, a motel was built in Supai and helicopter flights initiated between the village and Hualapai Hilltop several times a week. Several tractors and four-wheelers have been flown in to Supai to help with garbage collection, trail maintenance, and transportation for senior citizens, but they are the only motorized vehicles in the canyon. Unfortunately, all of these changes seem to have had an adverse effect on the production of baskets.

✦ MATERIALS AND CONSTRUCTION

A plentiful supply of the plants used in Havasupai basket making grow in Havasu Canyon adjacent to Havasu Creek. Willow, cottonwood, and devil's claw are used for coiled baskets; whereas catclaw (acacia), sumac, Apache plume, arrowweed, and serviceberry are primarily employed in twined ones. Willow is gathered in late August or early spring while cottonwood is cut in early spring. The slender year-old shoots of willow and cottonwood are split three ways for use as sewing strands and merely scraped when used as foundation rods. Then the pithy centers of the strands are removed and the bark peeled off, after which they are ready to be sized along with some final scraping to get the desired width. Sometimes weavers will leave this step until beginning a basket, when they known what size and width will be needed. Devil's claw, a low-growing shrub with a long curved pod that grows out of its fruit, is grown in the cornfields and harvested in August before being used to create designs on baskets.

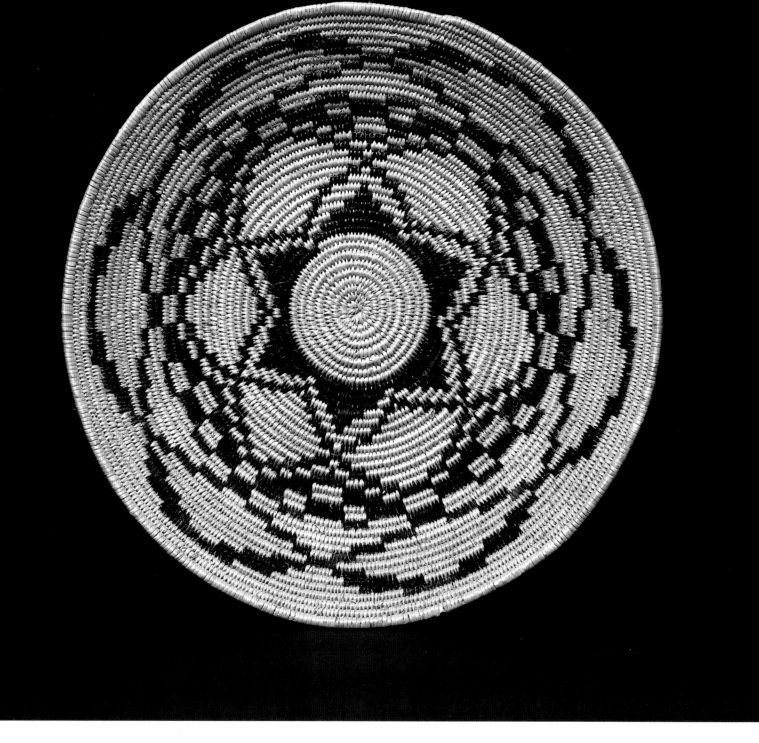

Catclaw, sumac, and some willow are used for making twined baskets. They require less preparation than do the materials used for coiling. These materials can be employed without removing bark for the foundation (warp) or split into two parts and used for twining (weft). Arrowweed bush, Apache plume, and serviceberry are employed for the rim on twined pieces because of their strength.

Several characteristics identify baskets made by the Havasupai. First, they are coiled to the left from the work side of the basket. The work side of the basket is the side facing the weaver. This side is always smoother than the reverse side, where the sewing strands are clipped. Second, Havasupai baskets always employ a general

black-on-white motif. Although some aniline dyes were used around the turn of the century, they are no longer employed. Third, weavers generally adhere to the use of an all-white rim, but this is not always the case, as can be seen in several baskets in the photographs. The majority of coiled pieces presently made are plaques, with occasional bowls and trays (one inch or more in height), and ollas. Twined baskets are now produced more frequently than coiled ones because they require less preparation of materials and less time to make and thus can yield a quicker profit.

While willow has played an important role in older baskets, it appears to be less frequently used by current weavers. Carolyn Putesoy is the only weaver who always employs willow in her baskets. The other weavers say they prefer utilizing cottonwood because it is easier to work with and whiter. Of the seventeen coiled pieces in my collection, three-quarters were made with cottonwood, both rods and sewing strands.

Havasupai weavers distinguish between twineware and coilware with the terms "rough" and "fine." They look at the work of other weavers very differently from those of us who collect baskets. While most observers are interested in the overall appearance of a basket, a weaver studies the construction and counts the number of stitches and coils used to create the design or shape. There appears to be little if any symbolism attached to the designs used by Havasupai weavers, the only criteria for selection being the appeal of a design and the feasibility of executing it given the weaver's expertise or accessibility to materials.

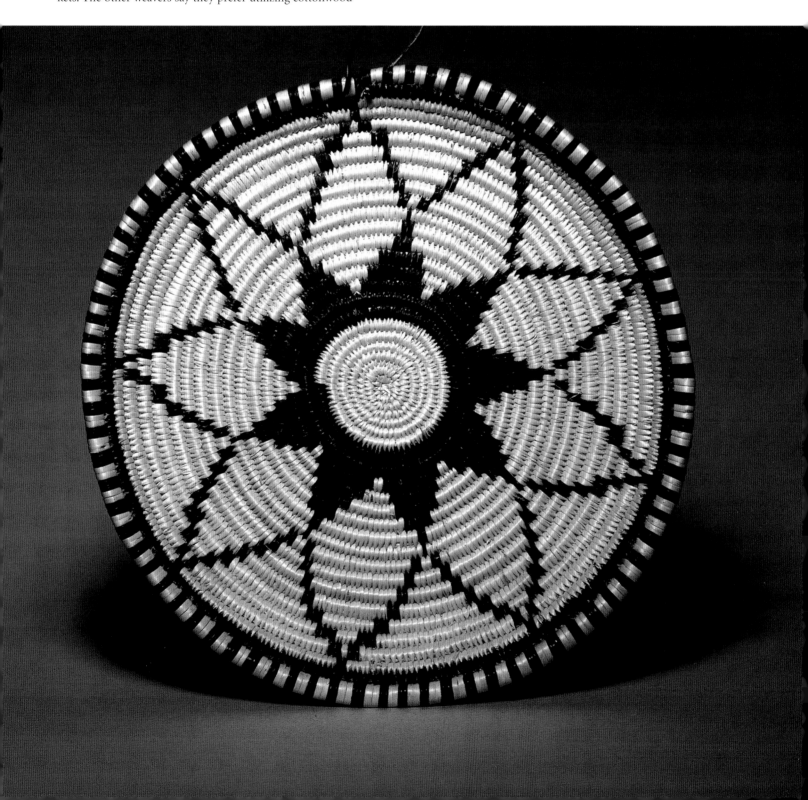

During the 1980s and 1990s, at least ten Havasupai women and one man were weaving: Sarah Jones Nodman Cook, Florence Marshall, Grace Hanna, Maude Jones, Ida Iditicava, Carolyn Putesoy, Flossie Wescogame, Minnie Marshall, Mae Tilouis, Bessie Rogers, and Erwin Crook. I have collected twenty-four baskets from these weavers. Seventeen are coiled, three-rod construction, including thirteen plaques and trays and four bowls; seven are twined pieces, including two trays, two small burden baskets, two small bowls, and one water jug. These twenty-four baskets cover a broad spectrum of quality and types made during the period. The sewing on the coiled pieces varies from nine to nineteen stitches per inch, with the majority in the range of twelve to thirteen stitches per inch. All the baskets have four to six coils per inch.

Sarah Jones Nodman Cook (1908–1989) was born in Supai. Her mother died when she was young, and she was raised by her grandparents. She left Supai in the early 1920s, returning only once, in 1927. She lived most of her life in Peach Springs, less than seventy-five miles from her birthplace, where she married Burt Cook, a Hualapai man, and raised a family. Although she learned to weave as a young girl, like many other weavers she did not pursue it while raising her family but resumed making baskets in 1971 (Bateman 1972, 69). Sarah made only coiled baskets, and since materials were scarce around Peach Springs her weaving was limited. She obtained most of her devil's claw and cottonwood from Flossie Wescogame in Supai.

Sarah made seven baskets between spring 1988 and her death in fall 1989. Weaving had become difficult because of failing eyesight, but all of her baskets have a consistent ratio of twelve to fifteen stitches and five to six coils per inch. She used devil's claw sparingly in her baskets because she did not like "designs too crowded." Of the seven baskets, three had circular designs. Sarah described one of them (page 15) as representing lightning and stars. The most dramatic design of the seven, it has four pairs of zigzag lines radiating outward from the center flanked by twelve small coyote tracks representing stars. The zigzag design is similar to ones seen on Apache, Yavapai, and O'odham baskets. However, the two lines that make up the four zigzags are usually not closed at the end as these are.

Sarah said the basket she is holding in above looked like a Ferris wheel, recalling from her youth how the lights blur and overlap as the wheel turns. The basket on the left on page 17 has a fret design, which is quite common on Havasupai baskets. More often several of these designs are used moving outward from the center of the basket. Flossie Wescogame uses the design in this manner. The placement of eight short lines encircling the piece just below the rim provides a finishing touch.

Two pieces made by Florence Marshall are shown on page 14. The design on the plaque combines two of her visual concepts.

TOP: SARAH NODMAN COOK AND THE AUTHOR WITH TWO OF HER RECENTLY COMPLETED BASKETS. (FROM LEFT) FERRIS WHEEL DESIGN, DIA. 12 1/4"; TWO FOUR-POINTED STARS, DIA. 12". BOTH HAVE A HEIGHT OF 1/2".

CENTER: HAVASUPAI WEAVER FLOSSIE WESCOGAME (CENTER), WHO SPECIALIZES IN SMALL COILED BOWLS. PHOTOGRAPH TAKEN AT HER HOME IN SUPAI IN 1980.

FACING PAGE: GRACE HANNA DISPLAYS SOME OF HER BASKETS AT HER HOME IN SUPAI, APRIL 5, 1991. HER SMILE EXPRESSES HER PRIDE IN HER WORK. FROM LEFT: LIGHTNING DESIGN, DIA. 10 1/2"; DIA. 10 1/2" (TOP); DIA. 10 1/4"; DIA. 10 1/4".

The V shapes represent the trail down into Havasu Canyon from Hualapai Hilltop, while the other five lines depict cornstalks. All of these shapes are placed to create a whirling motion. The ticking (alternating black and white) just below the rim acts as a frame for the design. The other basket made by Florence is a bowl with four triangles placed on a line encircling the piece. They represent Mount Sinyella, one of the few mountain peaks among the many plateaus that can be seen from the canyon.

Florence's daughter, Grace Hanna (below), weaves plaques that are very similar in size and style to her mother's. Three of her baskets shown in the photograph have a swirling design, while a fourth has a central design depicting motion surrounded by static, repetitive elements. Grace is very meticulous in the preparation of her cottonwood and devil's claw splints, something that is reflected in the quality of her baskets, which consistently have nine to twelve stitches per inch. The basket in the lower left of the photograph is unique. To create the five zigzag lines radiating from the center outward, she had to use an oval start then adjust it to make a round plaque.

Maude Jones and Ida Iditicava are sisters who both create some of the finest baskets in Supai. Their mother was Lina Manakaja Chikapanega Iditicava, a well-known weaver. Although they weave infrequently, they produce pieces of very fine quality with well-balanced designs. Maude's tray on page 22 has fifteen stitches per inch. The center design is a flower with four petals surrounded by two sets of eight-pointed stars, one set black, the other white. Eight large black-and-white triangles encircle the outer edge, creating an optical illusion of a square offset and superimposed on a second square. The design is perfectly balanced, and the black rim completes the piece. The use of devil's claw on the rims of Havasupai baskets, while not uncommon, has not been used extensively.

Ida's plaque illustrated on page 19, the finest work of all the pieces in the group, has a diameter of less than eight inches with nineteen stitches per inch. The quality of both Jones's and Iditicava's baskets compares favorably with those produced in the 1930s when Havasupai basket making was at its zenith.

The first Havasupai basket I collected was a small bowl with a negative design made by Erwin Crook. It has an average of thirteen stitches per inch. The splints of devil's claw are so closely placed together that the white foundation rods below are not visible. The second basket on page 18 is the most traylike of all the coiled pieces, with a height of two inches. While the design is typical of Havasupai baskets, there is also a Yavapai look to it, even though it lacks the dark center start and dark rim treatment seen in Yavapai pieces. The well-executed design is the most complex of all the coiled pieces in my collection.

Carolyn Putesoy has worked for years in the restaurant at Supai as cook and baker. She weaves a few baskets a year and has taught her daughter to weave. Interested in experimenting with

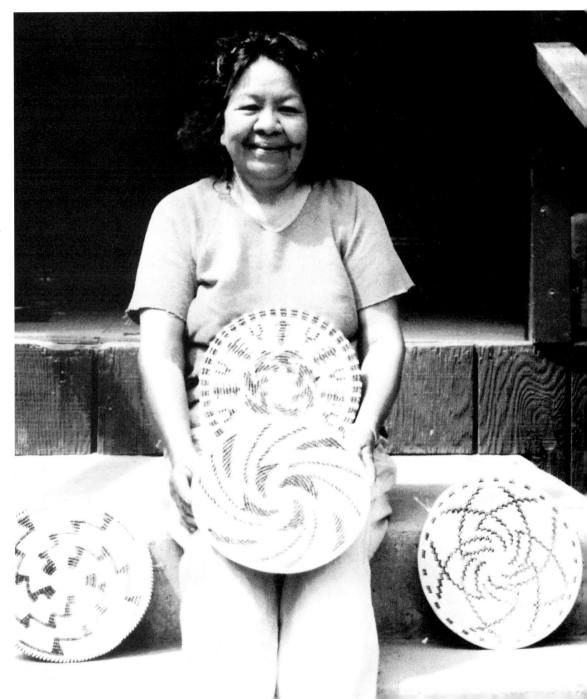

new designs, she gets many of her ideas from books and pictures of baskets. Many of her baskets are larger than the usual size produced by other weavers and are plaque shaped. Carolyn uses willow in her baskets rather than the cottonwood preferred by most Havasupai weavers.

Flossie Wescogame (page 20) coils small bowls and miniature pieces that she sells at the restaurant in Supai or to tourists who come to her house. She has been one of the most prolific weavers in Havasu Canyon, completing several small baskets a month.

As in the 1970s, the majority of baskets being produced are still small twined replicas of utilitarian pieces that can be made quickly to supplement the income of weavers and to provide souvenirs for visitors to the canyon. There are, though, several weavers who continue to do quality twining, and their work is eagerly sought by collectors.

Minnie Marshall is one of the best-known contemporary weavers. When shown her picture in *Havasupai Baskets and Their Makers: 1930–1940*, she asked for a pen and autographed the picture much to my surprise. For many years Minnie made both coiled and twined baskets, but by 1980 she had ceased to do coilwork because of her arthritis. She continues to do twinework, however, such as the five baskets shown below on which she used twill twining. The large tray without a design is exceptionally well made; the weft strands are very tight and uniform, giving the piece an interesting textural appeal. Minnie pays careful attention to the preparation of her materials in addition to using consistently uniform twining. The casual observer can see that the smaller tray is not as carefully made and lacks the smooth surface. The design of arrows pointing toward the center of the piece is a pattern frequently used on Havasupai coilwork. The small burden basket with the design near the rim is a perfect replica of an old utilitarian basket. The opening of the mouth is slightly larger than the length, which is typical of old pieces. The design and its placement are also typical, except for the horsehair carrying strap, which would not have been used on a larger basket. The materials used for these baskets include catclaw (acacia) and devil's claw for the weft strands with either willow or catclaw used for the foundation (warp).

22

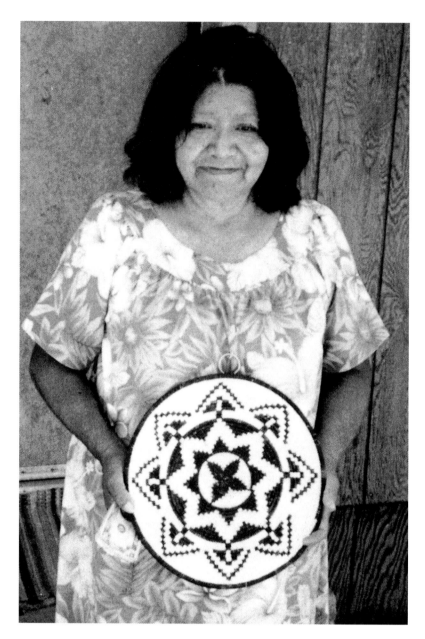

MAUDE JONES WITH ONE OF HER MASTERPIECES, PHOTOGRAPHED ON JULY 7, 1986 IN SUPAI. THE BASKET HAS SIX COILS TO THE INCH. DIA. 12". PHOTOGRAPH BY JOHN RUBIO.

BELOW: HAVASUPAI TWINEWARE. (FROM LEFT) TRAY WITH DESIGN BY MINNIE MARSHALL, 1983, DIA. 9 3/4"; TRAY BY MINNIE MARSHALL, 1983, DIA. 11"; SMALL JAR BY MAE TILOUIS, 1982, DIA. 6 1/2", H. 6 1/2"; SMALL BURDEN BASKET WITH DESIGN BY MINNIE MARSHALL, 1983, DIA. 10", L. 9 1/2"; BURDEN BASKET BY BESSIE ROGERS, 1982, DIA. 7 1/2", L. 10".

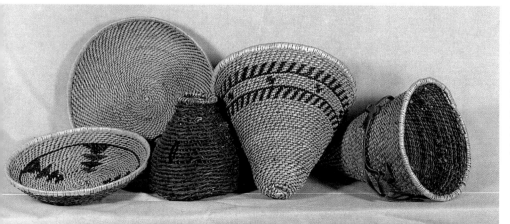

FACING PAGE: HAVASUPAI WEAVER CAROLYN PUTESOY WITH A 1983 COILED PLAQUE. FORMS WITH UNEMBELLISHED DESIGNS EXECUTED WITH MINIMAL USE OF DEVIL'S CLAW ARE TYPICAL OF MOST HAVASUPAI COILWARE PRESENTLY MADE. DIA. 9 1/2", H. 1". PHOTOGRAPH BY BARBARA MAULDIN, MUSEUM OF NEW MEXICO.

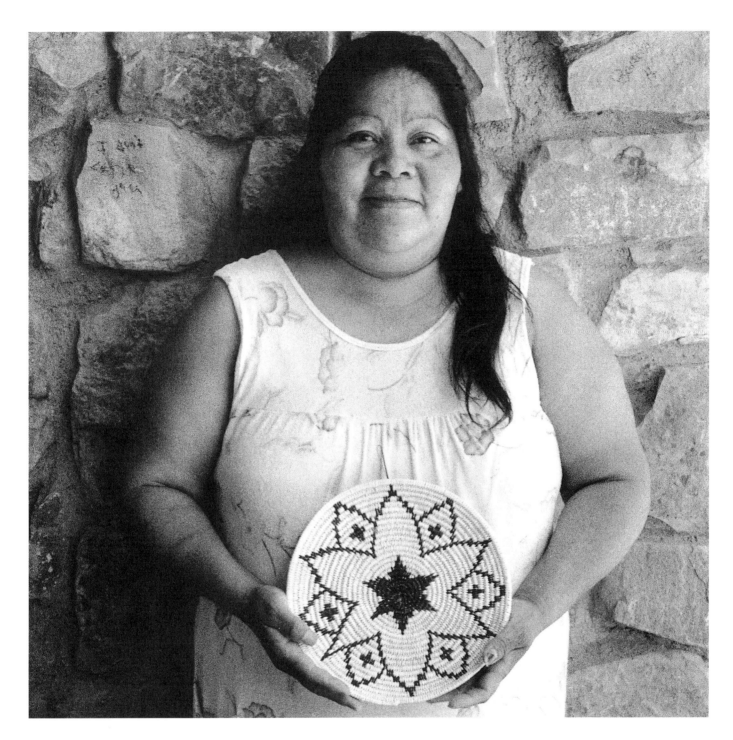

The future of Havasupai basketry is uncertain. On the one hand, the helicopter service has made Supai village more accessible; and the new motel has brought older, more affluent tourists to the canyon. Weavers command good prices for their work, and the demand for quality baskets is evident. On the other hand, many weavers choose to weave infrequently.

During my last visit to Supai in November 1993, I observed both evidence of decline in basket making and hopeful signs of interest in preserving this tradition among the current population. The winter before my visit, Cataract Dam, located on the plateau above Supai, had burst after heavy rainfall and flooded Havasu Canyon, damaging the village considerably and destroying the famous travertine pools below Havasu Falls. Several changes had occurred among the eleven weavers discussed above. Florence

Marshall and Mae Tilouis had died, while another weaver was no longer making baskets because of health problems. One woman had recently completed two fine coiled plaques that were for sale, while another had been actively weaving but had already sold her baskets. Two of the best weavers of coiled baskets said they would probably make some during the winter. A positive development was the existence of a new program to provide instruction in basket making that had been implemented in the school at Supai. Another was the tribe's establishment of a museum. The permanent exhibits are improving yearly, and a dozen or so baskets are currently displayed. A recent acquisition was an excellent coiled olla made by Erwin Crook. It is but one example of the skill that several contemporary Havasupai weavers possess if they choose to use it.

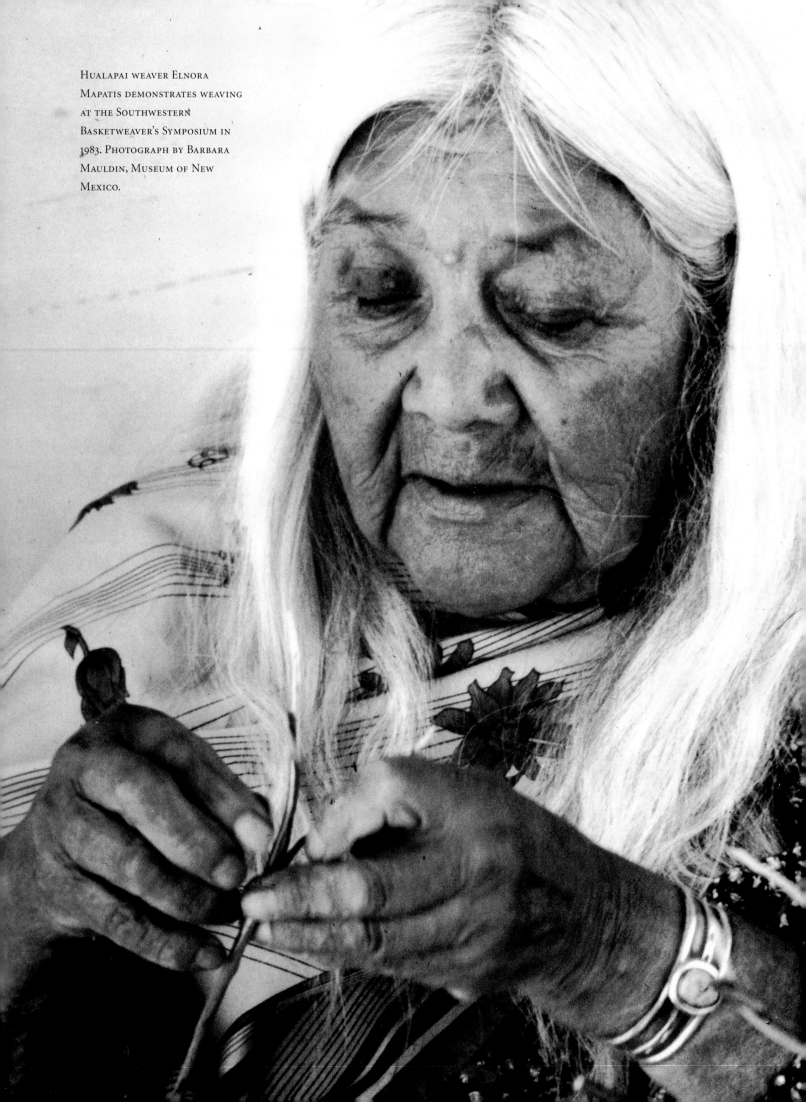

Hualapai weaver Elnora Mapatis demonstrates weaving at the Southwestern Basketweaver's Symposium in 1983. Photograph by Barbara Mauldin, Museum of New Mexico.

THE ART OF BASKET MAKING AMONG THE HUALAPAI appears to be on the brink of extinction, a situation it has faced several times in the past and always has recovered from. Perhaps the same will happen once again.

⊕ HISTORY The Hualapai, along with their close relatives the Havasupai and the Yavapai, are Yuman-speaking people. They once occupied a large area of northwestern Arizona bounded on the north by the Colorado River, on the west by the Black Mountains, on the south by the Bill Williams and Santa Maria Rivers, and on the east by the Santa Maria River and the South Rim of the Grand Canyon (see map). In this predominantly arid region of mountains and high deserts, vegetation varies from mesquite and cactus in the low deserts to oak, piñon, and pine at higher elevations. Within these boundaries the Hualapai led a nomadic existence, hunting and gathering a variety of plants and animals at optimal times.

The Hualapai experienced only occasional contact with the Spanish, fur traders, and emigrants before 1850. During the 1850s, however, the contact became more frequent and disruptive to their way of life. The United States Army sponsored several expeditions through northern Arizona in search of railroad and wagon routes (McGuire 1983, 27). In 1853 and 1854, Lieutenant Amiel Whipple and a crew surveyed for a possible railroad route. Two years later, Lieutenant Edward Beale's party built a wagon road along the thirty-fifth parallel, which cut through the heart of Hualapai territory. The new road was heavily traveled, making conflict inevitable.

HUALAPAI CAMP NEAR THE GRAND CANYON IN THE 1880S. TWO LARGE CONICAL GATHERING BASKETS CAN BE SEEN IN THE PICTURE. THE SHAVED HEADS INDICATE THE CHILDREN WERE PROBABLY ENROLLED IN SCHOOL. PHOTOGRAPH BY BEN WITTICK, COURTESY OF THE MUSEUM OF NEW MEXICO.

25

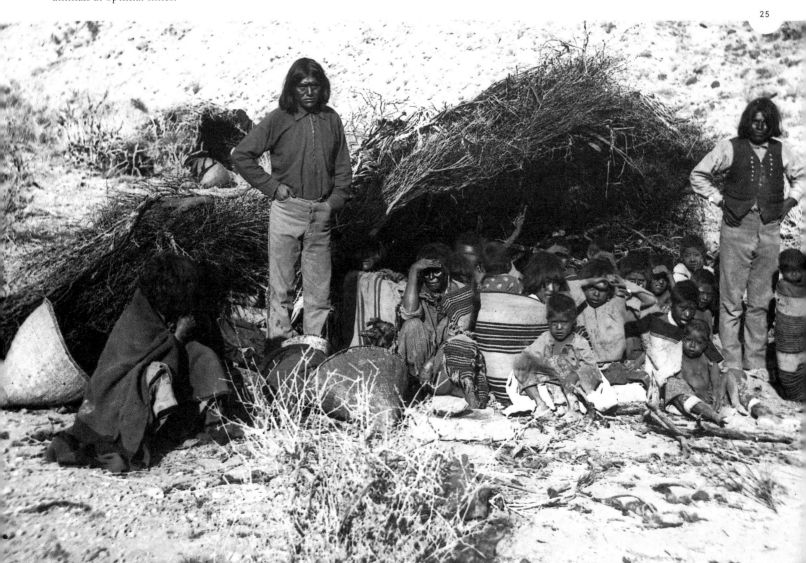

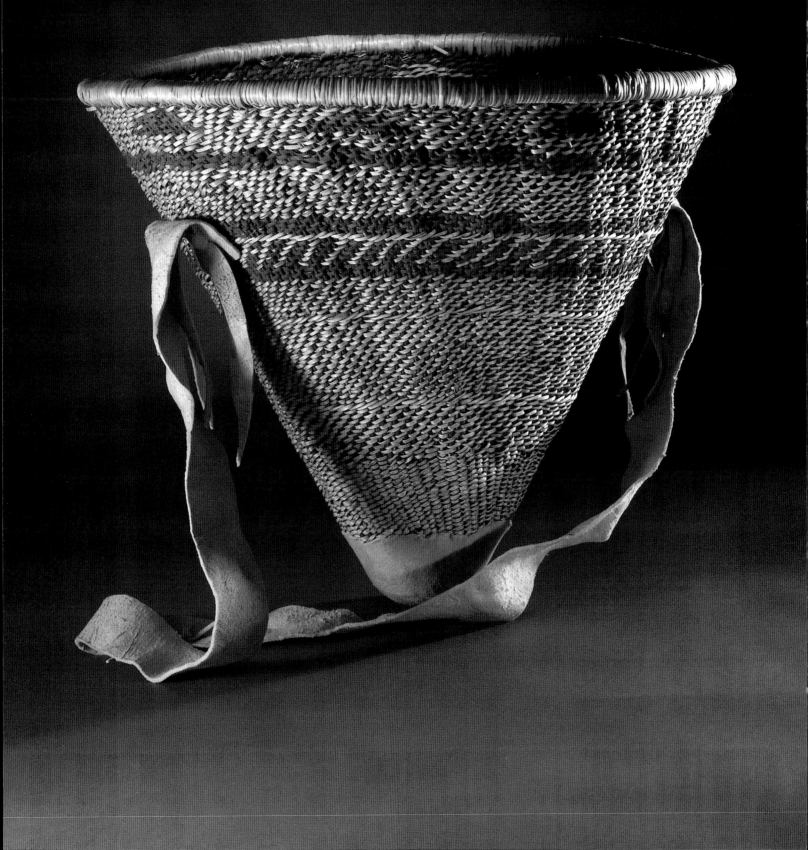

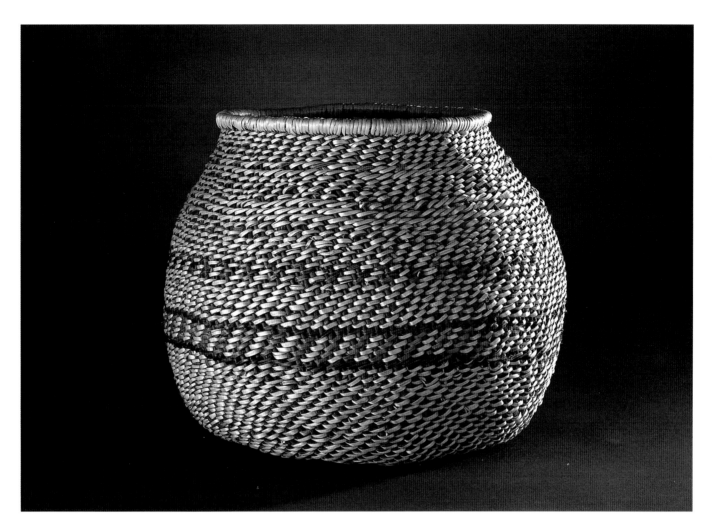

Large storage basket made for the author by Elnora Mapatis in 1981. One of her finest baskets, it is made entirely of sumac. She used brown and orange Rit dye and devil's claw for the design. Dia. 12", H. 10".

Baskets made by Hualapai weavers Beth Wauneka, Annie Querta, and Elnora Mapatis. Rit dye was used on all four baskets for black and other colors.

Facing page: Hualapai gathering and burden basket made by Beth Wauneka. Wauneka worked on this basket for several years before completing it in winter 1990. Dia. 16 1/2", L. 15 1/4".

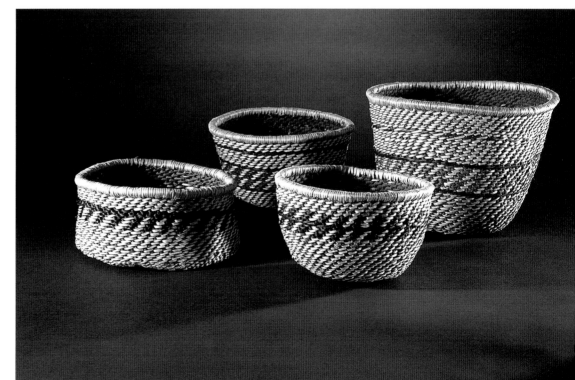

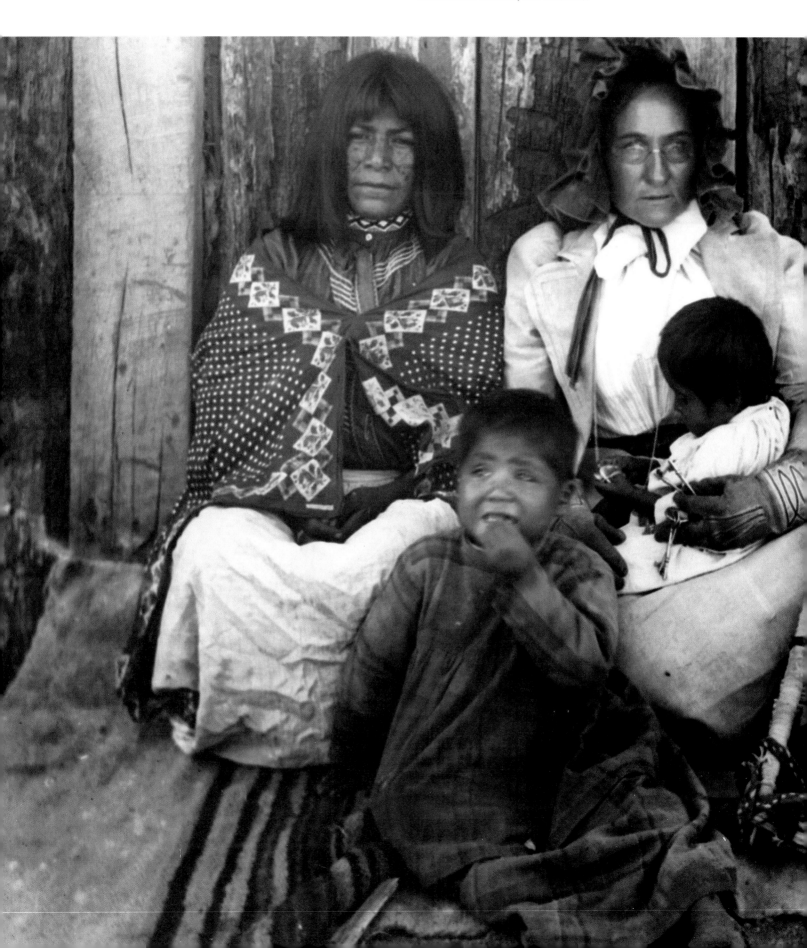

In 1866, when Hualapai headman Wauba Yuma was killed, war developed between the Hualapai and the invaders, lasting three years before the military from Camp Beale Springs and Fort Mojave forced their surrender. Following this conflict, they were interned at Camp Beale Springs, near present-day Kingman, Arizona, before being sent to La Paz on the Colorado River Indian Reservation.

Living conditions on the reservation, which they shared with the Mohave, were intolerable; insufficient government rations, a climate they were not accustomed to, homesickness, and disease were major problems. In 1875, they returned to their high-desert homeland only to find that in their absence miners and ranchers had taken possession. Forced to adjust, they combined their old hunting–gathering life-style with wage labor jobs in order to survive.

In 1883, they were given a reservation, which Indian Superintendent Oliver Gates described later as some of the most useless land on earth for agricultural purposes. Unprepared to become farmers, which was encouraged by the government, they worked in surrounding areas on the railroad, in mines, and on ranches. By the turn of the century, most Hualapai were living off the reservation either permanently or for long periods of time.

The forced changes in the life-style of the Hualapai had a devastating impact on their traditions, including basketry. The introduction of metal buckets and glass containers for use in daily life diminished the need for twined baskets previously used for such purposes. The result was a rapid decrease in basket making.

Between the 1890s and the present, however, there have been three revivals of basket making among the Hualapai separated by periods of decline. In 1894, Frances Calfee was sent by the Massachusetts Indian Association to open a school among the Hualapai at Hackberry. According to George Wharton James, she was responsible for encouraging women to start making baskets for sale, and after her arrival the production of coiled baskets increased rapidly. The railroad had been built through Hualapai territory in the 1880s, and the railroad station at Hackberry was the perfect place for weavers to sell their work to tourists. Shops at the Grand Canyon also became an outlet for Hualapai baskets as the number of tourists visiting there increased.

As a result of these new markets, the emphasis on basket types shifted from twined to coiled and from utilitarian pieces to made-for-sale collectibles (Kroeber 1935, 79).

By the 1930s, a decrease in the making of coiled pieces and an increase in the production of twined pieces was evident. In addition, the new twined baskets were different from earlier utilitarian ones; they were usually small- or medium-sized bowls, frequently with pedestals, and made for sale (the same type of bowls without pedestals are made today, with Rit dye used for coloring the weft strands used in the design). This transformation was the result of several specific factors related not only to the new market for baskets but also to changing environmental conditions. Since tourists buy greater numbers of cheap souvenirs than expensive ones, and since it takes less time to prepare materials for and weave twined baskets, they generated greater profit. Moreover, decreased availability of various materials was a significant factor in the shift. As more lands fell into the hands of private owners, they were off-limits for gathering. Additionally, willow and cottonwood, which are employed for coiling, are scarce around the Hualapai Reservation, whereas sumac, which is used for twining, is abundant.

Hualapai basket making reached a low point between World War II and the 1960s before undergoing a revival in the late 1960s and 1970s. At that time, copies of utilitarian twined pieces were again produced, including parching trays, conical baskets, and water jugs that had not been made for some fifty years (Bateman 1972, 73). In a period of only five years, the number of basketmakers increased from four to thirteen. This revival can be partially attributed to Mrs. Tim McGee, who taught a basket-making class in 1966 in Peach Springs. A second impetus was the new store owners in Peach Springs, who were interested in baskets and encouraged the weavers by paying them fair prices for their work. In 1967, only six baskets were offered for sale, but in 1970 over one hundred were brought to the store (Bateman 1972, 62). Some of the women who were weaving during this time were Jane Honga, Maud Sinyella, Alma Fielding, Elnora Mapatis, Nellie Mahone, Eva Schrum, Laura Majenty, Agnes Havatone, and Glada Manakaja. Five Havasupai women living in Peach Springs were also weaving (Bateman 1972, 75).

During the 1980s, only five Hualapai women were making baskets with any regularity: Elnora Mapatis, Annie Querta, Eva Schrum, Jenny Imus, and Beth Wauneka. Out of the five, Beth Wauneka is the only one still weaving.

⊕ MATERIALS AND CONSTRUCTION

Materials the Hualapai use for twining are readily available on or near the reservation. Sumac (squaw bush, lemonberry) twigs are used for the warp (foundation) and sumac splints for the weft (sewing strands) in all twined baskets. The sumac is whiter and easier to work with when harvested in the fall after the first frost. Preparing the branches to be used for the warp requires removing only the leaves from the twig. Sometimes the twigs are sized by running them through a hole in a tin lid; however, this is seldom necessary since most weavers spend little time in preparing foundation materials.

Preparing the twigs to be used for the weft takes more time. The branch is usually split in two parts, sometimes three, by the weaver holding one portion in her mouth and using both hands to guide and separate the twig into equal parts. Then the pithy center is removed, and the resulting two splints are sized for twining. The bark is left on these splints and can be seen on the inside of the basket, while the light interior of the splints can be seen on the basket's exterior. Either devil's claw or dyed sumac is used for executing designs. Since sumac is very porous, it easily absorbs the Rit dye used for reds, oranges, and browns. Sumac has a very pungent but pleasant smell that will linger for months where a basket is placed. Many weavers hang bunches of the sumac twigs in the house just for the aroma. The same aroma is recognizable on Ute, Navajo, Jicarilla Apache, and San Juan Paiute baskets that have been recently made of sumac.

To start a basket, two long sumac sticks are tied diagonally over two other long sticks to form the warp (combinations of threes or fours are also used). The splints employed to bind the four foundation branches are then twined around these sticks, with additional sticks being added to the pinwheel as the size of the circle grows (opposite). When the desired diameter for the bottom is obtained, the foundation sticks are bent upward at a forty-five-degree angle to build the sides. The rim is made from two split hoops, one placed on the inside and one on the outside of the basket. The warp sticks are bent parallel between the two hoops and are thus included in forming the rim, which is lashed together with sumac sewing splints.

⊕ WEAVERS AND THEIR BASKETS

In the 1990s, most of the Hualapai were living in modern houses on the reservation in Peach Springs, although smaller colonies were occupying Indian lands at Valentine and Big Sandy, Arizona. Many had intermarried with their close relatives, the Havasupai. The small number of baskets still being made are primarily twined bowls. Several three-rod coiled pieces using sumac and devil's claw were completed by Jenny Imus during the 1980s. Sarah Nodman Cook also wove a number of fine coiled pieces using cottonwood and devil's claw during this period, but she was a Havasupai living at Peach Springs. A few other weavers knew how to coil but were not producing because of health problems or family obligations.

One of the most productive weavers, Elnora Mapatis (1900?–1988), was born in Hackberry, Arizona, and worked for many years at the Grand Canyon before moving to Peach Springs. Her mother taught her to weave when she was young but she never used her skills until 1968, when Maud Sinyella asked her to help fill an order she had for baskets. Elnora said she only made small baskets until she became more proficient.

Elnora gained increasing recognition through her presentations at various arts venues. She participated in the Southwestern Basketweaver's Symposium in 1983 and demonstrated at Indian Market in Santa Fe, New Mexico, in 1983. Because of her outgoing personality and wonderful sense of humor, she was one of the highlights of the symposium and of the 1983 Indian Market.

Elnora made many small burden baskets, finishing them with a buckskin strap and bottom, as well as small- and medium-sized bowls. For my collection, I ordered a large storage basket (page 27), which turned out to be one of her finest baskets. Completed in 1981, it was probably one of the few if not the only one of its size made in the last quarter of the twentieth century. She may have copied the shape from one she saw years ago, since it does not conform to the bowl shapes made during the period. Baskets similar to this one, along with makeshift lids, were commonly used during the last century for storing pine nuts, berries, and seeds.

On this piece, Elnora used twill twining, in which two sewing strands are wrapped around two foundation rods to create a slight upward angle to the right. In this method of twining, which is the current prevalent method of the Hualapai, the foundation rods are visible. Six rows of three-strand twining were also used for textural variety and to reinforce the sides. A wide band of orange and

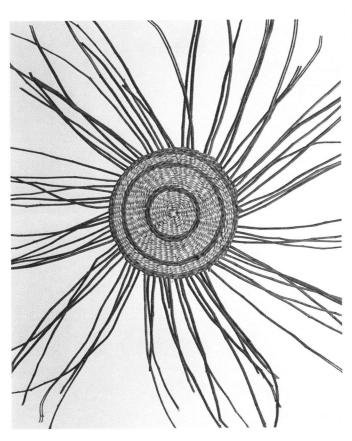

IN MAKING THIS BASKET, SEVENTY-EIGHT SUMAC BRANCHES WERE
USED FOR THE WARP, WHILE TWO SPLIT SUMAC SEWING STRANDS
WERE CROSSED OVER AND UNDER EACH BRANCH IN A SIMPLE TWINING
TECHNIQUE. THE DESIGN WAS CREATED BY USING GREEN SUMAC,
WHICH TURNS A RUST COLOR WITH AGE.

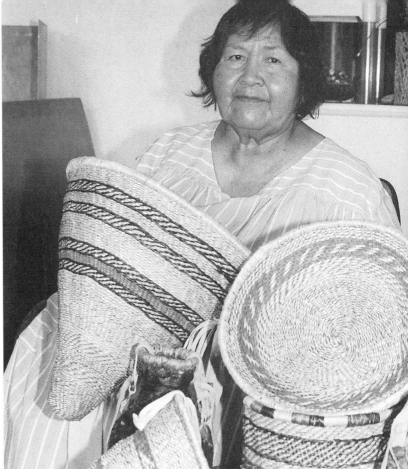

HUALAPAI WEAVER BETH WAUNEKA IN 1998 WITH SOME OF HER
RECENT WORK, INCLUDING PITCHED WATER BOTTLES, A STORAGE
BOWL WITH BLACK-AND-RED DESIGN, TRAY, AND BURDEN BASKETS.

brown is included on the bottom half of the basket with a smaller
brown design just above it and a single orange row right below the
rim. The three designs, with the largest at the bottom and the
smallest at the top, give the piece a delicate symmetry.

In 1999, three Hualapai basketmakers continue to make
twineware: Beth Wauneka, Betty Wescogame (daughter of Alma
Fielding), and Sheryle Beacher. Beth moved back to Peach Springs
in 1973 after living many years in California. Although her mother,
Bernice Whatsoniane, taught her to weave at a young age, Beth did
not begin making baskets until returning to Peach Springs.

She once described how the family used to travel from
Chloride to Hackberry so her mother could sell her baskets to buy
staples of flour, sugar, and coffee. Beth attended the old school at
Valentine, Arizona, until the ninth grade before going to the Indian
boarding school in Phoenix, where she completed her formal edu-
cation in 1940. Like her mother, who taught basket making at the
Valentine school from 1935 to 1940, Beth is a teacher. She has
taught Sheryle Beacher and several weaving classes at the local
school, as well as demonstrated at the Heard Museum in Phoenix
and at a show of Pai Indian arts at the Museum of Northern
Arizona in Flagstaff in 1998.

In the 1980s, Beth made three large burden baskets similar to
ones used in the nineteenth century (page 26). Sumac was used for
both the warp and the weft, with the natural color of the bark
employed for the design. Two-strand twill twining was used in

conjunction with several rows of three-strand twining. In the lat-
ter, the foundation rods are not visible to the eye. After the basket
was finished, a wet cloth was placed inside, and it was filled with
small rocks to mold the desired form. An elk hide strap for carry-
ing and a reinforced hide bottom complete the basket. The piece is
very well executed and could easily withstand the daily rigors of
hauling wood and camp equipment. A distinctive characteristic of
old Hualapai and Havasupai burden baskets was that the diameter
and depth were approximately of equal size, usually eighteen to
twenty-two inches. This shape helped to distribute the weight high
on the back, making the load easier to carry long distances.

Beth also makes bowls of various sizes, as well as small trays.
During the 1990s she made another large burden basket in addi-
tion to several twined water jugs and canteens waterproofed with
piñon pitch. She is planning to experiment with coiled baskets in
the near future.

The deaths of Eva Schrum, Annie Querta, Elnora Mapatis, and
Jenny Imus have reduced the ranks of Hualapai basketmakers, but
as in the past there always seem to be others to carry on the tradi-
tion. Betty Wescogame and Sheryle Beacher, neither of whom were
reported by Whiteford to have been weaving in the early 1980s, are
two examples of weavers committed to preserving the tradition.

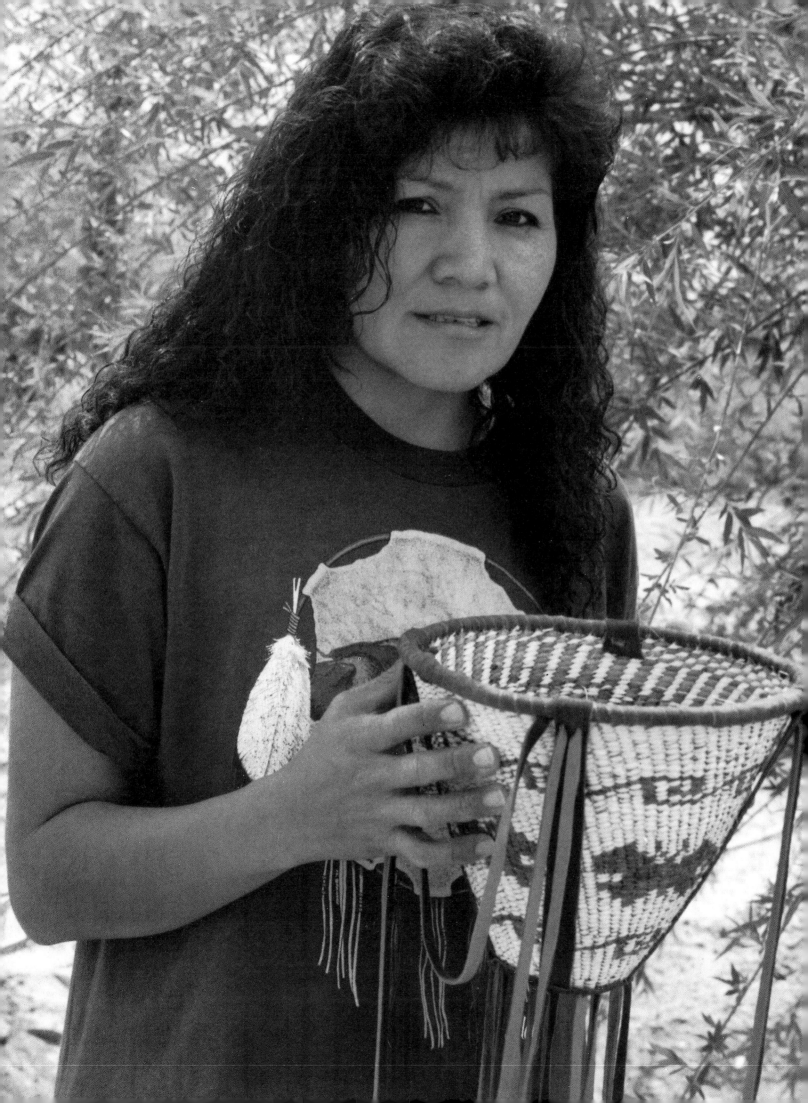

Today, the Western Apache are the only Apaches except the Jicarilla who still practice the art of basket making with any frequency. Since the early 1970s, there has been a resurgence in the production of twined pieces, but the coilware made at the beginning of the century for which they are so famous is close to extinction.

FACING PAGE: SAN CARLOS APACHE WEAVER MARY JANE DUDLEY IN 1997. DUDLEY FREQUENTLY USES A BUTTERFLY PATTERN ON HER WORK. THE WAVE DESIGN ON THE BASKET SHE IS HOLDING IS THE ONE HER GRANDMOTHER, CECILIA HENRY, ORIGINATED.

BASKETS MADE BY CAROLINE (HENRY) WATERMAN. SHE USES A SIMPLE TWINING METHOD OVER A SINGLE SMALL FOUNDATION ROD. THIS PRODUCES A PIECE THAT IS TIGHTLY WOVEN AND ALLOWS FOR A DETAILED PATTERN. (FROM LEFT) DIA. 12", H. 10 1/2"; DIA. 16", H. 14 1/2"; DIA. 14", H. 13 1/2". COLLECTION OF MELVIN AND JOYCE MONTGOMERY.

HISTORY The term Western Apache refers to those Apachean groups who live in Arizona and who have more in common with each other linguistically and culturally than with their relatives the Mescalero, Chiricahua, Kiowa–Apache, and Jicarilla who live further east. Although there is disagreement among scholars as to the migration route followed by these Athapaskans who came from northwestern Canada and Alaska, Morris E. Opler suggests it was probably through Utah or Colorado and the Great Basin. He based his conclusions on the fact that the Western Apache show so few Plains characteristics but so many Great Basin ones (Opler 1983, 382). As with all Athapaskans (which also includes the Navajo), they arrived in the Southwest during the late prehistoric period.

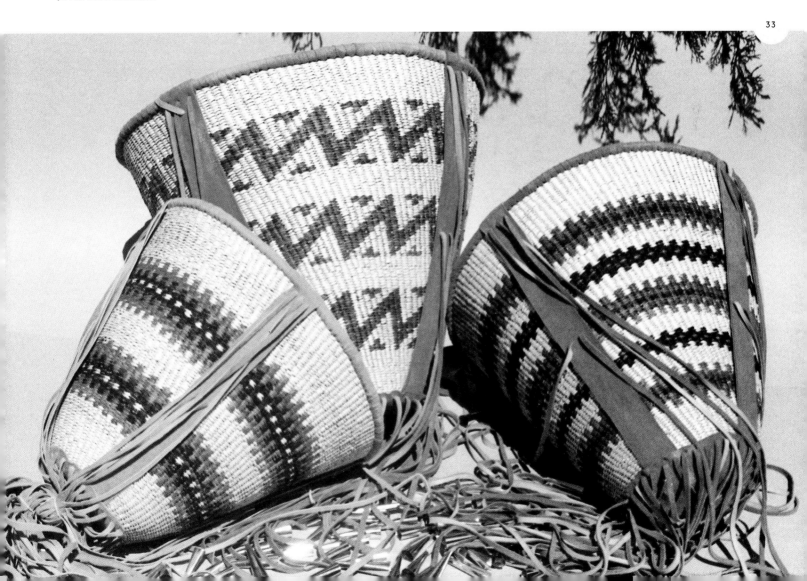

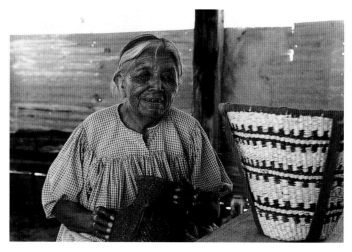

Western Apache territory originally covered much of the central and eastern portions of Arizona, stretching from the San Francisco Peaks and the Little Colorado River in the north to the Santa Catalina Mountains in the south and bounded on the west by the Verde River Valley and the present-day New Mexico border on the east (see map). Vast extremes in temperatures, as well as ecological and geological diversity, existed in their domain, with elevations ranging from 2,000 to over 11,000 feet and terrain consisting of rugged mountains, deep canyons, coniferous and deciduous forests, and deserts.

Several aspects of Western Apache culture can be directly traced to the influence of the Western Pueblo people. The development of agriculture, the social organization of matrilineal clans, and the ceremonial role of dancers as embodiments of the gods the Apaches call Gaans (Mountain Spirits) are borrowed characteristics (Opler 1983, 373). The Gaans perform Apache renewal ceremonies that restore harmony between humans and nature.

The Western Apache are made up of five subgroups: the White Mountain, San Carlos, Cibecue, Northern Tonto, and Southern Tonto. They practiced their traditional life-style of hunting and gathering along with limited agriculture well into historic times. Following a yearly cycle that required considerable mobility in order to exploit available plant and animal resources, they also planted corn, beans, and squash in the spring, returning in the fall for the harvest.

An important addition to their life-style was the horse, which was introduced into the Southwest by the Spanish. Serving as a source of food and transportation, it enabled them to increase their geographical boundaries for raiding, hunting, gathering, and trading. For the Apache, raiding was an economic pursuit used for obtaining horses or goods, whereas warfare was conducted to avenge a death or a wrong. Conflicts of both kinds between Western Apache and Euro-Americans had virtually ended by the time they were placed on reservations in the 1870s. While hostilities continued to exist, they did not result in the type of military warfare that persisted between the Chiricahua Apache and the United States Army until later in the century.

For the Western Apache, raiding and warfare were a natural consequence of Spanish and later Mexican presence. While very little of their territory was ever settled by the Spanish, they raided Spanish settlements frequently to obtain horses, food, and guns, with the intent of replenishing or acquiring necessities rather than forcing the Spanish out (Basso 1983, 466). Realizing that it was impossible to defeat the Apache militarily, the Spanish pursued a policy of warfare and appeasement, which provided them with rations and liquor. This policy proved successful until the disintegration of Spanish influence in the area. With Mexico's independence, hostilities increased as the new government attempted a military means of dealing with the Apache that resulted in the resumption of raiding and warfare.

In the 1850s, the situation changed when Arizona and New Mexico came under the ownership of the United States. For the first time, settlers and miners began moving into Apache territory. Gold was discovered on Northern Tonto lands, and the army was called in to protect the settlers and miners against the Apache. In 1872, General George Crook initiated a campaign against the Tonto Apache that resulted in hundreds of them being killed and the survivors being taken to the Camp Verde Reservation. The Cibecue and White Mountain Apache were less aggressive in their resistance to military occupation, even though Fort Apache was established in their territory in 1868 (their strategy eventually paid off when they were awarded the White Mountain Reservation). They continued to carry out raids in Mexico and act as scouts in General George Crook's campaign against the Tonto Apache (Basso 1983, 480).

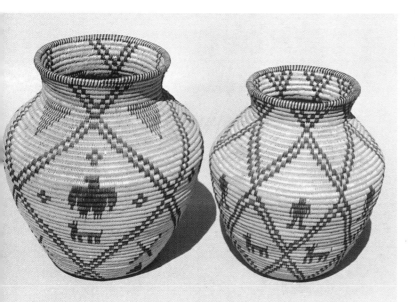

34

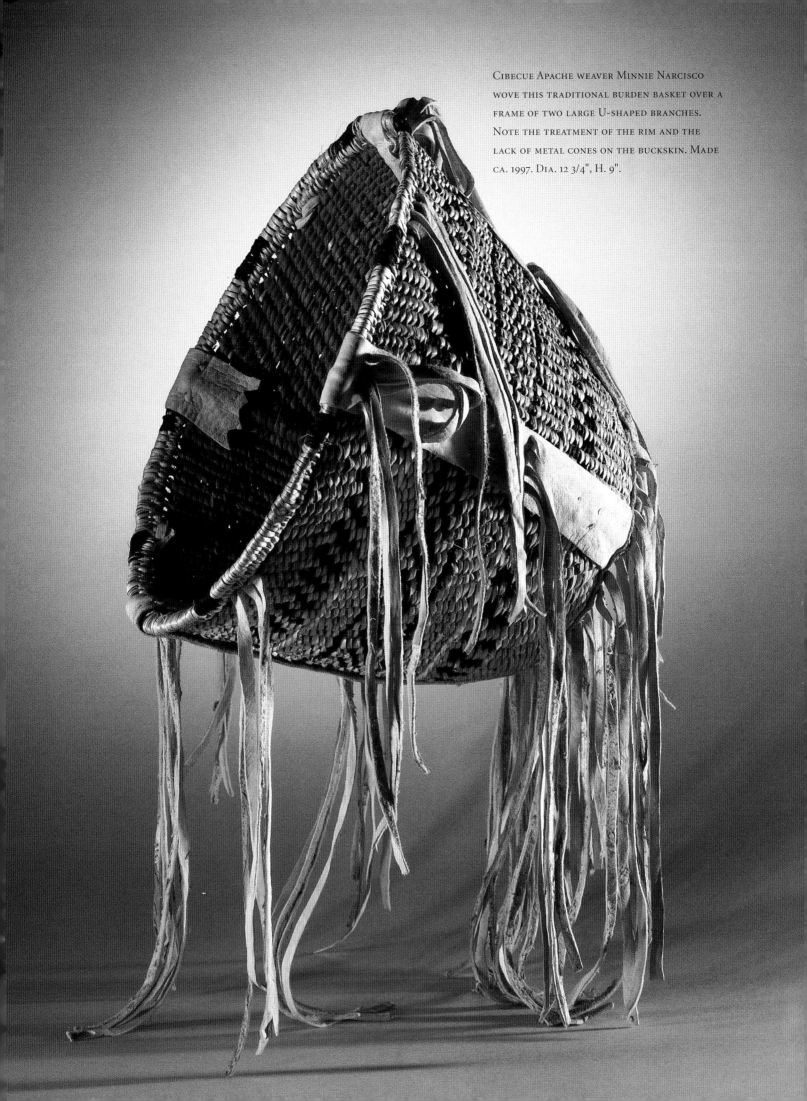

CIBECUE APACHE WEAVER MINNIE NARCISCO
WOVE THIS TRADITIONAL BURDEN BASKET OVER A
FRAME OF TWO LARGE U-SHAPED BRANCHES.
NOTE THE TREATMENT OF THE RIM AND THE
LACK OF METAL CONES ON THE BUCKSKIN. MADE
CA. 1997. DIA. 12 3/4", H. 9".

APACHE INO

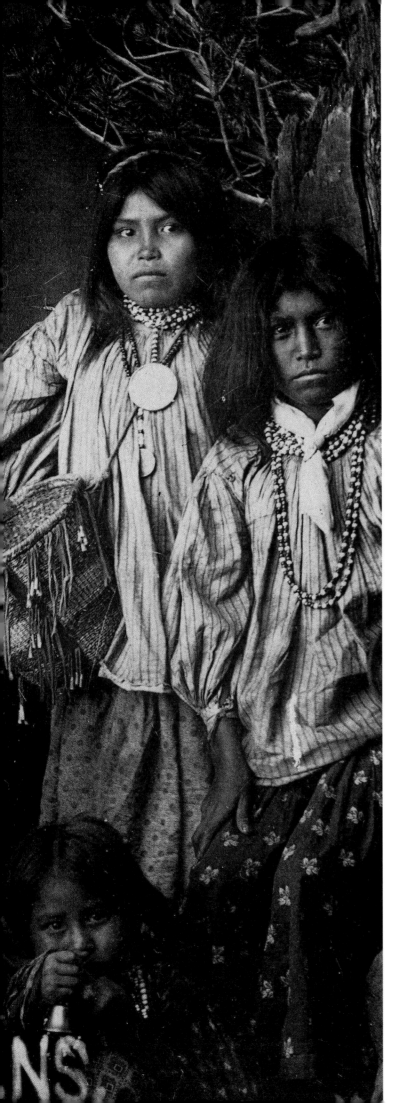

When the San Carlos Agency was established, the Tonto Apache and the Yavapai were moved there from Camp Verde, as were the Cibecue and White Mountain bands. While this policy proved to be unsuccessful for everyone involved, it did help officials see the necessity for separate reservations for the Tonto bands, Cibecue and White Mountain bands, and the San Carlos bands. This had considerable impact on basket making since it fostered the exchange of patterns, techniques, and materials between these groups. The Fort Apache Reservation (later called the White Mountain Apache Reservation) was established for the Cibecue and White Mountain bands. The Northern and Southern Tonto bands were eventually allowed to return to Camp Verde, Clarkdale, Middle Verde, and Payson, where they were given small reservations. In the ensuing years, most of the Yavapai left San Carlos for the Verde Valley reservations and Fort McDowell.

Very little is known about Western Apache baskets before the reservation period in the 1870s. They made twined and coiled types, both of which were produced in the region long before their arrival (Roberts 1985, 214). The utilization of a three-rod triangular foundation in their coilware and the use of twined burden baskets and water jars show considerable similarity to basket types of their Yuman neighbors (Yavapai, Hualapai, and Havasupai) to the west and north. Their Navajo and Jicarilla relatives, though, made coiled rather than twined water jars. The Navajo also produced wicker burden baskets similar to those made by the Pueblo rather than like the twined ones of the Western Apache. Apparently, the different Apache groups, as latecomers to the Southwest, selected the basketry forms and methods best suited to their needs or that were used by their neighbors. One interesting difference between the Yuman and Western Apache burden basket, however, is its shape. The basket produced by the Yuman (as well as those made in the Great Basin) is conical in shape whereas the Apache one has a cylindrical shape with a slightly rounded bottom, a shape reminiscent of those made by the Pueblo and Navajo, although the construction is different. The form of the Western Apache burden basket seems to be more conducive to carrying items on a horse than the conical one used by the Yuman and Great Basin tribes, who had little access to the horse. For a nomadic people like the Western Apache, baskets were practical necessities, facilitating the transport of possessions.

The different forms of Western Apache baskets can be placed into three categories: coilware plates and shallow bowl forms used for preparing and serving foods; deep bucket-shaped twineware forms with rounded bottoms decorated with buckskin fringe used for gathering and transporting goods; and twineware jars and bottles covered with piñon pitch used for carrying and storing water. In addition, crude twined and wicker pieces were made quickly to serve as trays for beating seeds and drying salt, then frequently discarded after use.

37

STUDIO PORTRAIT OF A WESTERN APACHE FAMILY, CA. 1890. NOTICE THE WATER JUG AND THE BURDEN BASKET WITH TIN CONES ON THE BUCKSKIN FRINGE. COURTESY OF THE ARIZONA HISTORICAL SOCIETY.

Although baskets began to be replaced by metal containers in the mid-1870s when all five groups of Western Apache were placed at the San Carlos Reservation, they continued to be made and used since there was still a need for them. Since Apache camps were frequently located considerable distances from water, water jugs sealed with piñon pitch were still useful. The form of these water jugs was ideal for their function. The narrow opening at the top prevented water spillage when carried with a tumpline on the forehead and the container balanced on the upper back. In addition, specific types of baskets were still needed for the Sunrise Ceremony; burden baskets were used to hold foods and gifts for those in attendance, while coiled trays were employed to carry sacred pollen.

Attempts to differentiate between baskets made by each of the subgroups have proved unsuccessful. Distinctions between the work of each group quickly disappeared as the weavers exchanged ideas and designs while at San Carlos. Most of the old baskets in the American Museum of Natural History and other collections are labeled "White Mountain" and "San Carlos," with San Carlos pieces by far the most common (Roberts 1985, 131). Those representing early Tonto Apache and Cibecue peoples are lost in collections labeled "Western Apache" (Whiteford 1988, 65). According to Whiteford, it is difficult to distinguish between White Mountain and San Carlos baskets since they have more similarities than differences.

The history of basket making among the Western Apache in the postreservation era falls into three periods. The first period (post–San Carlos—1930) was one of considerable change for traditional coiled baskets. There was improvement in the quality of work with the introduction of pieces made for sale to a non-Indian public. New forms included the coiled olla and large shallow plates. The vase-shaped olla was probably copied from the traditional water jars and containers for storing corn and seeds (Whiteford 1988, 81) and was frequently several feet high (page 34). Often taking up to a year or longer to be completed, they were popular among collectors and tourists. These ollas exemplify the extraordinary skills basketmakers possessed during the period. By the turn of the century, however, it had become apparent that the monetary reward for producing these pieces was not proportionate to the time it took to make them, and a decline in their production occurred. Coilware plates and shallow bowls of the period reflect increased use of florid designs, many employing human and animal figures for the first time. The use of negative designs (black backgrounds with white designs) was popular as was the use of red yucca root. Old pieces from this period with a pattern executed in red yucca root and black devil's claw are referred to as "polychrome" and are sought after by collectors.

Twined burden baskets also underwent changes in their manufacture during the period. The quality of work on these pieces improved along with the use of a wire hoop to replace or reinforce

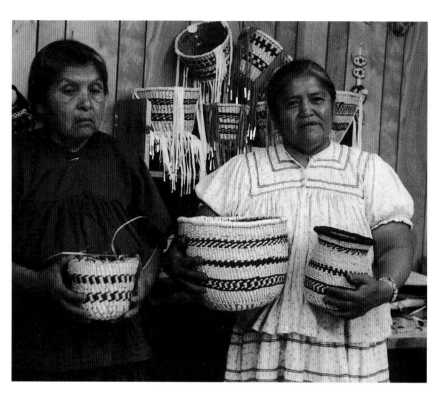

the traditional willow rim. Commercial dyes, especially red and green, were introduced in the designs. Buckskin fringes provided elaborate decoration on the rims and sides tipped with small tin cones (opposite). Buckskin was also sewn over the bottom for reinforcement. All of these elements combined to make functional yet extraordinarily beautiful works of art. Despite this creative environment, though, increasingly fewer baskets were being made.

The second period (1930–1960s) was dominated by the Depression and World War II. During the 1930s, economic conditions deteriorated, accompanied by high unemployment. The scarcity of money and lack of jobs forced people to drastically change their life-style. Tourism ceased, along with the demand for baskets and other Indian arts and crafts. As a result, Western Apache basket making was severely curtailed. Weavers were forced to focus instead on other economic pursuits, and transference of weaving skills from the older to the younger generation ceased. Thus, an entire generation of potential weavers never learned the skills and information necessary to perpetuate the craft. The number of coiled baskets made declined drastically and has continued to do so ever since. By the 1970s, only a dozen or so coiled pieces were produced yearly (Guy 1977, 15). In the 1990s, only three weavers on the San Carlos Apache Reservation occasionally made coiled baskets.

By the 1960s, however, improved economic conditions along with better roads and transportation encouraged Americans to again take holidays and explore areas of the West previously relatively inaccessible. A renewed interest in Native American religion, traditions, and arts and crafts developed, promoted by businesses and state governments as it had been earlier in the century.

The most important changes, however, began to occur within the Indian community, when parents and elders realized that the younger generation could no longer speak their native language and knew little about their cultural heritage. Alarmed at the loss of their traditions, Indian leaders began to assume greater control in the education of their youth. Schools were built on the reservation so students could live at home, and classes aimed at teaching youths and adults traditional basket making, tanning, and beadwork were established.

Another aid to the preservation of Western Apache and other Indian traditions was legislation passed in the 1960s and 1970s providing funding for programs to teach traditional crafts among the Western Apache and many other Indian tribes. The Economic Opportunity Act (EOA), the Comprehensive Employment Training Act (CETA), and the later Job Partnership Training Act

(JPTA) were instrumental in funding basket making and other arts and crafts programs in the community of Cibecue on the White Mountain Apache Reservation. Consequently, an unusually high number of women (both young and old) know how to weave in this small community. Some explained that while they remembered things taught them in their childhood by older relatives, their interest in basket making was inspired by these classes and their teacher, Minnie Narcisco.

Another development that affected the future of Western Apache basket making occurred in 1968 on the San Carlos Indian Reservation when Melvin and Joyce Montgomery became the new owners of the Peridot Trading Post. Joyce Montgomery had previously lived on the reservation, after her father bought the store in 1951 and before getting married and moving away. Other members of her father's family had also traded with the Apache, including an uncle, Earl Osborne, who had established a trading post in 1907 at Rice (later called San Carlos after the old San Carlos was flooded as a result of the Coolidge Dam).

The Montgomerys, who had a strong interest in Apache arts and crafts, realized that a market for baskets existed off the reservation, although none of the other traders in the area had encouraged the basket trade. Joyce Montgomery recalls that in 1968 very few baskets were brought in for sale, but in the following years the number increased. Joyce and Melvin encouraged weaving by being willing to pay a fair price for quality work. The income helped stimulate an active trade that continued until 1985, when the store was closed. The productive partnership that developed between the Montgomerys and the basketmakers was aided by Joyce Montgomery's ability to discern quality work and pay extra for it, thus encouraging the production of quality baskets. Moreover, the

39

SMALL, FINELY WORKED BURDEN BASKETS WITH INTRICATE DESIGNS USING WILLOW MADE BY SAN CARLOS APACHE WEAVER BEATRICE SIGN IN THE 1980S. (FROM LEFT) DIA. 9", H. 6 1/2"; DIA. 5 1/2", H. 4 3/4"; DIA. 8", H. 6 3/4". COLLECTION OF MELVIN AND JOYCE MONTGOMERY.

Montgomerys also stimulated the sale of baskets by displaying sometimes as many as one hundred pieces on nails in the rafters of the store above shoppers. The weavers paid considerable attention to the work of their peers, as did many of the other patrons of the trading post.

With a consistent outlet for their work, the number of weavers, as well as the number of burden baskets made, increased rapidly. According to Joyce Montgomery, the high point in basket sales was in the late 1970s. She attributes the decline afterward to the fact that many of the older basketmakers had problems, such as advancing age or raising grandchildren, that prevented them from weaving.

In addition to sales at the store, the increased mobility of many families who owned cars made it possible for weavers to sell their work in Tucson and Phoenix or for collectors to travel to the homes of weavers to purchase baskets. In 1996, basketmaker Evalena Henry remarked that many buyers like to purchase directly from the artist, adding that she sells much of her work to people who have commissioned it or who come to her house.

Gusta Thompson and Cecilia Henry were two of the older generation of San Carlos weavers well known for their work. Gusta specialized in coilwork while Cecilia's specialty was twineware. Gusta Kidde Thompson (1904?–1986) was born in old San Carlos at a time when most young girls were taught to make baskets, so it is likely she learned at a young age. She chose to live in a traditional Apache way, preserving and promoting her heritage, while actively participating in the modern world around her. Living her entire life in a small house with no electricity or indoor plumbing, she raised a son and a daughter who died young. A small woman with considerable energy, she built a wickiup by her house, which she used part of the year. She loved demonstrating and selling her arts and crafts at the Arizona State Fair in Phoenix, which she did many times, always deriving pleasure from meeting new people and seeing old friends. Due to failing eyesight, she was forced to stop making baskets several years before her death, residing her last years with her great-granddaughter, Bernadette Goody, and her family.

Cecilia Nelson Henry (1902–1996) was raised by her grandmother after her mother's untimely death. Her cousin, Elsie Johnson, who had also been orphaned at a young age and was four years her senior, lived with them. All three had horses, and they camped in the mountains around San Carlos, exploiting the natural resources available and keeping out of sight of the Bureau of Indian Affairs school agents. Their grandmother wanted to prevent them from being sent away to boarding school; her solution was to continually be on the move and trade the baskets she made for food and other items necessary to keep the small family together. Eventually, however, the authorities caught up with the two girls, and they were sent to the boarding school in old San Carlos, an experience that made them unhappy. It was only when an arranged marriage to Robert Henry was agreed upon that Cecilia was able to leave school and start raising a family consisting of nine children—five girls and four boys.

Cecilia's grandmother wove both coiled and twined baskets, and it was from her that Cecilia learned to make her first piece when she was about six years old. Although Cecilia learned to weave both types of baskets, it is her twined pieces that she is remembered for. She made hundreds of baskets during a career spanning forty years. After her husband's death in 1950, she began weaving regularly to support her family. Much of her early work included making the pitched *tus'* (water jars) for use by the Indian community. These jars, sealed with piñon pitch, were used for aging an alcoholic beverage made from fermented ground corn and maguey called corn beer, or *tulpai*. The pine pitch on the jars was instrumental in creating the desired taste.

The designs on Cecilia's ollas and burden baskets included the diamonds, zigzags, and circling horizontal bands employed by weavers in earlier times. In addition, she created her own interpretations of butterflies, deer, elk, eagles, and squirrels, all images she did from memory without using drawings. One of her designs was adapted from an image she saw on a freeway overpass near Squaw Peak in Phoenix. This "freeway" or "wave" pattern (page 43), as she called it, became a hallmark of her work and is used by her daughter Evalena Henry and several other family members.

The use of small tin cones attached on the end of buckskin-fringed burden baskets has been attributed to Cecilia by several contemporary weavers. Cecilia cut the cones, called bells by Apache weavers, from Clabber Girl Baking Powder cans. Apparently, however, such cones were used in the past, as can be verified by a photograph taken in the late nineteenth century (page 37). Mescalero basketmakers also used them on short buckskin strips placed under burden basket rims (opposite). Despite their earlier use, Cecilia was undoubtedly instrumental in reintroducing and popularizing them in the 1950s and 1960s. These bells have been a hallmark on Western Apache baskets ever since.

FACING PAGE: SAN CARLOS APACHE WEAVER CECELIA HENRY WITH ONE OF HER LARGE CREATIONS. SHE WAS EIGHTY WHEN SHE COMPLETED THIS OLLA. PHOTOGRAPH COURTESY OF EVALENA HENRY.

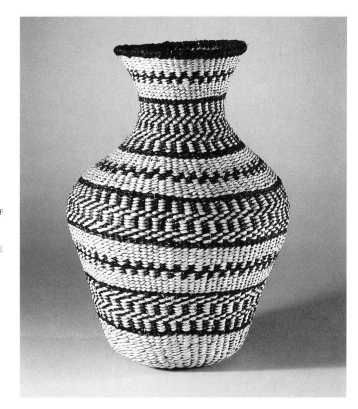

OLLA BY CIBECUE WEAVER LINDA GUZMAN, MADE IN 1996. COILED BASKETS SUCH AS THIS WERE MADE AT THE TURN OF THE CENTURY, OFTEN WITH VERTICAL DESIGNS, WHEREAS TWINED PIECES OF THE TYPE SHOWN HERE HAVE HORIZONTAL PATTERNS. DIA. 11", H. 14 3/4".

A *Tus'* MADE IN 1996 IN THE OLD STYLE BY CIBECUE WEAVER MINNIE NARCISCO. WHEN CAULKED WITH A PASTE THAT INCLUDES JUNIPER LEAVES AND THEN SEALED WITH HOT PIÑON PITCH, IT WILL HOLD MORE THAN THREE GALLONS OF LIQUID. DIA. 12 1/2", H. 14 1/2".

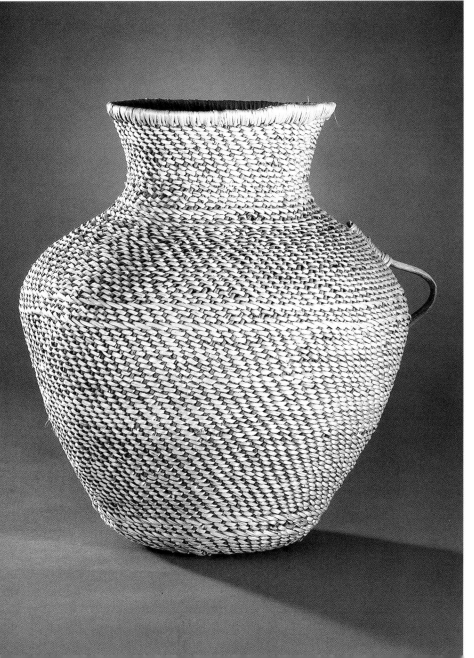

MESCALERO APACHE BURDEN BASKET. THREE HORIZONTAL BANDS OF PAINTED RED AND BLACK ENCIRCLE THE PIECE. TWO ROWS OF TIN CONES BELOW THE RIM AND AT THE BOTTOM ARE ATTACHED. THIS TREATMENT IS VERY DIFFERENT FROM THAT USED BY THE WESTERN APACHE. MADE CA. 1880. DIA. 11 1/2", H. 10 5/8". COLLECTION OF THE MUSEUM OF INDIAN ARTS AND CULTURE/LABORATORY OF ANTHROPOLOGY.

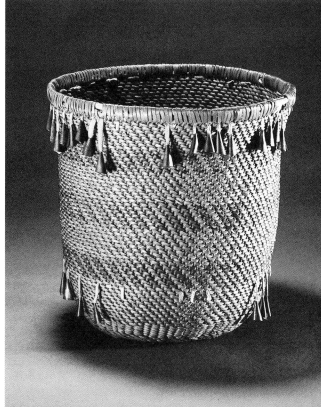

TWO TWINING METHODS ARE USED: TWILL TWINING (TOP) EMPLOYS
TWO SEWING STRANDS TWISTED OVER TWO FOUNDATION RODS,
LEAVING PART OF THE WARP EXPOSED. FOUR ROWS OF THREE-STRAND
TWINING CAN ALSO BE SEEN. IN SIMPLE TWINING (BOTTOM), TWO
SEWING STRANDS ARE TWISTED AROUND ONE FOUNDATION ROD AND
THE FOUNDATION IS COMPLETELY COVERED.

⊕ MATERIALS AND CONSTRUCTION

The materials used in making Apache baskets include sumac, willow, mulberry, cottonwood, and devil's claw. Sumac is used predominantly for the foundation (warp) and sewing splints (weft) of water jars produced in the Cibecue community. Cottonwood foundation rods are used by some Cibecue and San Carlos weavers since they frequently are longer and have a smaller diameter. The extra length of the cottonwood is necessary when making large vase-shaped baskets like those by Linda Guzman. In Cibecue, baskets are frequently made using strands of mulberry with the pattern executed in devil's claw. These baskets are readily distinguished from those made in other areas of both reservations because they have an extreme contrast between the white background and the black design.

The use of mulberry by Cibecue weavers has been mentioned frequently in research done on Apache basketry, and while the weavers also use the term, there is some conjecture as to its accuracy. There are at least four different varieties of "mulberry" that weavers have identified on the reservation. The bushes vary in size, as does the color of the bark, but they all have the distinctively pungent smell of sumac, though some have a stronger smell than others. In many parts of the West, I have found mulberry growing within clumps of sumac, especially in areas with more moisture, and this has probably added to the confusion. This situation only causes confusion for researchers, though, since Apache basketmakers have no problem knowing which plants to harvest for the task at hand. There is a definite difference in the materials used in Minnie Narcisco's *tus'* (page 41) and those used in Linda Guzman's olla (page 41). Minnie calls her material sumac; Linda calls hers mulberry; both smell like sumac. Linda Guzman gathers her materials (mulberry/sumac) throughout the year, while most weavers harvest after the first frost until early spring. Certainly anyone who has seen her work can attest to the careful attention she pays to the preparation of her materials.

Most of the twined baskets produced by the Western Apache, whatever the form, are made with a willow warp and weft. However, Evalena Henry of San Carlos said she uses tamarisk rods to add strength to the foundation of her larger pieces. The bark is left on many of the willow splints to create the pattern. These basket designs lack the contrast created by the use of devil's claw and instead depend on the subtle variation of browns, rusts, and tans to develop the pattern. The range of colors on the bark allows for great diversity, producing attractive results.

Three different twining techniques are used for creating a variety of textures on baskets and for adding strength. First, in simple twining, two sewing splints are used around the warp of one stick, creating vertical columns down the side. This method, the one used on most of the burden baskets currently made, creates a tight, fine surface in which the warp is completely covered. Second, in

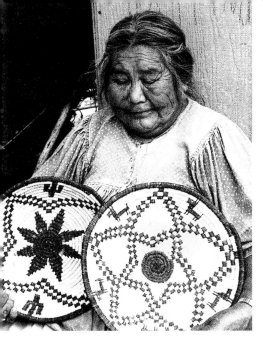

San Carlos Apache weaver Mary Porter in 1993. Both baskets have cottonwood foundations with cottonwood and devil's claw sewing splints. (from left) 1980, Dia. 12", H. 2 1/2"; 1983, Dia. 13", H. 2 1/2".

San Carlos Apache weaver Evalena Henry, daughter of Cecilia Henry, in 1996. She specializes in making large baskets; the one she is working on in the photograph has her mother's wave design on it.

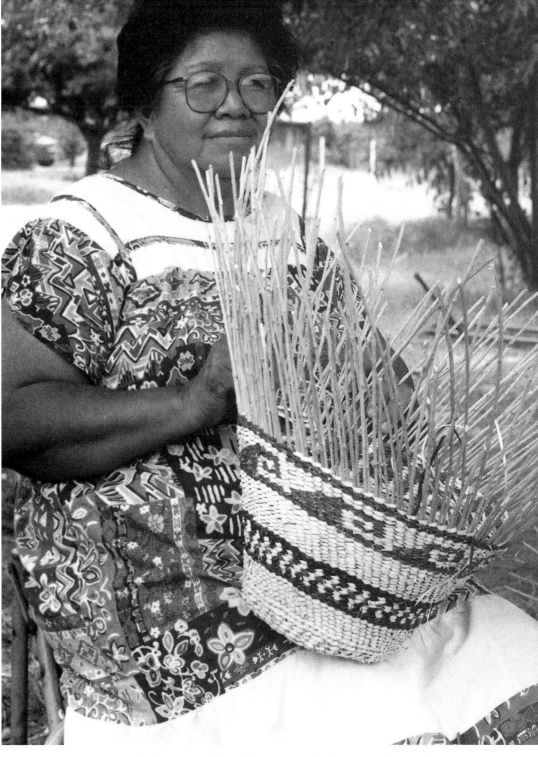

twill twining, the two strands used around a warp of two sticks angle diagonally to the right, exposing part of the warp. This technique is employed on water jars or in conjunction with simple twining for textural variation. Finally, another technique involves using three weft strands at crucial points to reinforce pieces and for decoration. This method creates a raised line on the surface of baskets that can be detected by the trained eye (opposite, top).

The renewed interest in twined basket making that occurred in the late 1960s and early 1970s resulted in increased production of burden baskets. These were not only more truncated and cone shaped than the earlier ones but they were also generally smaller in size. Since that time, such replicas of the traditional burden basket have been the predominate type made. The bottom of these baskets, like the old utilitarian ones, is usually concave to give strength to the fragile start area and to add balance when setting. Strips of commercial hide have replaced buckskin for wrapping the rim, which is also reinforced with a heavy wire ring. Hide also covers the bottom, with long fringes suspended from the sides and bottom tipped with small cones of tin. These baskets typically range in size from six to ten inches in diameter and five to nine inches in height. While this size is the most salable, large ones with a diameter of thirty to thirty-six inches are made occasionally. Although it is always a challenge for a weaver to see how large such baskets can be made, the largest pieces are sometimes less aesthetically pleasing than the smaller ones.

The designs used on twined baskets are usually repeated bands that encircle the piece. These horizontal patterns are much easier to weave than vertical ones. In addition, design elements, such as isolated people, dogs, horses, deer, and more recently butterflies, are becoming more common, but they are always executed horizontally, never vertically.

Since the production of coiled baskets is near extinction among the Western Apache, only a few general comments will be included about materials and construction. In recent years, cottonwood and willow have been used for the foundation with sewing strands of cottonwood and devil's claw. The quality of these baskets, referred to as flat baskets by the weavers, has deteriorated significantly, while the quality of twined pieces has remained constant and in many cases shown considerable improvement. Production of coiled baskets has declined largely because they are more difficult and time-consuming to make than twined ones, so the profit margin is less. Moreover, while both Minnie Narcisco and Cecilia Henry have provided leadership and renewed interest in twined baskets, there has been no such leadership for making coiled baskets.

✪ WEAVERS AND THEIR BASKETS, SAN CARLOS APACHE RESERVATION In 1999, at least fifty Western Apache women on the White Mountain Apache and San Carlos Apache Reservations were active in basket making. San Carlos has the largest number of weavers, followed by Cibecue and then Whiteriver on the White Mountain Reservation. In the 1970s, Celina Perry (Cecilia Henry's daughter) taught a basket-making course for two years sponsored by the Gila Pueblo College Extension Service at San Carlos. The JPTA, EOA, and CETA programs mentioned earlier also provided work and training for many basketmakers in Cibecue. The combination of these classes, programs, parental teaching, and Cecilia Henry's leadership in showing that a monetary reward was possible all combined to reinstate basket making as a respected profession.

Cecilia Henry played a pivotal role in the renaissance of twined basket making that has occurred on the San Carlos Apache Reservation since the 1960s. She founded a dynasty of basketmakers who still carry on the tradition (see genealogy chart). Of her nine children, four daughters have received recognition as basketmakers: Celina Henry Perry, Viola Henry Taylor, Evalena Henry, and Joann Henry Taylor. In addition, a daughter-in-law, Evelyn Henry, has gained recognition for her work. Granddaughters Novine Cobb, Mary Beth Caoose, Katie Kozie, Lorena Upshaw, Mary Jane Dudley, Velvetta Volente, Velda Peapot, and Velma Padilla are also weavers. Several basketmakers of this generation are doing extraordinarily creative and fine work. Cecilia Henry's willingness to share her knowledge and skill with others, not only her family, created an environment that nurtured the revival of the art.

Mary Kinney Porter (1918) was born in Winkleman, Arizona, to Western Apache parents, Wilford Kinney and Christine Dewey Kinney. When she was eight years old, the family moved to San Carlos Indian Reservation, where she has lived ever since. Mary never had a formal education and speaks very little English, so her husband, Henry Porter, and her daughters act as translators for her. Her husband, who was born at Peridot on the San Carlos Indian Reservation, has worked as a miner and ranch hand as well as serving in the South Pacific during World War II. The couple had four children, three daughters and one son.

Mary explains that even though her mother was a basketmaker she did not start to take weaving seriously until 1958, when she was forty years old. Her older sister, Winfred Miller, taught her. She continued to weave into the early 1990s doing both twinework and coilwork. There are two other women who have continued making coiled baskets occasionally since Mary stopped producing them.

Depending on basket making to supplement the family income, Mary wove throughout the year if the materials were available. Her husband, when he was alive, and her children helped with the harvesting and preparation of the materials, which were collected on the reservation. Many of Mary's baskets were sold to members of the Apache community for use in ceremonies, including the first basket she made.

Mary uses a spring start on her coiled pieces, accomplished by employing a cottonwood or willow sewing splint tightly wrapped in a circle, to which one and then two other foundation rods are added. Sewing splints of devil's claw are then used to overstitch the start. Mary says she always uses devil's claw on the start of her coiled baskets and also finishes the rim with it. When asked why she always ends her design butted against the rim, she explains that it would not look right if a white space were left between the design and rim. The patterns she uses come from memory or imagination, since she never consults a book to find designs. She always uses cottonwood sewing splints in her coiled pieces, with both willow or cottonwood rods utilized for the foundation. Designs are executed in devil's claw, which she gathers on the reservation. She uses a commercial awl with a clear yellow plastic handle. In addition to coilwork, Mary makes small (three-inch) twined burden baskets with commercial buckskin strands tipped with tin cones. Such baskets are popular with tourists as inexpensive souvenirs that are representative of Apache basketry.

Lorraine Hunter is another San Carlos weaver who makes flat pieces. While there are probably a dozen women in San Carlos who know something about coiled baskets, she and Kathrine Brown are the only ones who occasionally weave them (opposite). Lorraine, who taught herself to weave, uses the same materials as Mary Porter for her baskets and in 1996 made her first olla, probably the first one to be produced in the last twenty years at San Carlos. Lorraine's work shows great promise. Her sister, Charlene Tuffley, also made flat baskets during the 1980s.

✪ WEAVERS AND THEIR BASKETS, WHITE MOUNTAIN APACHE RESERVATION The two communities on the White Mountain Reservation with the largest populations are Whiteriver and Cibecue. While both of these towns have basketmakers, the more isolated Cibecue has by far the largest number of weavers and is noted for its production of the twined water jar called a *tus'*.

44

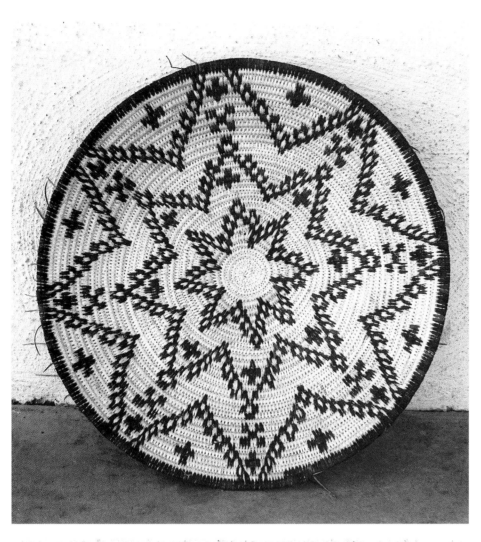

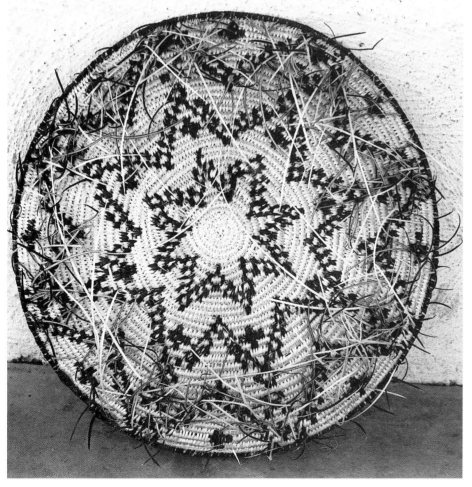

Tray made by San Carlos weaver Lorraine Hunter in spring 1996. She trims the ends of the cottonwood and devil's claw after completion of the piece. Dia. approx. 15". Collection of the weaver.

In the past, this type of basket was covered with piñon pitch to make it watertight, but it is now usually sold without. Different textures are created by using two- and three-strand twining methods on such pieces. Occasionally, a design is applied by using either devil's claw or unpeeled willow, resulting in a very attractive vase-shaped basket (page 51). Twined burden baskets are also produced at Cibecue, but the weaving of coiled pieces like those made in the past has long been abandoned. None of the older weavers I interviewed remember anyone making them; although one woman said she started such a basket in the early 1970s she never completed it and never attempted it again.

Coiled baskets made by Mary Porter. (from left) 1993, Dia. 11", H. 2"; 1989, Dia. 11", H. 2"; Bottom: 1989, Dia. 11", H. 2"; 1989, Dia. 12 1/2, H. 2 1/2".

When I asked all the women in Cibecue who had taught them to make baskets, they all answered Minnie Danford Narcisco (b. 1913). Minnie still lives in Cibecue, where she continues to make baskets at the age of eighty-five. Since 1970 she has conducted a number of classes concerning twining techniques and tanning procedures for the women in the community. The most recent workshop was funded by Job Partnership Training Act monies; started in 1985, it continued over several years. After Minnie stopped teaching, two of her students, Marie Gregg and Bernice Enfield, took over the task until the program was terminated due to loss of funds.

Minnie is undoubtedly responsible for preserving the art of basket making in Cibecue. Like Cecilia Henry, she has been willing to share her knowledge with others in her community despite the fact that teaching basket making is extremely time-consuming since it requires the gathering and preparation of materials in addition to instruction and demonstration.

Minnie makes all types of twined baskets. Her *tus*'s are special favorites of mine. She is the only basketmaker who still makes these baskets with the same shape and size as older utilitarian pieces (opposite). She employs two-strand twill twining on most of them, with three-strand twill twining where extra strength is needed to help control the shape.

46

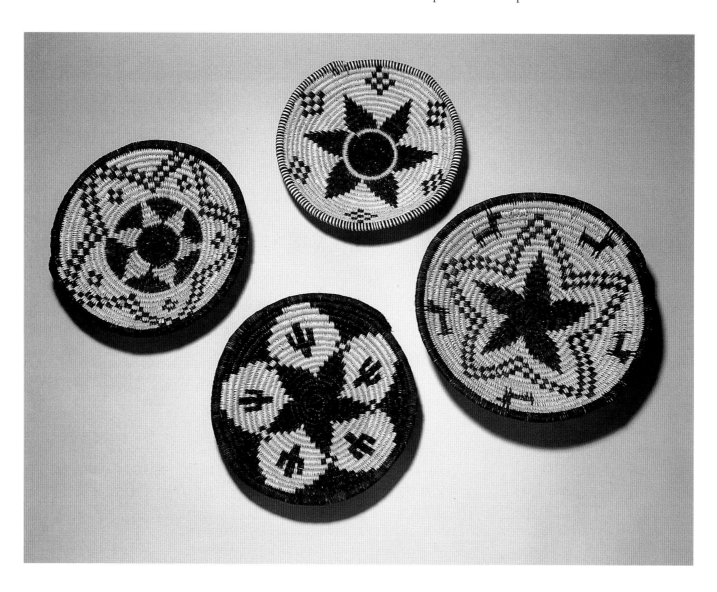

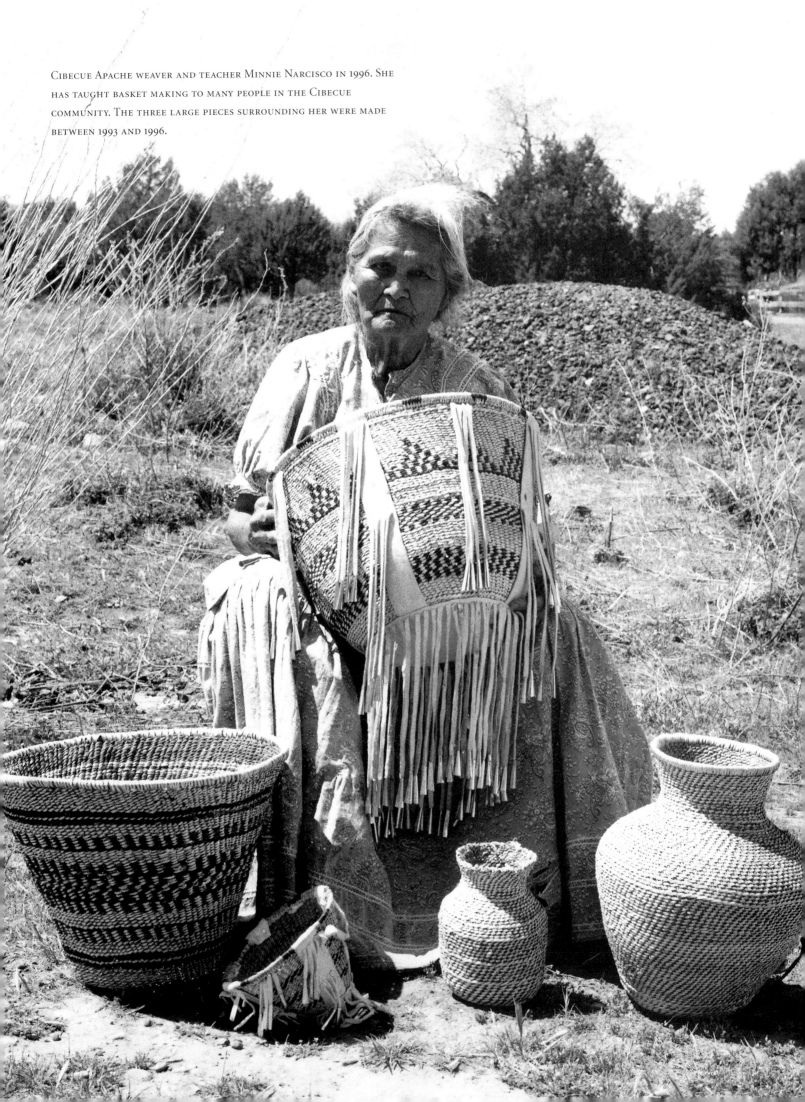

CIBECUE APACHE WEAVER AND TEACHER MINNIE NARCISCO IN 1996. SHE HAS TAUGHT BASKET MAKING TO MANY PEOPLE IN THE CIBECUE COMMUNITY. THE THREE LARGE PIECES SURROUNDING HER WERE MADE BETWEEN 1993 AND 1996.

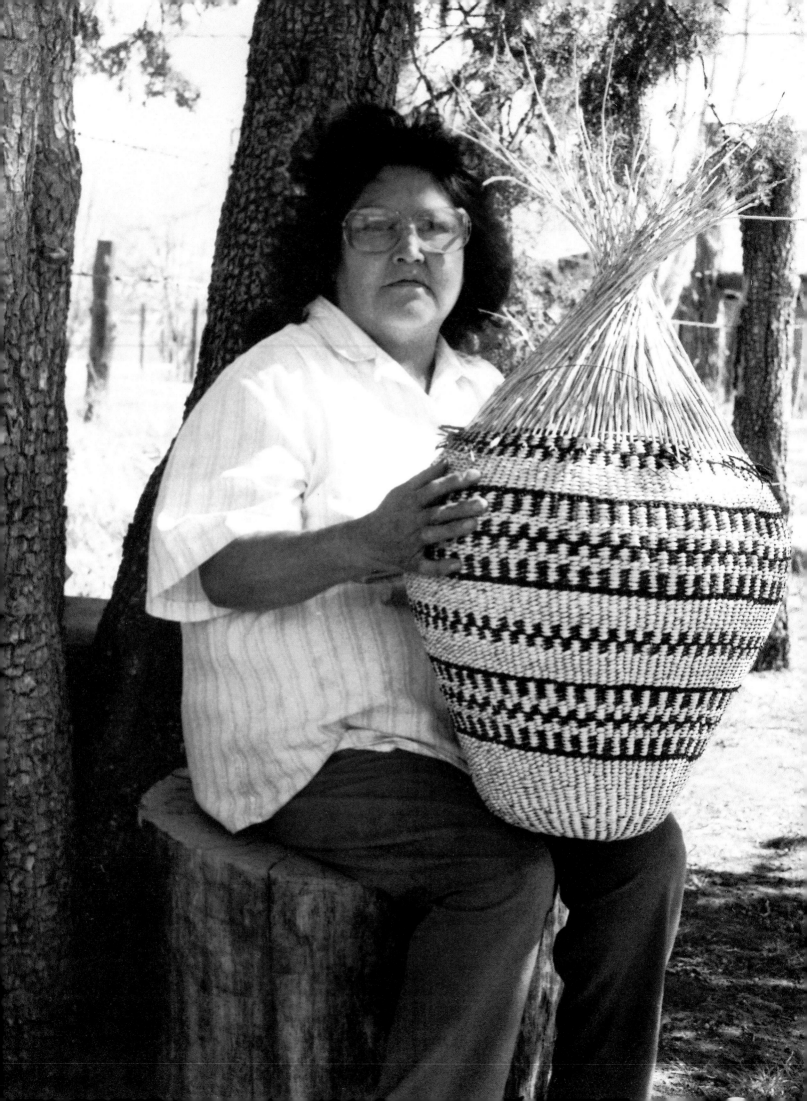

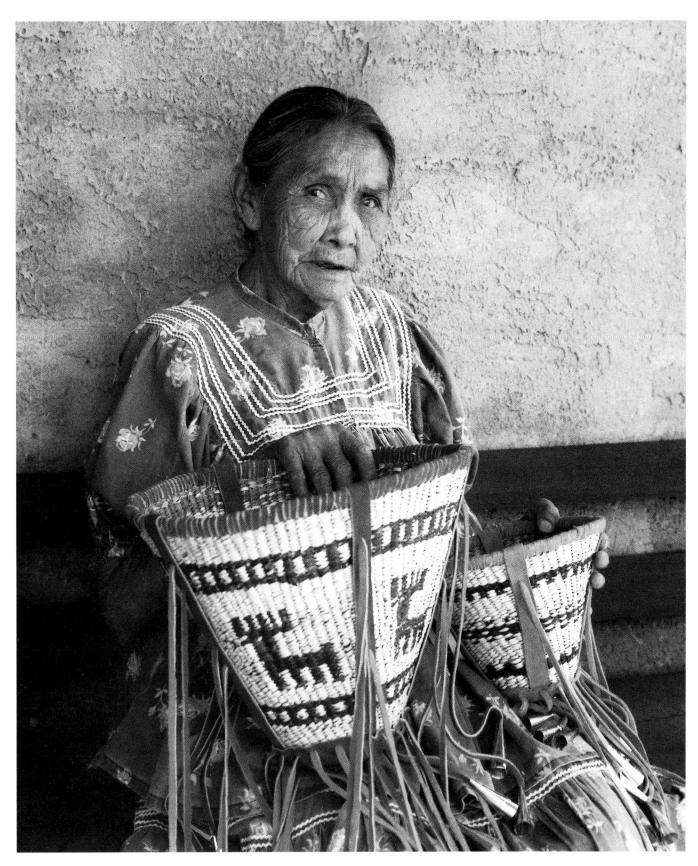

49

FACING PAGE: CIBECUE APACHE WEAVER LINDA GUZMAN WITH A
LARGE OLLA, MARCH 12, 1996. A FULL-TIME WEAVER, SHE AVERAGES
ONE BASKET THIS SIZE EVERY WEEK. SHE USES A COTTONWOOD
FOUNDATION ON THESE LARGE PIECES, WITH SUMAC AND DEVIL'S
CLAW SEWING SPLINTS.

WHITE MOUNTAIN APACHE WEAVER FREDA NEWHALL IN 1996. FREDA
LEARNED TO WEAVE FROM HER MOTHER, CLARA WOOL, AND HAS
TAUGHT HER GRANDDAUGHTER, CAROLINE WATERMAN. SHE USES
WILLOWS FOR BOTH THE WARP AND WEFT IN HER BASKETS.

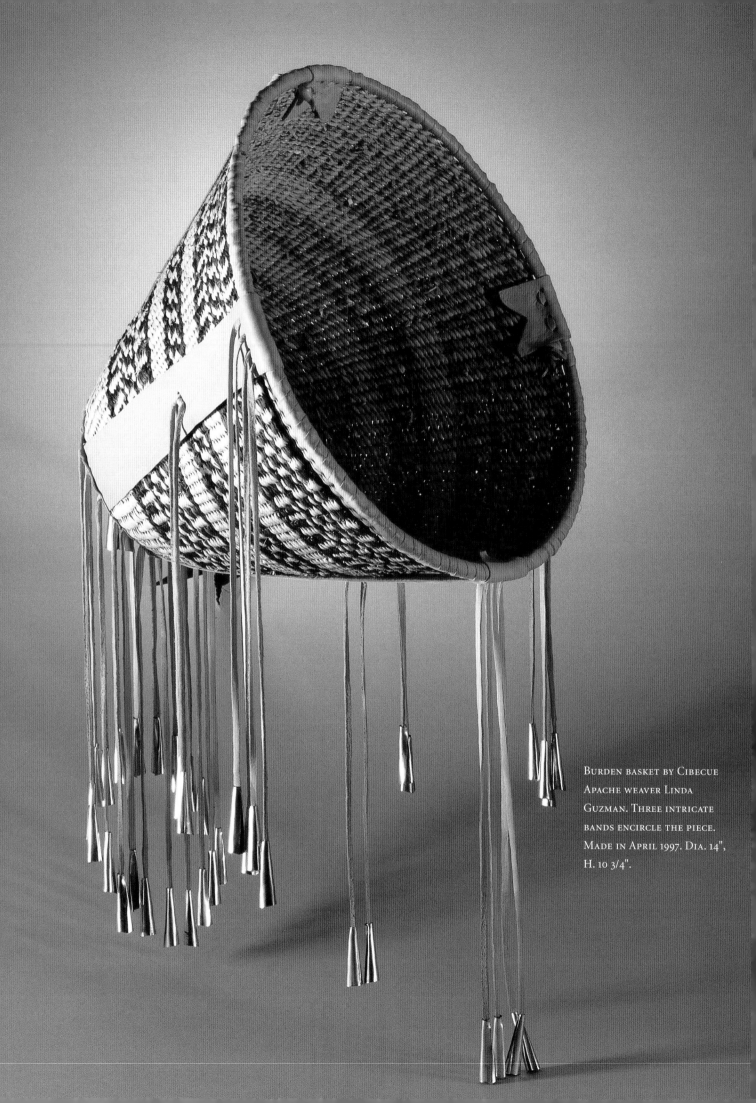

BURDEN BASKET BY CIBECUE
APACHE WEAVER LINDA
GUZMAN. THREE INTRICATE
BANDS ENCIRCLE THE PIECE.
MADE IN APRIL 1997. DIA. 14",
H. 10 3/4".

One of the most prolific and talented weavers in Cibecue is Linda Guzman, who learned to weave in a class taught by Minnie in the late 1960s. After taking the class and before making any baskets herself, she moved to Phoenix, where she married and raised a family of four children. In 1981, she returned to Cibecue and, unable to find work, decided to use her basket-making skills, becoming one of the best Western Apache weavers. Her work can be seen throughout the Southwest in museums, private collections, and trading posts. She prefers making giant twined ollas and burden baskets using a cottonwood foundation with mulberry/sumac and devil's claw sewing wefts. The ollas are frequently three feet high with a diameter of up to twenty-four inches. These graceful vase-shaped forms are decorated with horizontal patterns, sometimes including people and animal motifs (page 48).

Linda's burden baskets have similarities to her ollas. They also tend to be extremely large and usually have the same black design on a white background trimmed with a fringe of white commercial hide tipped with tin cones. A large olla and burden basket with the same designs entered in the 1996 Gallup Inter-Tribal Indian Ceremonial show won first place. The dramatic contrast between black and white on these pieces was emphasized by Linda's use of black dye to enhance the devil's claw.

While the future of coilwork among the Western Apache is very precarious, as it has been for most of this century, the future of twined basket making looks very encouraging at San Carlos and to a lesser degree at Cibecue. Whiteriver does not have as many weavers but is in the process of building a cultural center near Fort Apache, where classes on basket making may be taught, thus increasing the number of weavers. There are currently several women who are doing better work than was ever done in the past. As the quality of craftsmanship improves, the size of pieces frequently decreases. Like all artists, these basketmakers are exploring the potentials of their own capabilities and the possibilities of their craft.

A good market exists for Western Apache baskets with the Montgomerys actively participating, even though they no longer have the store. Collectors and traders now seek out the weavers to place orders. Additionally, good outlets for their work exist in nearby Tucson and Phoenix.

Baskets made at Cibecue and San Carlos between 1980 and 1996. (rear, from left) Water jar (*tus'*) rubbed with clay (without piñon pitch) by Emma Allen; willow olla by Evalyn Henry; olla with devil's claw design by Bernice Endfield. (front) Small willow olla by Novena Cobb; sumac water jar (without pitch) by Minnie Narcisco.

51

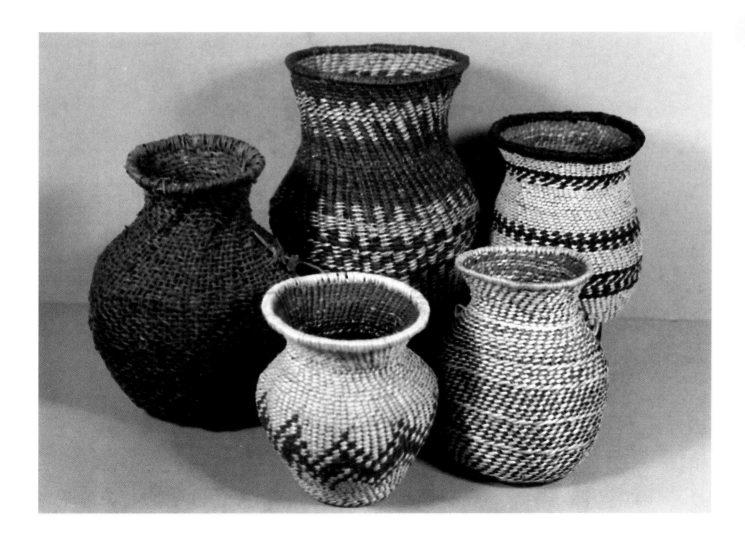

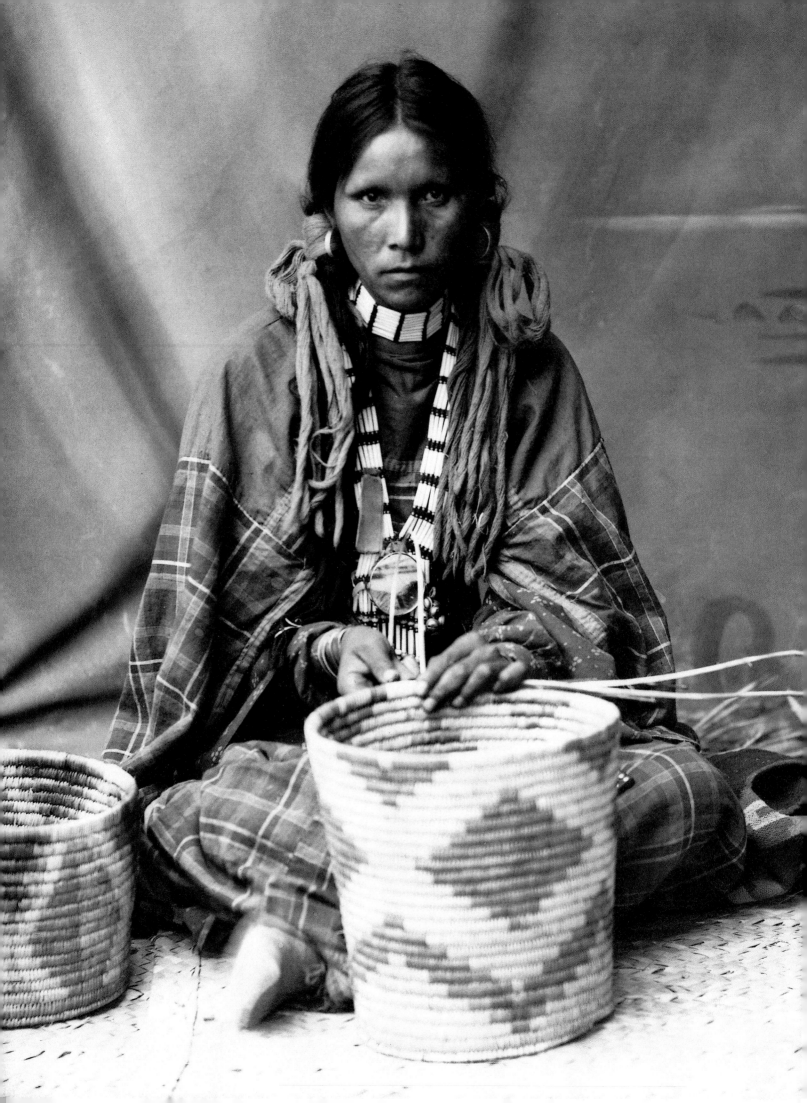

JICARILLA BASKETS SHOW LITTLE RELATIONSHIP to those made by other Apaches (Mescalero, Chiricahua, or Western Apache) but instead resemble those made at an earlier time by their Pueblo neighbors. The Jicarilla Apache migrated into the Southwest between A.D. 1200 and A.D. 1500, and their history and basket making are closely associated with that of the Pueblo Indians. The evolution of their basket making is vague, as is that of the Pueblo before the mid-nineteenth century. When the Jicarilla arrived in the Southwest, the importance of baskets among the Pueblo was already in decline as they became more reliant on pottery.

FACING PAGE: JICARILLA APACHE WEAVER DARCIS TAFOYA DEMONSTRATING AT THE 1904 WORLD'S FAIR IN ST. LOUIS, MISSOURI. COURTESY OF THE NATIONAL MUSEUM OF THE AMERICAN INDIAN, SMITHSONIAN INSTITUTION, NEG. T-15147.

BASKET DANCE AT SAN ILDEFONSO PUEBLO IN 1920. THE BASKETS ARE PROBABLY JICARILLA (WHITEFORD 1988). PHOTOGRAPH BY SHELDON PARSONS, COURTESY OF THE MUSEUM OF NEW MEXICO.

⊕ HISTORY The Jicarilla, along with the Navajo, Western Apache, Mescalero Apache, and several other Apachean groups, are Athapaskan-speaking peoples who migrated into the Southwest from the north. Late arrivals in the area, they established themselves in the mountains and adjacent plains of southern Colorado and northern New Mexico (see map). These lands included the headwaters of five major rivers: the Arkansas, San Juan, Canadian, Pecos, and Rio Grande, in addition to high mountain ranges with conifer forests, fertile valleys, upland plateaus, and grasslands extending from the base of the Rocky Mountains eastward.

Before obtaining the horse from the Spanish, the Jicarilla Apache used dogs to help transport their belongings between temporary camps while pursuing buffalo, and they practiced simple sedentary farming in semipermanent villages for part of the year. It is likely this practice was acquired from the Pueblo people, since they wintered near the Pueblos and traded with them (Tiller 1983, 440). The Jicarilla developed a life-style and material culture that had affinities with that of both the Plains Indians and

53

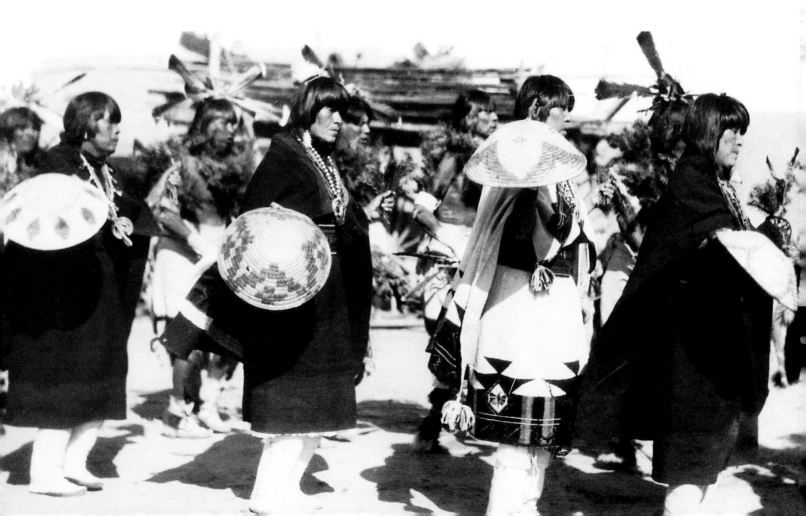

the Pueblo. They used the tepee and travois like Plains Indians, while they practiced agriculture, irrigation, and pottery making and basket making like the Pueblos (Tiller 1983, 440; Whiteford 1988, 49).

Their semisedentary life-style was not changed greatly by early Spanish colonization along the Rio Grande Valley, but in the late seventeenth century a new threat did transform their culture. French fur traders pressing westward from the Mississippi River Valley began trading with the Comanche and furnishing them with guns. Raiding war parties of mounted Comanche accelerated their attacks on Jicarilla camps, as well as on Spanish and Pueblo settlements. Without guns the Jicarilla were no match for the Comanche. Pressured by the French in the East, the Comanche on the Plains, and the Spanish settlements along the Rio Grande, the Jicarilla were forced to retreat into the mountains of southern Colorado and northern New Mexico, venturing to the Plains only for brief hunting trips. As a result, they developed a close relationship with Pecos, Picuris, and Taos pueblos, and it was during this time they adopted many Pueblo skills, probably including basket making.

When Mexico won independence from Spain in 1821, Mexican citizens received large land grants on Jicarilla lands; later after the Mexican-American War (1848), ranchers, farmers, and miners also moved into Jicarilla territory. Consequently, the Jicarilla joined forces with the Ute to fight the intruders. In 1855, they signed a peace treaty at Abiquiú, New Mexico, at which time they were to be given a reservation, but the treaty was not ratified. Left to their own resources until 1874, they were eventually given a reservation on the headwaters of the San Juan River. Two years later this reservation was taken away because of pressures from settlers already on the land and because the Jicarilla had not occupied it. In 1883, they were moved to the Mescalero Apache Indian Reservation in southern New Mexico, where they remained for three years. Determined to return north, they were finally given their present reservation in northern New Mexico in 1887.

The Jicarilla Apache Indian Reservation straddles the Continental Divide at altitudes between 6,000 and 8,000 feet. Since the soil proved to be unsuitable for farming, the Jicarilla were forced to depend on government rations. Conditions were harsh in the early twentieth century. Livestock was introduced, and the size of the reservation increased to accommodate them. Tuberculosis was a serious problem, and a sanatorium was established to help eradicate the disease. Sheep ranching helped the economy throughout the 1920s but in 1932 a severe winter destroyed more than half the herd. In the 1950s, economic conditions began to improve with the discovery of oil and gas on the reservation. The increase of wage labor jobs available in Dulce (tribal headquarters) brought about a redistribution of the population, with more people moving to the urban center of Dulce. A lawsuit filed with the Indian Claims Commission for lands lost by the Jicarilla was settled in 1970, with more than $9,000,000 awarded to the tribe. In the mid-1960s, basket making was included in the Jicarilla Arts and Crafts Program supported by the tribe.

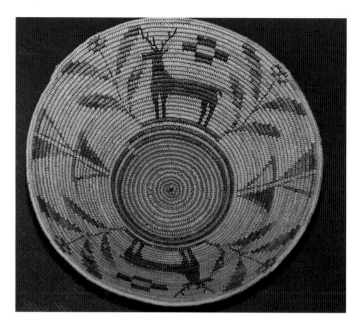

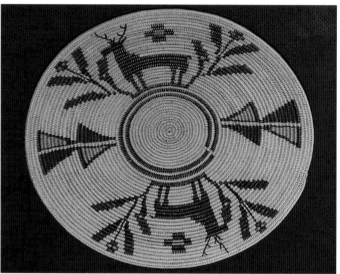

LARGE BOWL WITH FLAT BOTTOM (TOP) BY JICARILLA APACHE WEAVER TANZANITA PESATA, MADE CA. 1957-68. THE ANIMAL, PLANT, AND GEOMETRIC SHAPES ARE HARMONIOUSLY INTEGRATED IN THE PIECE. DIA. 18 1/2", H. 8". JICARILLA WEAVER LORETTA ROMERO REPRODUCED THE BASKET IN 1998 USING A PLAQUE SHAPE OF APPROXIMATELY 24" IN DIAMETER BY 1" HIGH. COLLECTION OF THE JICARILLA ARTS AND CRAFTS/MUSEUM.

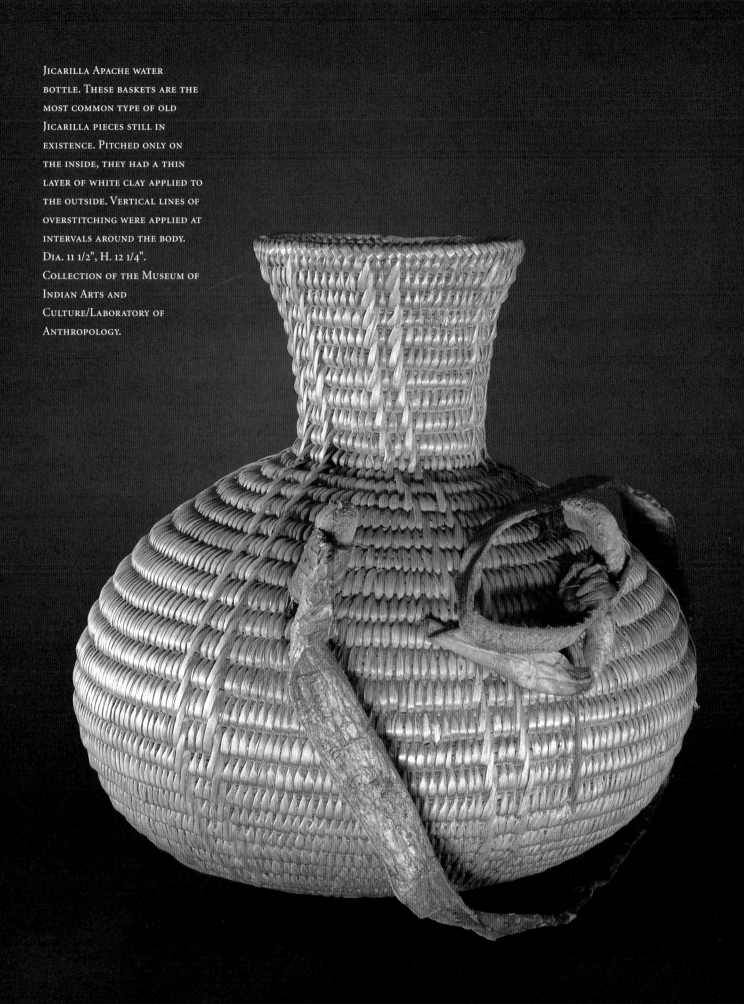

JICARILLA APACHE WATER
BOTTLE. THESE BASKETS ARE THE
MOST COMMON TYPE OF OLD
JICARILLA PIECES STILL IN
EXISTENCE. PITCHED ONLY ON
THE INSIDE, THEY HAD A THIN
LAYER OF WHITE CLAY APPLIED TO
THE OUTSIDE. VERTICAL LINES OF
OVERSTITCHING WERE APPLIED AT
INTERVALS AROUND THE BODY.
DIA. 11 1/2", H. 12 1/4".
COLLECTION OF THE MUSEUM OF
INDIAN ARTS AND
CULTURE/LABORATORY OF
ANTHROPOLOGY.

Large bowl made by Tanzanita Pesata in 1966. The central rings in this piece show the ticking she frequently used. She had a true artist's eye for combining geometric and animal designs into a unified whole. Dia. 21 1/2", H. 8 1/2". Collection of the Jicarilla Arts and Crafts/Museum.

Deep bowl by Mattie Quintana shows three different patterns repeated four times around the sides. The careful placement of each design element provides balance, unity, and simplicity. Dia. 16", H. 5". Collection of the Jicarilla Arts and Crafts/Museum.

Coiled baskets made for trade with the Pueblo were being produced by the Jicarilla as early as the 1880s. The Pueblo relied on Jicarilla baskets for the women's basket dance (page 53), for winnowing wheat, and for serving food on feast days. Although little information is available on Jicarilla basket making prior to the 1880s, in 1856, a government agent at Abiquiú reported they were making willow baskets (Tiller 1983, 57). Both George Wharton James (1902) and Otis Tufton Mason (1902) published extensive books on American Indian basketry of the time without mentioning anything about Jicarilla basketry, a strange omission considering the fact that many collections include Jicarilla baskets made during the late nineteenth and early twentieth centuries (Whiteford 1988, 49). Nevertheless, Jicarilla basket making skills were recognized enough by 1904 for Darcis Tafoya, a Jicarilla weaver, to demonstrate at the St. Louis World's Fair (page 52).

The Jicarilla also made baskets for trade with Hispanics, Anglos, and the Navajo. As Navajo baskets became more associated with ceremonial rather than utilitarian uses, greater taboos were placed on Navajo weavers, and the Jicarilla began producing a type of tray with a wedding design and ceremonial pathway for them. Interestingly, this pathway, or break, in the design on Navajo baskets can also be seen on old Pueblo baskets (Ellis and Walpole 1959, 197).

Hispanic and Anglo settlers living in the area also provided a ready market for Jicarilla basketry. These large, sturdy baskets produced for this market were essential items in most frontier households of the area. Some made in large cylindrical shapes with lid and handles were used as cloth hampers, while others with loop handles or openings on both sides functioned as laundry baskets. As tourism increased, the Jicarilla became creative and adept at developing baskets with a variety of shapes and striking designs to attract buyers. As the history of the Jicarilla shows, they are survivors, having turned many obstacles that confronted them to their advantage.

In the first half of the twentieth century, there was a gradual decline in Jicarilla basket making caused by a combination of developments. First, as the Jicarilla began to lead a more settled existence, they traded less with neighboring Indians. Second, when the use of metal containers for cooking and carrying became more common the demand for baskets decreased. Finally, due to the reservation's isolated location, dirt roads, and few visitors, weavers had little opportunity to sell their work other than trading at the Mercantile in Dulce for groceries and supplies. Although this was a period of extreme poverty and hardship, with tuberculosis also taking a toll, a few women nevertheless continued making baskets.

APACHE MERCANTILE IN DULCE, NEW MEXICO, OWNED BY FRED CARSON AND BARTON COX. IN 1964 IT WAS SOLD, RELOCATED, AND RENAMED THE BIG D SHOPPING CENTER. PHOTOGRAPH BY FRED CARSON, 1963.

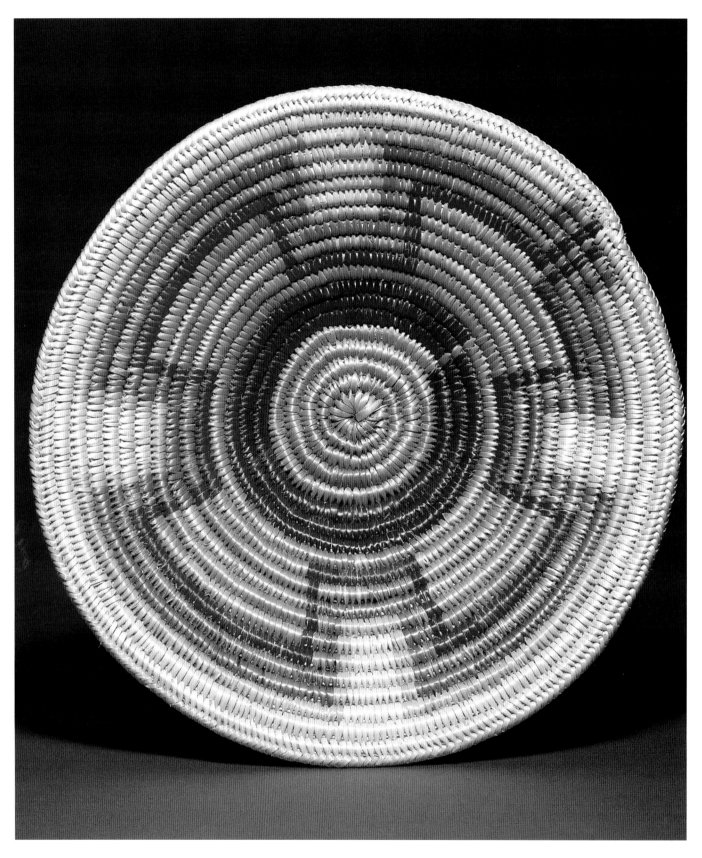

58

Three-rod bowl made in 1980 by Jicarilla weaver Mildred Monarco showing a fret design with a ceremonial pathway similar to those found on Navajo baskets. Tightly sewn, it has nine stitches per inch. Dia. 11 1/2", H. 2 1/2".

In the late 1950s, Barton Cox and Fred Carson bought the Apache Mercantile from Don Christianson. The only store on the reservation, it provided a number of services from cashing dividend checks to buying cattle, sheep, and wool to selling dry goods and groceries. Cox says there were very few active basketmakers when he took over the store, a conclusion confirmed by Ellis and Walpole in their 1959 study. Both men encouraged basket making and purchased all the baskets brought to the store, an average of one a week, for which they paid between $25 and $30. They sold these high-quality baskets, which included the work of Tanzanita Pesata and Grace Maria, to collectors and the few tourists passing through Dulce. Tony Reyna, a Taos Pueblo businessman and trader, bought many of them. Taos Pueblo and the Jicarilla have had an exceptionally close relationship that dates back at least to the early part of the nineteenth century.

In 1963, Cox and Carson sold the Apache Mercantile, and it was relocated down the street with a new name—Big D Shopping Center. The new trader, Joe Brooks, and his wife, Mary Gene, appreciated the basketry, entering pieces in the New Mexico State Fair and encouraging the women to continue bringing their work to the store to sell. Since the quality was always good, they bought all the baskets offered, which included work by Margarita De Dios, Hazel De Dios, Telchan Piaz Largo, Mattie Quintana, Beloria Tiznado, Columbia Vigil, Mattie Vincent, Louise Atole, and Tanzanita Pesata. Brooks states that the weavers always set the prices for their work.

Tanzanita Pesata (1885–1968) is recognized by many as the finest Jicarilla Apache basketmaker. Not only were her technical skills outstanding but she continually explored new dimensions in design. In comparison with the finest Native American baskets from California and the Southwest, her baskets stand out because of their unique bold designs and technical precision, yet she always worked within the parameters of traditional Jicarilla basketry.

She learned to weave from her mother at a young age and later taught basket making to her daughter, Mildred Monarco, daughter-in-law Louise Pesata, and granddaughter-in-law, Lydia Pesata (Herold 1978, 28). A photograph of Tanzanita shows a tall, slender, dignified woman with beautifully sculptured cheekbones, long braids, and a blanket placed casually over her shoulder.

She sold her work in Pagosa Springs, Colorado, and in Dulce at the Apache Mercantile and later the Big D Shopping Center. Tanzanita spoke very little English so she usually sent her son, Japan, into the Big D Shopping Center to sell her baskets. Brooks remembers that after the transaction was completed, he would go out to the parked truck to acknowledge Tanzanita, although on a couple of occasions he traded directly with her. Shortly before her death, she made two special orders for him, both kidney-shaped fishing creels with lids.

Tanzanita's baskets showed great technical skill. She used a loop start on her baskets with a three-rod foundation for smaller, finer work and a five-rod foundation for larger pieces. She made large cylindrical-shaped wastebaskets and covered cloth hampers, large, deep bowls, shallow trays, and water jugs. The water jugs were made in the Jicarilla fashion with hot piñon pitch applied to the inside and a white clay rubbed on the outside.

Tanzanita's innovative designs ranged from combinations of geometric shapes to animals and, later, flowers, feathers, and trees (Herold 1978, 31). They were usually carefully placed to create a sense of symmetry. These pieces reflect some of her finest technical work and artistry. A distinguishing characteristic of her work is an encircling band of ticking (alternating black and white stitches) shown on page 56—a technique her granddaughter-in-law, Lydia Pesata, also used on the start of a basket she made in 1994.

⊕ MATERIALS AND CONSTRUCTION

Coiling is the only method of construction used by the Jicarilla. They employ the branches of both willow and sumac. Willow shoots are gathered and peeled for the foundation rods and used in combinations of three or five, depending on the size of the basket. They are also utilized for the sewing strands but do not hold the dye as well as sumac so are used only for white backgrounds or for tan elements. The tan color is created by using willows that are harvested in the fall and then split three times into sewing strands. The bark is left on the strands, and they are bundled into a coil, which is boiled in water until the desired tan color is achieved. Finally, the strands are peeled and sized for use.

Sumac is the predominate material used for both foundations and sewing splints. In preparation for use as sewing strands, it is split into three parts by utilizing the teeth and both hands, then peeled, pithed, and smoothed with a piece of leather before being colored with either synthetic aniline dye or vegetal dye. Although aniline dyes are used more frequently, the colors in vegetal dyes are more muted than those in commercial dyes. The sewing splints are boiled in the dye solution for several hours and then soaked for three or four days to set the color, according to the desired hue. Both sumac and willow are harvested in the late fall after the first frost or in early spring, depending on their intended use. The long, slender shoots that sprouted from the ground during the past growing season are the ones selected since they lack branches.

Old Jicarilla baskets are usually easy to identify because of several characteristics. They have large coils, frequently five-rod, with flat bottoms and straight sides flaring outward to create a deep tray. Other shapes include large cylindrical cloth hampers with lids and wastebaskets made for non-Indian households. Frequently, rectangular openings on the sides or raised coils on the rims provided handles for winnowing or carrying. Designs, which often employ natural tan-colored willow, are often simple, massive, and include V shapes, elongated diamonds, crosses, and frets.

In some ways Jicarilla Apache basketry resembles Pueblo basketry, as suggested by a 1950 study conducted by Florence Ellis and Mary Walpole. Studying several pieces that had been made at Zia and Santa Ana Pueblos early in the twentieth century, they concluded that a similar type had been produced among all the Keres-speaking pueblos (and possibly others) for the last 1,600 years. They also noted a second type, heavier in construction, which was

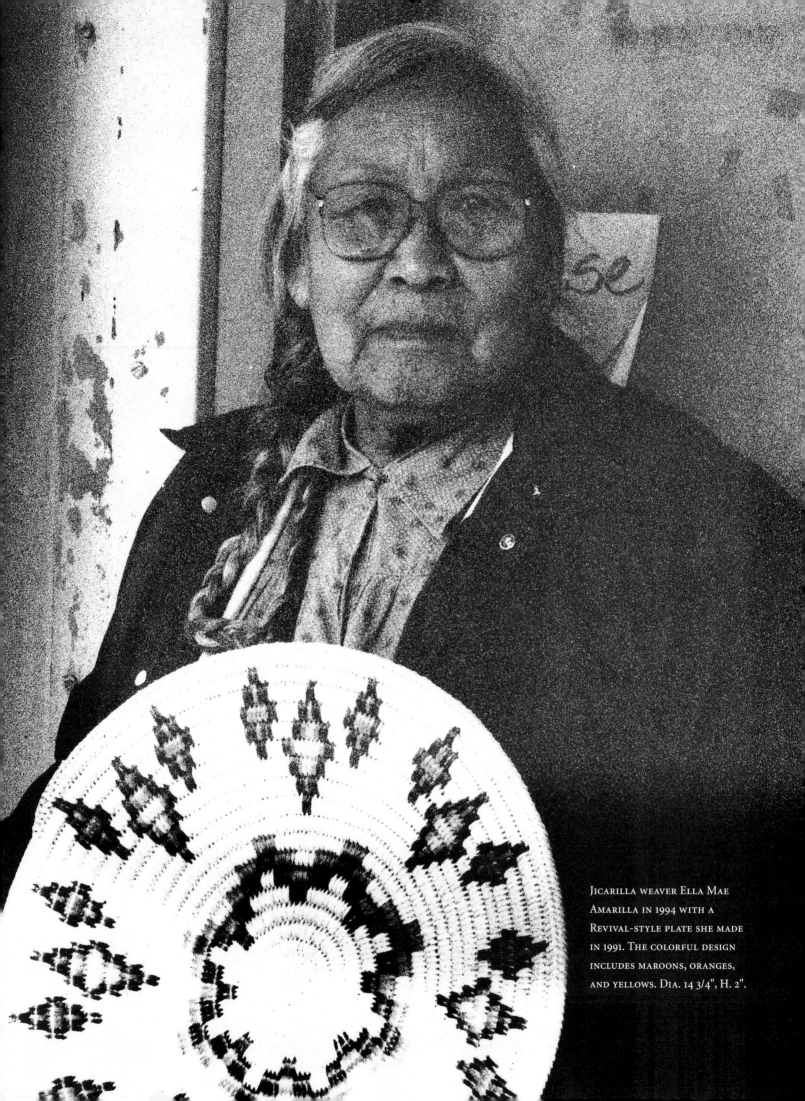

JICARILLA WEAVER ELLA MAE
AMARILLA IN 1994 WITH A
REVIVAL-STYLE PLATE SHE MADE
IN 1991. THE COLORFUL DESIGN
INCLUDES MAROONS, ORANGES,
AND YELLOWS. DIA. 14 3/4", H. 2".

still occasionally made at Santa Ana, Jemez, and the Tewa-speaking pueblos. These pieces were of a more recent derivation (A.D. 1100–1300) and showed a similarity to Jicarilla baskets; both use a triangular stacked foundation, thick coils, and false braided rims. Since contact between the Jicarilla and the northern Pueblo goes back hundreds of years, it would appear that the Jicarilla learned basket making from the Pueblo and possibly in turn influenced the construction of Pueblo baskets.

Jicarilla Apache baskets resemble Navajo, San Juan Paiute, and Ute baskets in the materials used. Woven right to left from the work surface and finished with a herringbone rim, they lack the fine coiling found in early Navajo baskets, which were constructed with two rods and a bundle foundation. Jicarilla pieces made for trade with the Navajo are often mislabeled as Navajo in private collections and museums. Adding to the confusion is the fact that when Navajo weavers stopped making baskets in the early twentieth century, the San Juan Paiute and Ute supplied their needs. In virtually all aspects these pieces resembled the type of baskets the Jicarilla were manufacturing for the trade also. Unfortunately, many old pieces of all four tribes have faded so badly it is difficult to see the designs. Over time, aniline dyes on sumac or willow fade unless kept out of the sunlight, although vegetal dyes retain color better.

The Revival-style baskets presently made by the Jicarilla are much smaller in size than earlier ones and usually have a three-rod foundation rather than the five-rod one more commonly used in the past. The types made are flat or shallow trays with bold designs of zigzags and other geometric elements, as well as a few small water jugs. Aniline dyes are still commonly used along with some vegetal dyes. Designs of plant and animal forms, popular earlier, are now seldom if ever used.

The Jicarilla Apache have focused extensively on preserving traditional arts and crafts over the years. The tribe has funded a work program to preserve and teach basket making and beadwork for more than twenty-five years. While other tribes in the West and Southwest have at various times also provided monies and instruction, none has made such a long-range commitment as the Jicarilla.

In the early 1960s the tribe established an Arts and Crafts Program that offered classes in bead- and leatherwork, employing twenty full-time people (Tiller 1992, 210). The women worked with beadwork and buckskin, while the men tooled leather belts and wallets in addition to making saddles.

Brenda Julian was appointed director of the Jicarilla Arts and Crafts Program, a position she has continued to hold until the present time. When the program first started, she explains, a large

BELOW LEFT: COILED WATER JUG LINED WITH PIÑON PITCH MADE BY LYDIA PESATA, 1993. DIA. 7 1/2", H. 10 1/2". COLLECTION OF THE JICARILLA ARTS AND CRAFTS/MUSEUM.

BELOW RIGHT: SMALL CYLINDRICAL BASKET BY BERTHA VELARDE DEMONSTRATING A THREE-ROD FOUNDATION AND FINE SEWING, MADE CA. 1980. DIA. 8", H. 10". COLLECTION OF THE JICARILLA ARTS AND CRAFTS/MUSEUM.

61

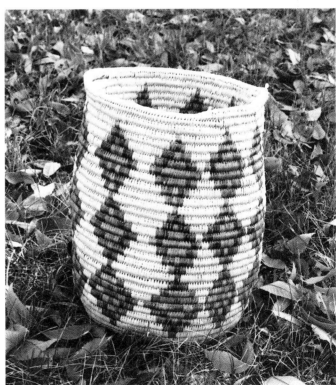

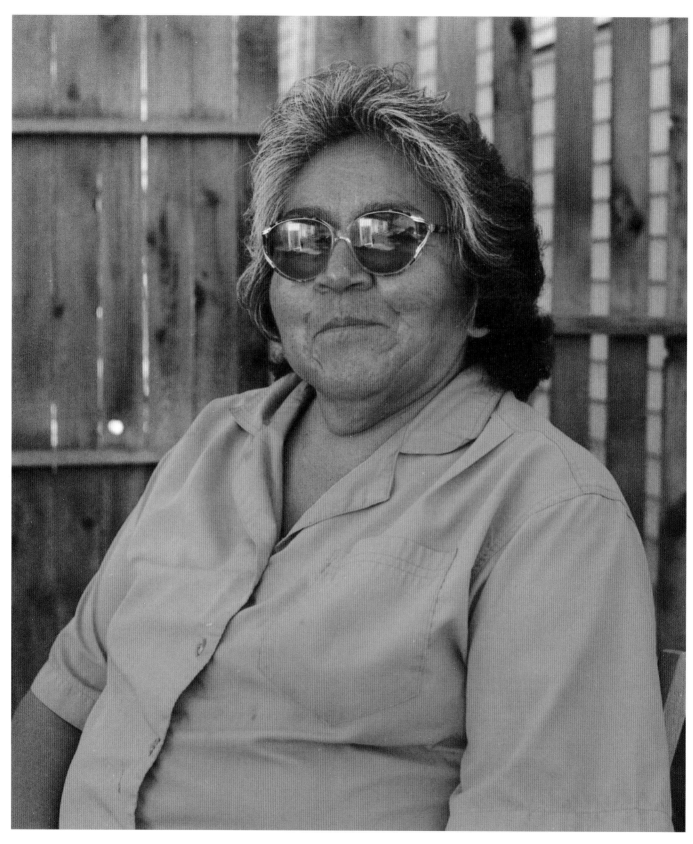

JICARILLA APACHE BASKETMAKER LYDIA PESATA AT DULCE, NEW
MEXICO, IN 1995. SHE WON THE NEW MEXICO GOVERNOR'S AWARD IN
1988 FOR HER WORK IN PRESERVING TRADITIONAL ARTS AND CRAFTS.

FACING PAGE: THIS BASKET ORIGINALLY WAS MADE BY ALMA
NOTSINNEH AND IS PART OF THE COLLECTION OF THE JICARILLA ARTS
AND CRAFTS/MUSEUM. IN 1984, CECILIA HARINA DUPLICATED THE
BASKET FOR THE AUTHOR WHILE WORKING THERE. DIA. 16", H. 4 1/2".

number of women applied, and in order to employ everyone interested, a schedule was developed that allowed for the women to work alternate two-week periods. Five experienced basketmakers—Columbia Vigil, Mattie Vincenti, Hazel De Dios, Florence DeJesus, and Mildred Monarco—taught those first students.

Brenda oversees an operation that includes anywhere from eight to fifteen women who are employed full-time at an hourly wage doing beadwork and basketry. When a basket is completed, it becomes the property of the crafts center and is priced for sale at the Jicarilla Arts and Crafts Museum or at the state fair or other art shows. The women gather their own materials (sumac and willow) and strip, split, and dye them. They use Rit dye for most of their colors with the exception of some tans, reds, yellows, and greens produced by vegetal dyes. The basketmakers select the shapes and designs of the baskets unless they are commissioned.

Constructed in 1983, the building houses the arts and crafts workplace and also the museum. An unassuming light green metal structure surrounded by trees and lawn, inside it is a long, narrow room with glass cases from floor to ceiling containing a dazzling display of over a hundred Jicarilla baskets. The older ones are usually large, deep trays or large cylindrical baskets made using five-rod construction with burnished geometric, floral, and animal designs muted with age. Recently made Revival-style baskets in the museum are for sale. Usually smaller with designs of vibrant reds, greens, blues, and yellows, they are displayed in cases in the center of the room, along with an impressive array of beadwork. The women work in a large, well-lit back room. Besides the five weavers who worked and taught in the early years at the old Arts and Crafts Program Center, Louise Atole, Louise Pesata, Bertha Velarde, Cecilia Harina, and Lydia Pesata are some of the other noted basketmakers who have worked there. Weavers working at the center during the winter of 1994 to 1995 included Grace Maria, Ella Mae Amarilla, Floripa Manwell, Iris Howe, Ardella Veneno, and Loretta Romero.

Lydia Pesata (page 62) is the best-known contemporary weaver among the Jicarilla Apache. She was born near Cuba, New Mexico, to Jicarilla parents, Anna Tafoya and Cevero Caramillo. Since her mother did not weave, it was not until after she married

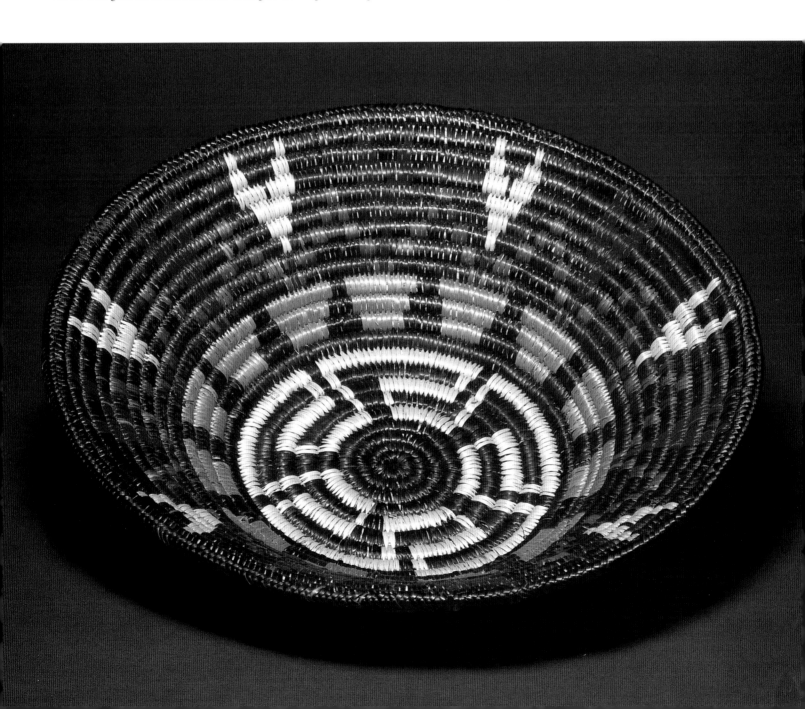

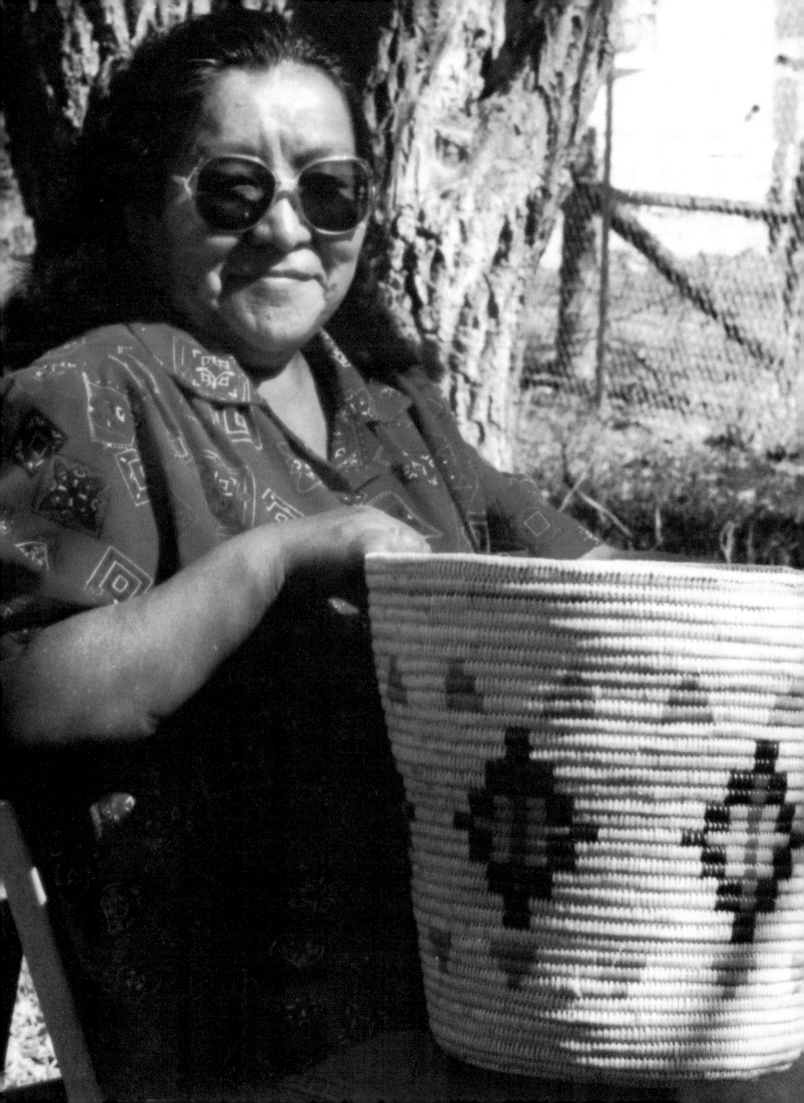

Melbourne Pesata at age twenty that she became interested in basket making while watching his grandmother Tanzanita Pesata prepare materials. She says it was her determination and perseverance that enabled her to perfect the skills needed. The first basket she made was a large tray executed with an all-black design, while her second basket had a design taken from a Tandy book on beadwork patterns. The latter basket is housed in the Jicarilla Arts and Crafts Museum. She estimates that she has made two hundred baskets during her lifetime.

Not long after she started to weave, Lydia Pesata became interested in exploring the methods and materials needed to make vegetal dyes, which create more muted colors than aniline dyes when used on sumac. Since commercial dyes had been the accepted method for so many years, she found very little information available on the process. Nevertheless, with the little information she could obtain from older weavers she began experimenting with different leaves, barks, and flowers. Red, yellow, and tan were the only natural colors used then by Jicarilla basketmakers, and this remains the case today. The following are some of the plants used by Lydia to prepare her dyes: hollyhock flowers, currants, mountain mahogany bark, and chokecherry for reds; dandelion roots and stems for lavender; alder bark for orange; barberry root and Oregon grape for yellow; Indian tea for gold; sumac berries for gray; and sumac bark for black (Whiteford and McGraw 1994, 49).

As Lydia readily admits, experimenting with natural colors is the aspect of weaving that is her greatest passion. She hopes that one day they will again be used with greater frequency by other Jicarilla basketmakers, although she acknowledges that preparing them is time-consuming and hard work.

For a number of years, Lydia ran the Cultural Resource Center program in Dulce, where she taught traditional arts, beadwork, and basket making. This program was not affiliated with the museum. Several of her students who learned weaving at the center, including both her daughters, have since been employed by the Jicarilla Arts and Crafts Center. In 1988, Pesata received the New Mexico Governor's Award for her contributions to the preservation of traditional Jicarilla arts and crafts.

Loretta Romero (opposite) presently works at the Jicarilla Arts and Crafts Museum. She worked with Pesata during the 1980s at the Cultural Resource Center, where she learned to weave before beginning her present job in 1992 because she wanted to continue making baskets. Loretta works quickly and with confidence, producing about one hundred pieces a year. She always uses three- or five-rod foundations on her baskets, many of which are sold through the crafts center.

The future of Jicarilla basket making looks promising if the tribe continues to support the art as it has in the past and the arts and crafts program can keep finding markets for the baskets produced. While the women weaving there receive a salary, their challenge will be to maintain the quality of their products. To do so, they must have a clear vision of the characteristics that have made Jicarilla baskets so unique and outstanding in the past while encouraging individual creativity and experimentation.

Baskets presently made are usually ten to fourteen inches in diameter and are shallow trays with three-rod foundations. However, the use of bright colors on repetitive isolated designs (one of the trademarks of Jicarilla baskets) appears to have a more dramatic effect when executed on larger baskets with five-rod foundations. Although in recent years the majority of weavers have been older women, it is very probable that many of the younger generation will become interested when they are older.

FACING PAGE: LORETTA ROMERO WITH A BASKET SHE MADE WHILE WORKING AT THE JICARILLA ARTS AND CRAFTS/MUSEUM IN 1994. THE CENTRAL DESIGN WAS MADE OF DYED SUMAC (BLACK, YELLOW, AND RED), WHILE THE TWO ROWS OF TRIANGLES WERE CREATED WITH NATURAL DYED TAN WILLOW. THE PIECE HAS A FIVE-ROD FOUNDATION OF WILLOW WITH MOSTLY SUMAC STITCHING.

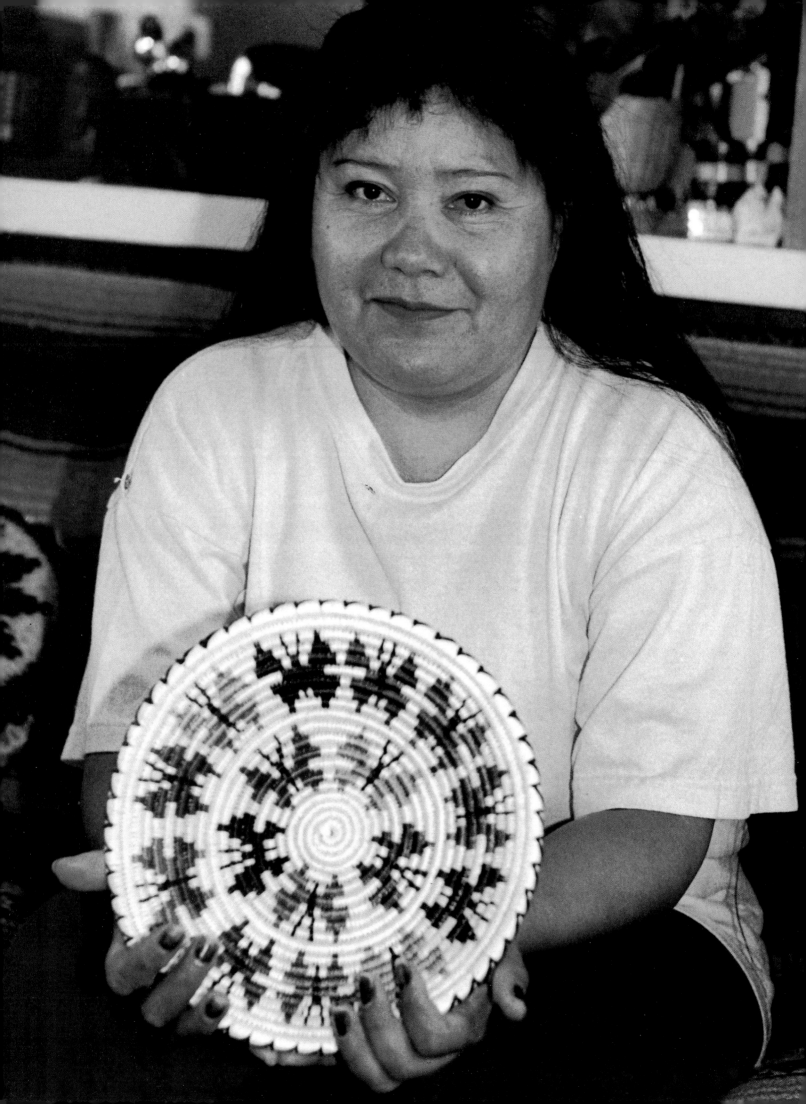

BASKETS FROM THE NINETEENTH CENTURY represen-
tative of the Ute, San Juan Paiute, and Navajo Tribes are
very scarce. It is only with the last hundred years that we
have been able to see the work of these weavers. Because
their history of weaving is so intertwined and the forms, designs,
and materials they use so similar, it is impossible to examine the
basketry of these tribes in isolation. While the Ute, San Juan
Paiute, and Navajo each have their own history, geography, and
traditions that have affected their basketry, it has been the supply-
and-demand network among the three that has had the greatest
impact on the art during this century. In general, the most influ-
ential factor affecting basket making in the western United States
in recent times has been the non-Indian market, but this has not
been the case with these groups. During most of the twentieth
century, the Ute and San Juan Paiute have furnished the Navajo
with ceremonial baskets, although in recent years a new develop-
ment has changed this old network.

FACING PAGE: SAN JUAN PAIUTE WEAVER ROSE ANN WHISKERS WITH
ONE OF HER BUTTERFLY DESIGNS. SHE DOES EXCEPTIONALLY FINE
WORK. DECEMBER 28, 1997. DIA. 9 5/8", H. 2".

BASKETS DISPLAYED AT SHIPROCK TRADING POST, MARCH 1999. ALL
OF THE PIECES WERE MADE BY FANNIE KING EXCEPT FOR THE
BUTTERFLY PATTERN MADE BY LORRAINE KING FOWLER AND THE
WEDDING PATTERN (TOP RIGHT) MADE BY PAULINE TODACHEENIE.

Although there are a few distinguishing features, without
knowing an artist's ethnicity it is often impossible to accurately
identify the tribal origins of most baskets made during the last
century. Intermarriage, traders, and collectors are all factors that
have contributed to such homogeneity. Among the Navajo and the
San Juan Paiute, basket making is still a vital economic and cere-
monial part of their cultures. This is no longer the case among the
Utes.

⊕ HISTORY The Ute are a Southern Numic-speak-
ing people. Their traditional lands covered a vast geographic area
encompassing three-fourths of the state of Colorado and over half
the state of Utah. The region is traversed by the high peaks and
forests of the Rocky Mountains, with extensive plains on the
Colorado side and deserts on the Utah side. The Ute can be divid-
ed into three broad geographical groups: the Southern, Northern,
and Western, each containing several subgroups, or bands. The
Capote, Muache, and Weeminuche bands occupied the southern
portions of Ute territory. The Capote and Muache bands had early
contact with the Spanish settlements in New Mexico and were
allies with the Jicarilla Apache, who were their neighbors to the
south and east. The Weeminuche, who occupied southwestern

67

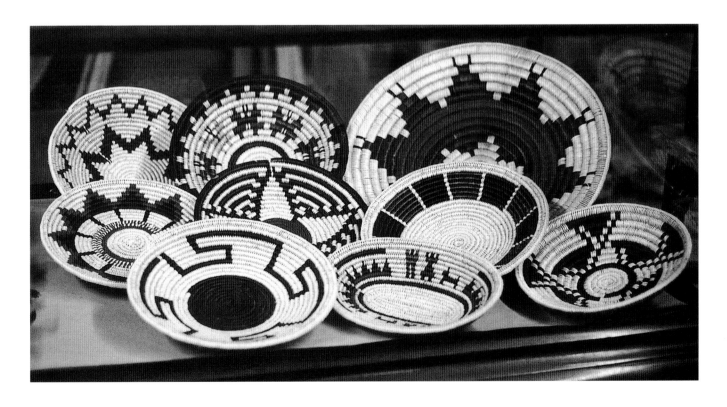

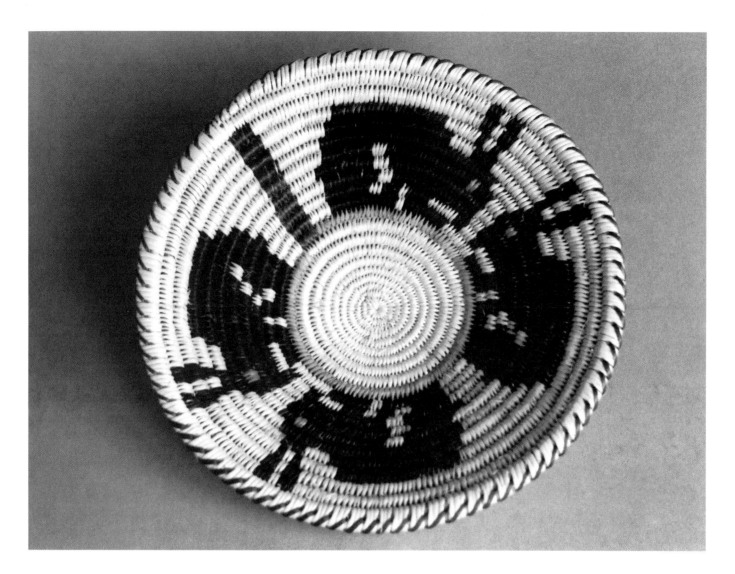

Colorado and eastern Utah, were more isolated from the Spanish colonies, and their lands were the last to be settled by Anglos. The Northern Ute, consisting of the Tebeguache (Uncompahgre), Yampa, White River, and Uintah bands ranged, over northern and central Colorado and eastern Utah. The Pahvant inhabited the desert regions of central and western Utah.

There were considerable differences in the life-styles and material cultures of these bands because of the varied habitats they occupied. The Pahvant lived much like their Southern Paiute and Western Shoshone (Gosiute) neighbors, building brush wickiups and wearing long rabbit skin robes in winter, while the northern bands, which were influenced by the life-style of the Plains Indians, used buffalo-hide tepees and wore buckskin clothing. Basketry also varied according to area, with twineware commonly made in western regions and coilware predominating in eastern locations (Fowler and Dawson 1986, 726).

Since many of their lands were isolated, the Ute were able to continue their nomadic existence well into the second half of the nineteenth century. Eventually, however, in 1868 mounting pressures from farming, ranching, and mining interests forced them to sign a treaty agreeing to remain west of the Continental Divide. Subsequently, a critical situation developed when this treaty was broken. The White River and Yampa bands became frustrated with broken agreements and their agent, Nathan Meeker, who was determined to make farmers and Christians out of them. When trouble developed, Meeker sent for military support, and troops were dispatched. Before the soldiers arrived, twelve Anglo employees, including Meeker, were killed by the Ute; thirteen soldiers died in a Ute ambush before ever reaching the agency. These incidents became known as the "Meeker Massacrei" and the "Thornburgh Ambush." After this the Ute's fate was sealed, and during the next three years all the northern bands were exiled to the Uintah and Ouray Reservation in Utah.

Meanwhile, the southern bands, consisting of the Muache, Capote, and Weeminuche, had already been placed on a narrow strip of land in Colorado along the New Mexico border—the Southern Ute Reservation. The Weeminuche were less than satisfied with sharing the reservation with the Muache and Capote since they considered it their land. Additionally, they were unhappy with the government pressuring them to accept allotments and take up farming. As a result, in 1895 they moved to the western end of the reservation, where the Ute Mountain Ute Reservation was created for them with its headquarters in Towaoc. Consequently,

the Weeminuche became known as the Ute Mountain Ute; however, a small band of Weeminuche who claimed the Blue Mountains of Utah as their home refused to move to the reservation and, along with Southern Paiute in the area, established themselves in Allen Canyon and White Mesa (Dutton 1976, 7). It is the descendants of this latter group who have preserved Ute basket making into the 1990s.

There has been little systematic research on Ute basketry (Fowler and Dawson 1986, 726), but Omar C. Stewart did study the basketry of the Pahvant Ute in 1942, while Anne M. Smith investigated basketry of the Uintah, White River, and Uncompahgre groups in 1974. Their findings indicate that the following types of twined baskets were made: conical burden baskets and berry baskets, seed beaters, fish traps, and cradle baskets. Types of coiled baskets included water bottles, cooking baskets, eating bowls, berry baskets, and winnowing/parching trays. Pahvant Ute also made the twined winnowing/parching trays, water jugs, and caps. Most of the twined pieces were made in western areas of the Ute territory, where they were in close contact with the Western Shoshone and Southern Paiute who used these items. Unfortunately,

FACING PAGE: BASKET STARTED BY RACHAEL EYETOO AND FINISHED BY HER DAUGHTER. THE COIL REPRESENTING THE GROUND IS MADE WITH YUCCA. NOTICE THE PATHWAY AND THE RIM FINISH, 1989. DIA. 12 1/4", H. 2 3/4".

STUART HATCH IN FRONT OF HIS TRADING POST, FEBRUARY 14, 1996. HIS BUSINESS HAS BEEN IN THE SAME LOCATION AT FRUITLAND, NEW MEXICO, SINCE THE LATE 1940S.

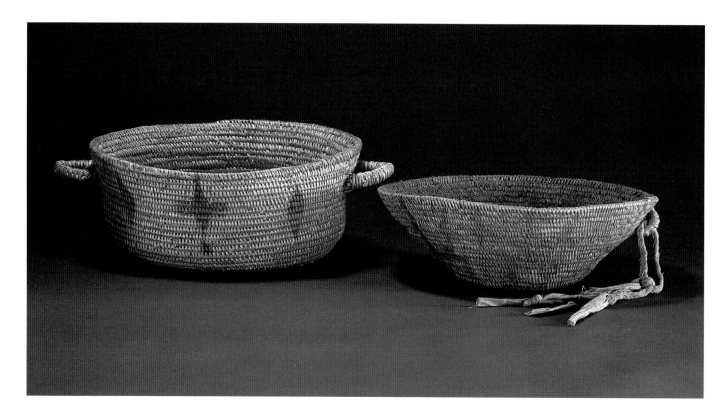

twined baskets are no longer produced by any Ute weavers and have not been for most of this century, with the exception of the Pahvant Ute.

The majority of old Ute baskets still in existence are coiled water bottles that are globular shaped with a flat bottom and horsehair handles. Made in all eastern regions of Ute territory, they were frequently sealed with piñon pitch inside and rubbed with white clay outside. Sometimes a single or double overstitching ran horizontally up the side of the bottle and was repeated several times around the piece (Fowler and Dawson 1986, 728). Similar features can also be seen on Jicarilla Apache water bottles still being made.

By 1900 Ute twined basketry had become obsolete, and the few coiled pieces made lacked any design other than those painted on the basket. At this crucial juncture it was the Navajo market for ceremonial baskets that helped preserve the art among the Utes. Ute-made coiled trays were acceptable to Navajo medicine men for use in curing and wedding ceremonies as long as they conformed to a certain style, form, and design. Ute women were not restricted as Navajo weavers were because of taboos. The Ute communities that supplied such baskets to the Navajo were those closest to the Navajo Reservation, including the Southern Ute Reservation, Ute Mountain Ute Reservation, and the Allen Canyon–White Mesa communities.

In 1938, Omar C. Stewart explained this transformation that was taking place. "Because the baskets still are necessary for ceremonial use, the Navajo pay a good price for them to the Southern Paiute and Ute, who unrestricted by taboos, have acquired a new art during the last decade or two. Not the art of basket making—they had that—but the art of making a particular basket in a manner previously unknown to them. To make the wedding basket, the Ute and Southern Paiute acquired a new shape, the technique of

elaborate decoration (which they lacked), and changed their direction of coiling and their method of sewing." Neither the Ute nor the San Juan Paiute used designs of any kind on their coilware before the arrival of Euro-Americans, although they did rub paint on the outside of some pieces (Stewart 1938b, 26–27).

In 1936, the Indian agent in Allen Canyon wrote, "The Allen Canyon Utes have built up a reputation for themselves for their basket making. . . . The Navajo discovered this basket and immediately adopted it for a medicine basket, thus a market was made for it." By "discovered" it is assumed he meant that Ute weavers were able to make the desired form and design. Continuing, he writes, "Weaving is to be encouraged as a means of self-support. One of the better weavers is to be chosen to instruct younger women to this art. The goal for this year is to have these women weave about 550 baskets" (Black 1936, 42). It is not known whether this goal was achieved, but there were a number of known weavers at Allen Canyon who were regularly weaving to supplement the family income.

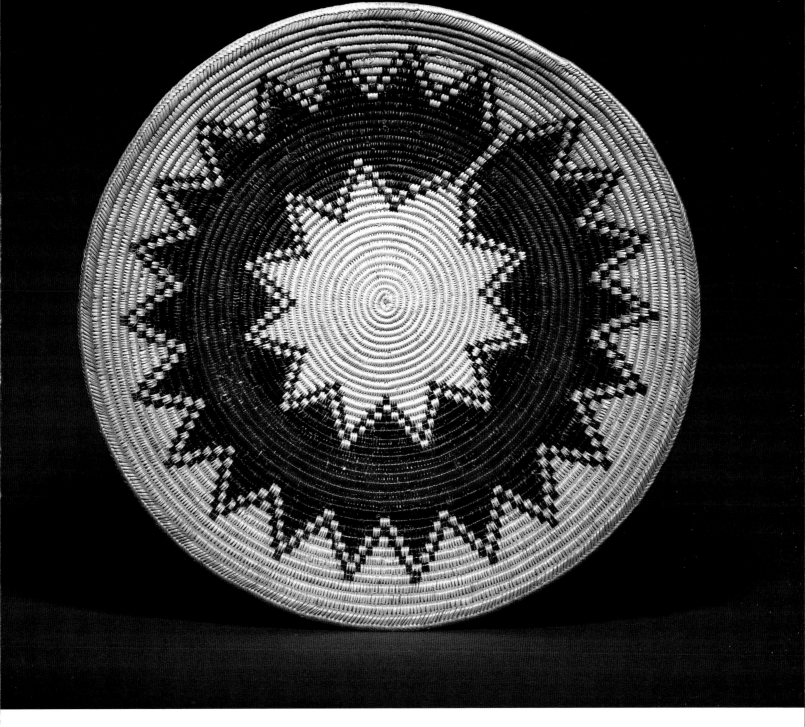

By the end of World War II, the largest concentration of Ute or Ute–Paiute basketmakers was in the Allen Canyon–White Mesa area, although in 1946 Stewart Hatch, who worked at the Ute Mountain Trading Company near Towaoc, reported that two women on the Ute Mountain Indian Reservation sold their baskets at the store. According to Hatch, there was considerable interchange between people at White Mesa and Towaoc, many of whom were related. Since both women had last names which were common at White Mesa (Wells, Sanup) they may have been from there. In any case, it seems likely that there was some weaving activity on the Ute Mountain Ute Reservation at this time. Moreover, in 1938, Omar C. Stewart had apparently seen baskets being made at Towaoc and heard they were being made on the

Southern Ute Reservation at Ignacio (Stewart 1938b, 27). In the 1990s, no one living permanently on either the Ute Mountain Ute Reservation or the Southern Ute Reservation is making baskets, although cradle boards with willow shades are still made.

In 1994, when I asked Stuart Hatch who the best basketmaker among the Utes at Allen Canyon and White Mesa was, he replied without hesitation, Jane White. Since Stuart has spent a lifetime trading with the Ute, Paiute, and Navajo, his opinion intrigued me, and after seeing one of White's baskets, it was clear why her work had left such an impression on him (above). I later asked Ray Hunt, who has also spent a lifetime in the trading business, the same question. Again, Jane White was the answer.

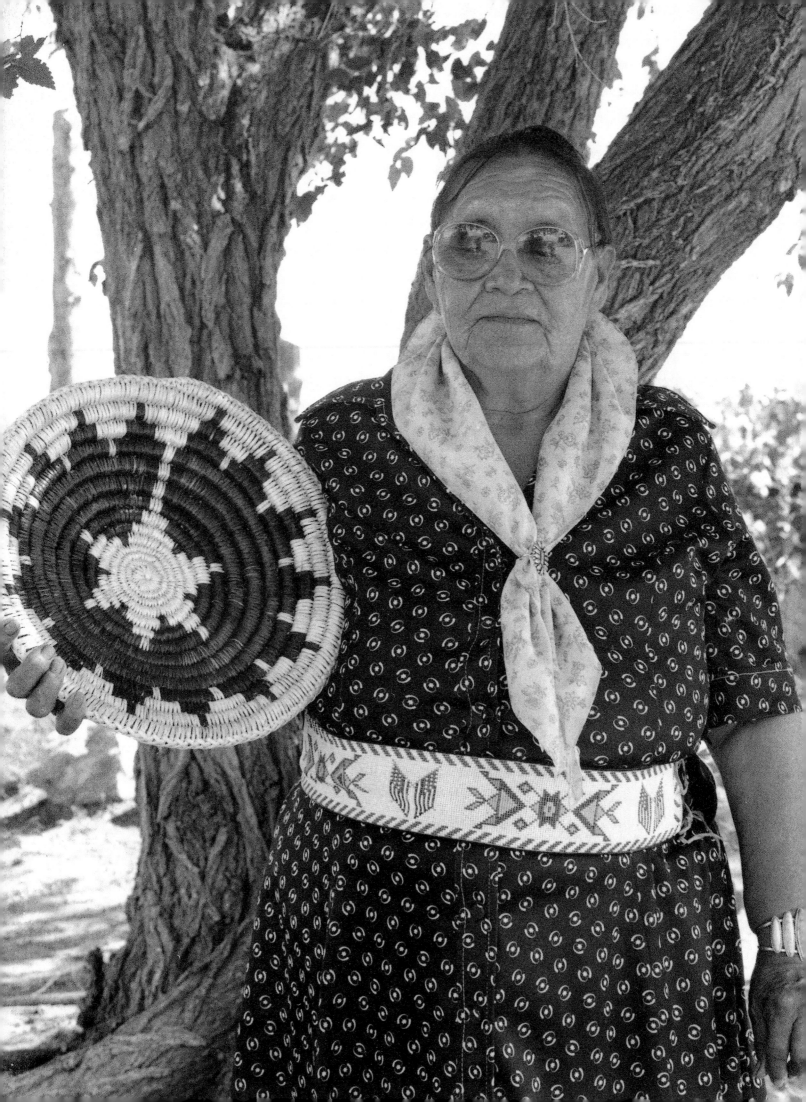

Jane White (1884?–1972) and her sister Mae White (1898–1971) were the daughters of Mancos Jim, a respected leader among the Allen Canyon Ute. Very little is known about Jane White's childhood except that her family, like other Indians in the area, lived a nomadic existence, visiting relatives on the Ute Mountain Ute Reservation during the year while tending gardens at Allen Canyon in the summer and wintering on White Mesa.

Jane and her sister were both the wives of Jess Posey, and since Jane married first she was the number one wife. Jess Posey was the eldest son of Paiute Posey, who has since become famous for his role in the 1923 conflict known as the "Posey War," which involved a conflict between the Utes and the Mormon community at Blanding. The elder Posey died of wounds received in the conflict, and Jess can be seen in many photographs that record the incident. All of the Indians not involved in the action were detained in a guarded, fenced compound in Blanding, and it is almost certain that Jane would have been among them, although there are no photographs of her.

73

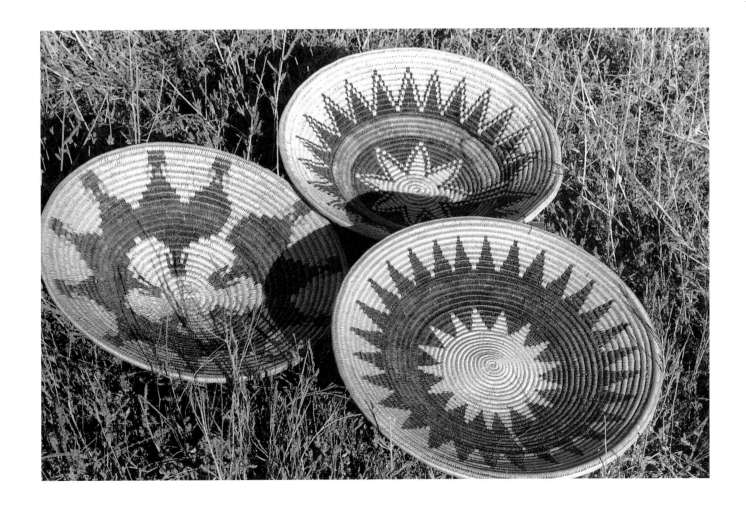

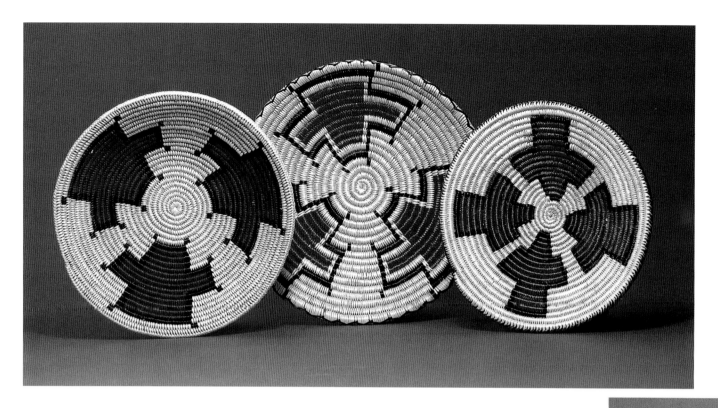

The Posey family camped at the spring in Hammond Canyon on allotted lands given to them after 1923. Located in a side canyon off Allen Canyon, the spring contained the only drinking water in the area and thus everyone periodically came there. On their land the Poseys had fruit trees and a garden with corn, squash, and melons to supplement the rations given them.

Jane and Mae White were known for their abilities at gambling with cards, frequently winning the other women's rations issued by the agent in Allen Canyon (Black 1936, 45). In later years, Jane White, who never had children, lived in a government-built house at White Mesa before she was killed in an automobile accident near Bluff at about age eighty-eight.

Jane White made ceremonial-style (wedding) baskets, selling them at the trading post in Allen Canyon and later in Blanding at Parley Redd's store and Hunt's Silversmith Shop. The unusually refined basket pictured on page 71 was made prior to 1936 and sold to the Allen Canyon Trading Post (Hatch, 1987–1998). It has a three-rod foundation with thirty-seven coils; the red band is five coils wide, while the black stepped triangles on each side are eight coils, for a total of twenty-one coils used for the design. The more coils used in a design, the more detailed and delicate the design appears. Tight stitching and small coils of this quality are seldom seen even in old Navajo-made baskets of the last century. Jane continued to weave right up until her death, selling a basket the day before the accident. Unfortunately, she is not identified with most of her work, but the perfection of her baskets remains a lasting tribute to her artistry.

Unfortunately, the community at White Mesa, which contributed so importantly to the preservation of basketry in the past, now has few basketmakers. Although approximately ten women and one man have the needed skills, they only weave occasionally. The craft is disappearing rapidly, and drastic intervention is needed to help guarantee its continuance into the twenty-first century.

THESE THREE BASKETS HAVE VARIATIONS OF THE DESIGN KNOWN AS RAIN BY THE PAIUTE AND SPIDER WOMAN BY NAVAJO WEAVERS. (FROM LEFT) FANNIE KING, 1998, DIA. 12 1/4", H. 2 1/2"; MARY ANN OWL, 1995, DIA. 13 3/4", H. 2"; MABEL LEHI, 1990, DIA. 11 1/4", H. 2".

RIGHT: NAVAJO WATER JUGS WITH HORSEHAIR HANDLES, SEALED WITH PIÑON PITCH INSIDE AND OUT. (FROM LEFT) MARY BITSINNI, 1978, DIA. 6", H. 9"; THREE-ROD TIGHTLY STITCHED, 1991, DIA. 8 1/2", H. 10 1/2"; OLD JUG REPITCHED BY ETTA ROCK, DIA. 10", H. 10".

This recent critical situation has resulted from several developments. First, many of the older weavers have either died or are no longer able to make baskets. The early death of Susan Whyte in 1994, and the deaths of Rose Mary Lang and her mother, Rachael Eyetoo, have severely curtailed production. Moreover, two older weavers, Stella Eyetoo and Alice May, seldom weave anymore, although Stella Eyetoo told me she made three "medicine baskets" in 1994. Of the White Mesa weavers, Lola Mike continues to be the most active (page 72).

Another obvious challenge to basket making at White Mesa is the Ute Mountain Ute casino near Towaoc, Colorado, which provides employment for people at White Mesa. Residents living at White Mesa who are enrolled on the Ute Mountain Ute tribal rolls receive dividend checks from the casino profits. The increase in monies and jobs has undoubtedly had some impact on the need to weave to supplement family income. Finally, a third development that has affected Ute basket making in the last ten to fifteen years has been the increased number of Navajo weavers, resulting in a decrease in demand for Ute medicine (wedding) baskets.

✦ THE SAN JUAN PAIUTE, LIKE THE UTE, belong to the Southern Numic branch of the Uto–Aztecan family. The Numic-speaking peoples began to drift into the Great Basin from a point somewhere near Death Valley around A.D. 1000 (Miller 1986, 102). One of sixteen subgroups of Southern Paiute, which includes the Chemehuevi, the San Juan lived in the most easterly location of Paiute territory. The geographical boundaries of their domain were the San Juan River on the north; the Colorado and Little Colorado Rivers on the west and south; and Monument Valley and Black Mesa in the east (see map). The area consists of high-desert terrain slashed by deep canyons of red sandstone with forests of piñon and juniper in the higher elevations surrounding Navajo Mountain. This entire region is now part of the Navajo Reservation except for a smaller portion included in the Hopi Reservation. Most of the San Juan Paiute still live in the area, even though it is on the Navajo Reservation. They were hunters and gatherers who practiced some agriculture and brought with them the cultural characteristics associated with other Numic peoples of the Great Basin. The Havasupai were their friends; however, they

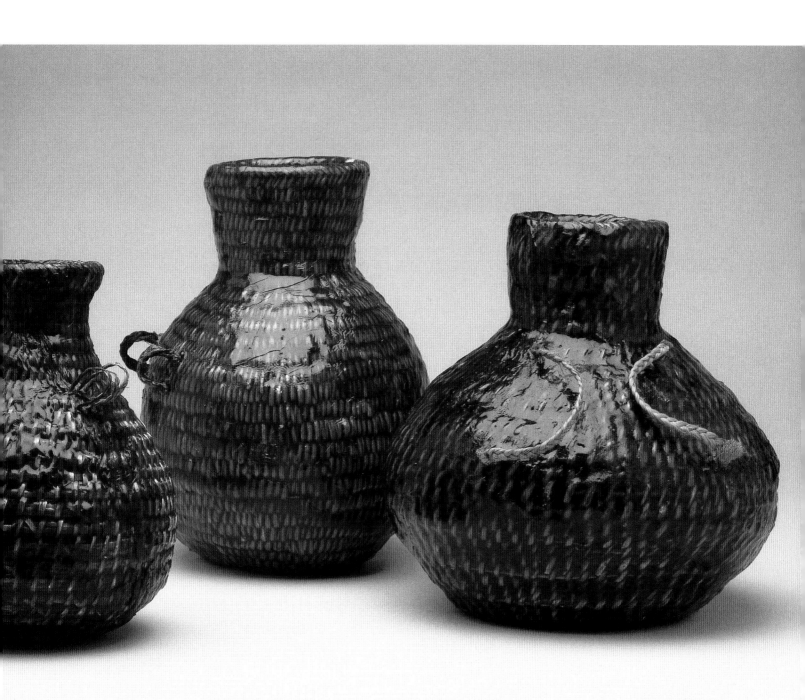

were enemies with the Hopi, probably because of the rich farmlands along Moencopi Wash and other areas, which both groups coveted. In historic times they have had strained relations with the Navajo.

Because of the rugged, isolated nature of their lands, the San Juan Paiute were not affected by outsiders until the 1860s, when the Navajo began filtering in. The military campaign against the Navajo led by Kit Carson in 1863–64 was aimed at stopping Navajo hostilities against settlements. Its goal was to destroy their economic base, round them up, and relocate them three hundred miles away at Fort Sumner, New Mexico. It is estimated that several thousand were able to escape westward into the isolated regions in and around Paiute territory. In 1868, the Navajo returned from their "Long Walk" and were given a reservation near Paiute lands. In the ensuing years, the Navajo population grew, and their reservation boundaries increased, encompassing Paiute lands. The small number of San Juan Paiute were forced to retreat into more isolated areas.

The second encroachment on Paiute territory occurred with the Mormon settlement of Tuba City in the 1870s. The Mormon settlement was the probable cause for their abandonment of their Moencopi farms around Tuba City. Years later, the government bought the settlers out, and the land became part of the Navajo and Hopi reservations, the Paiutes having already abandoned the area.

In 1909, Superintendent S. Janus of the Western Navajo Agency reported that the San Juan Paiute maintained camps at Willow Springs on the Echo Cliffs, at Cedar Ridge, upper Paiute Canyon, and around the Oljeto area in Monument Valley. They pursued some dry farming while maintaining herds of sheep and goats that were wintered around Navajo Mountain (Bunte 1985, 12). In 1907, they were given a reservation called the Paiute Strip, but it was later included as part of the Navajo Reservation. Increasing Navajo encroachments forced many living at Paiute Canyon and in the Oljeto area to move north to Allen Canyon and White Mesa, where they lived with the Ute. Basketmakers Stella Eyetoo and Lola Mike are both current residents of White Mesa who moved when they were young from these areas on the Navajo Indian Reservation.

During the 1980s, the San Juan Paiute hired attorneys to help them gain tribal recognition from the United States government, supplying the Bureau of Indian Affairs with a history of the tribe and genealogical records of its members. Anthropologists Pamela A. Bunte and Robert J. Franklin were hired to assemble the information. Recognition was granted on December 11, 1989 (Bunte 1985, 97–98).

It also became evident that the San Juan Paiute would need to become involved with a lawsuit between the Hopi and Navajo over reservation boundaries since Paiute lands were involved. More than two hundred tribal members are hoping for the restoration of some of their lands, which are today part of these two reservations.

The San Juan Paiute have historically made both twined and coiled baskets, but it is their coilwork for which they are currently known. These baskets have been an important source of income and item of trade. The basket trade between the Paiute and Navajo dates back to the 1870s when the Paiute provided the Navajo with water jugs sealed with piñon pitch (Bunte 1985, 11). Early Paiute coiled baskets had little or no design. It was probably when they began to produce the wedding pattern for the Navajo (from the 1920s to the 1930s, according to Omar C. Stewart) that design began to play an important role in their basketry.

When San Juan Paiute and Ute weavers took over the production of these baskets, they were careful to re-create a piece that was acceptable to Navajo medicine men. For over fifty years from the 1930s through the 1970s, San Juan Paiute and Ute weavers have produced the vast majority of baskets made by the three tribes, whether wedding design or other designs. After a wedding basket was used in a ceremony, it was usually given to the medicine man as partial payment; he in turn would trade it for goods or cash. This custom resulted in the distribution of these baskets around the reservation, with the traders buying and selling them repeatedly.

FACING PAGE: Navajo weaver Sally Black demonstrating how to split sumac at a workshop she conducted at Nations of the Four Corners in Blanding, Utah, spring 1995.

Vase-shaped basket by Navajo weaver Jeannie Rock Begay, with a three-rod foundation and herringbone rim finish. A partial wedding design encircles the bottom portion with dogs on the upper part, 1992. Dia. 8 1/2", H. 9".

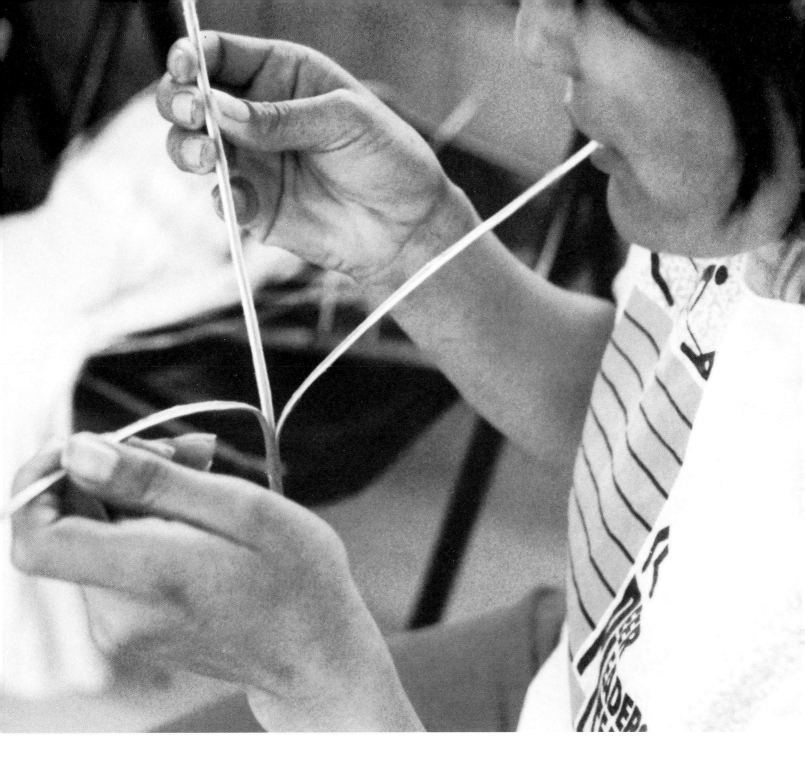

The creativity of the weavers frequently led to artistic variations of the wedding design and the eventual invention of new patterns. At first the changes were subtle. One early wedding basket had small amounts of bright yellow, while others had small squares (ears) attached to either side of the outside points on the black design. Later, other geometric shapes were employed in conjunction with the wedding pattern. The use of butterfly images incorporated into a traditional wedding design is considered a hallmark of recent San Juan Paiute baskets as is the use of a butterfly pattern by itself (page 66), although Stuart Hatch said he first saw butterflies used in a design in the late 1940s. Susan McGreevy has divided what she terms "new wave" San Juan Paiute basketry into three categories: improvisations on the wedding theme, interpretations of designs from other tribes, and original design baskets (McGreevy 1985, 30).

No recent history of San Juan Paiute basket making would be complete without commentary on the role of William Beaver. After receiving a degree in anthropology, he worked at the trading post at Shonto. In 1960 he and his wife purchased the Sacred Mountain Trading Post, where he could pursue his passion for Navajo pottery and Paiute baskets. He has been instrumental in supporting and promoting both. Located on the main highway between Cameron and Flagstaff, Sacred Mountain became a popular stop for San Juan Paiute weavers on their way to Flagstaff for supplies. Beaver encouraged them by purchasing their work, most of which bore the wedding design in the early years. He sold many of the baskets to tourists or Navajo while keeping exceptionally fine or unusual baskets, eventually accumulating some one hundred pieces, including wedding baskets, water jugs, and pieces with unusual designs (McGreevy 1985, 28).

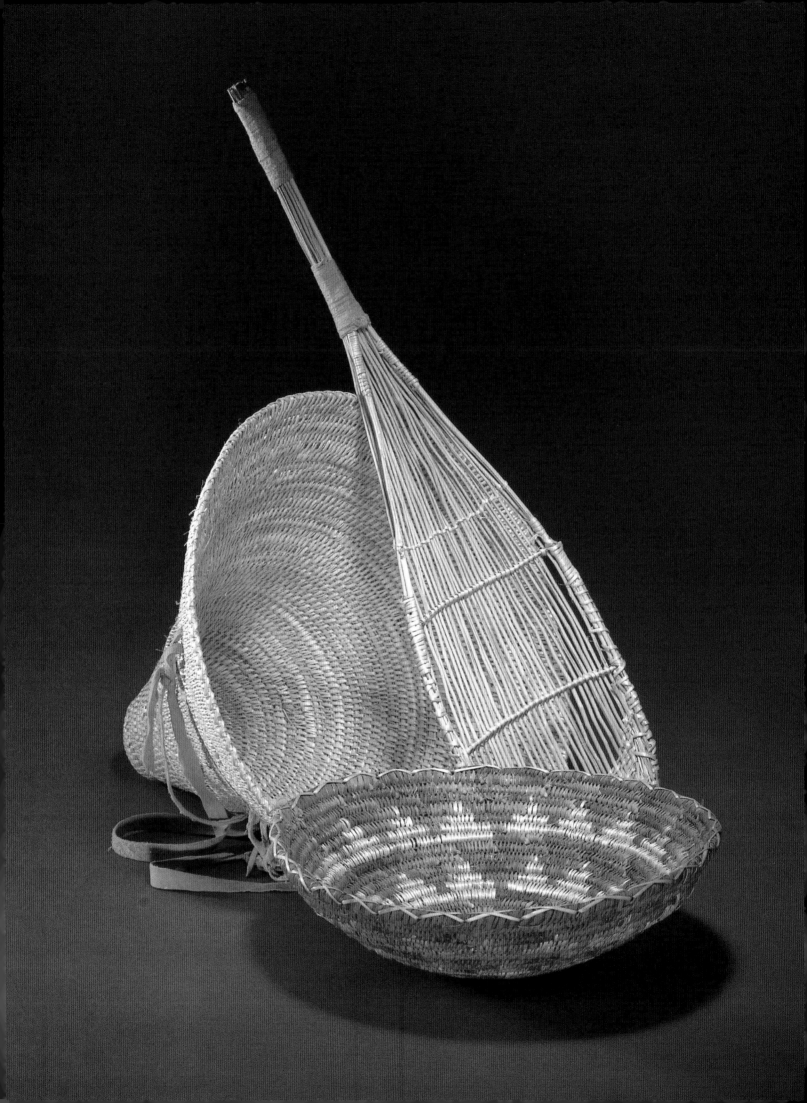

Ultimately, Beaver sold this collection and began a second one. He worked closely with weavers in preparing pieces for his second collection. Interested in utilitarian baskets, he encouraged young weavers to learn from their elders about "old-timer baskets." As an incentive he provided photographs from the Fred Harvey Basket Collection and O. T. Mason's *Aboriginal American Indian Basketry,* as well as other books and pictures (McGreevy 1985, 29). Eventually, Beaver's second collection became the basis of a show at the Wheelwright Museum of the American Indian in Santa Fe, New Mexico, in 1985-86. This successful show introduced the public to the extraordinary talents of the San Juan Paiute and created a greater interest in their work and in basketry in general. The show's impact on San Juan Paiute basketmakers is less clear. Because jobs are scarce, many men still seek employment off the reservation, while most young girls are taught to weave since making baskets is one of the main sources of income. In the mid-1980s, a basketry cooperative was established with money from the Administration for Native Americans, but it has since been abolished.

Intermarriage between the San Juan Paiute and their neighbors, the Navajo and Ute, has made it difficult to ascertain how many weavers there are among them. This is because according to the law individuals enrolled as San Juan Paiute cannot also be enrolled in another tribe, even though they may have the percentage of blood required; they must choose their affiliation.

Of the more than two hundred enrolled members of the San Juan Paiute Tribe, the majority of older women weave or have the skill. My research indicates there are 125 to 150 basketmakers presently (1999) among the San Juan Paiute, Navajo, and Ute. This figure includes Southern Paiute weavers at Kaibab, Kanosh, and Cedar City, who learned from their San Juan relatives. I doubt whether there are any Ute weavers who are not part Southern Paiute or Navajo.

⊕ THE NAVAJO are one of several Athapaskan groups who migrated into the Southwest between A.D. 1200 and 1500. These nomadic Apachean peoples were hunters and gatherers who came from northwestern Canada. Since the Navajo and Apache had a similar language and life-style, it has been difficult for scholars researching their early history during the sixteenth and seventeenth centuries to distinguish between these tribes. When the Spanish arrived, they called the people now known as the Navajo "Apache" in combination with words describing their characteristics or location (Brugge 1983, 490). In the seventeenth century, those groups living in western regions between Jemez Pueblo and the Hopi mesas and north of Acoma Pueblo were referred to as Apaches de Nabajo by Frey Alonso de Benavides, who remarked that the "Nabajo" were skillful farmers whereas none of the other Apache in the south practiced agriculture. He goes on to say that the word Nabajo means large cultivated fields (Roessel 1983a, 47).

The Navajo people tell of a place in northern New Mexico that is the homeland of their ancestors—called Dine'tah. According to legend, it was here on Gobernador Nob that Changing Woman was found as an infant and First Man and First Woman had their original home on Huerfano Mesa. The area consists of several

Sumac sewing splints dyed and bundled in preparation for weaving. Rit black and orange dye was used for coloring. The strands will be soaked in water before being used.

Facing page: Contemporary replicas of utilitarian baskets used by the San Juan Paiutes for harvesting, gathering, and winnowing. (from left) Rose Ann Whiskers, 1998, Dia. 13 3/4", L. 10 1/2"; Lilly Whiskers Duran, 1995, Dia. 11 1/2", H. 3"; Mabel Lehi, 1998, L. 23", W. 6 1/2".

rugged canyons (Gobernador, Largo, La Jara, Blanco) on the San Juan drainage east of Farmington, New Mexico. It was also here that the Pueblo people took refuge with the Navajo during the Spanish Reconquest of New Mexico in 1692. For the next seventy-five years, they lived together, leaving a rich material repository showing the cultural synthesis that had occurred. Pueblo influence can be seen in Navajo pottery, rock art, basketry, spinning, textile weaving, and masonry architecture. It is likely the clan system also developed during this period, with some based on Apache bands and others on Pueblo groups. Later, the region was abandoned as a result of increased Ute raids and drought (Brugge 1983, 495). Migrating in a southwesterly direction, the Navajo emerged as an agricultural and herding society with a complex ceremonial and religious system. Extremely adaptive, their culture was a synthesis of Apache, Pueblo, and Spanish elements.

With the abandonment of the Dine'tah region, Navajo raids on Spanish settlements increased (Brugge 1983, 495). The expansion of Spanish settlements and the loss of lands to the Ute forced the Navajo farther west into San Juan Paiute and Havasupai territory. When Mexico gained independence from Spain, the Navajo were confronted with a new problem, being the target of slave raids (Brugge 1983, 495). As tensions increased, their economy suffered and disagreement developed within their ranks. In the early nineteenth century, one group favoring peace with New Mexico broke away, eventually settling on the present-day Cañoncito Navajo Indian Reservation (McNitt 1972, 434).

After the defeat of Mexico in 1848, the United States gained control of a vast area that includes the present states of Texas, New Mexico, Arizona, Utah, Nevada, and California. An increased number of traders, settlers, and people heading to the gold country in California flooded the area, causing a greater threat to the Navajo way of life than any of the previous occupations. The influx of people forced the Navajo farther west, causing increased conflicts with non-Indians. Fort Defiance was built in the middle of Navajo territory as a base for military operations against them.

When Brig. Gen. James H. Carlton took command of the New Mexico military, his solution to the problem was to relocate all Navajo at a location called Bosque Redondo, where they would be provided for by the government and taught to become farmers. Consequently, he issued an ultimatum for all Navajo to turn themselves in, unconcerned about the number who could not read the written ultimatum. Those who refused to come in voluntarily were to be pursued by the military and brought to justice.

Christopher (Kit) Carson was in charge of the campaign (1863–64), which eventually resulted in the removal of almost 8,500 Navajo to Fort Sumner (Bailey and Bailey 1986, 10). Despite this campaign, however, some Navajo were able to seek refuge among the San Juan Paiute at Navajo Mountain and other western areas belonging to the Paiute and Havasupai.

The Bosque Redondo captivity is one of the great tragedies in American history. It showed the government's lack of empathy toward Native Americans and its willingness to apply a military solution to a problem it was unwilling to grapple with. Finally, in 1868 a treaty established a reservation for the Navajo on their traditional lands, and they were allowed to return home. In later years the reservation boundaries were expanded several times.

Most of our knowledge about Navajo culture derives from the reservation period that began in 1868. Trading posts played a major role in societal change, acting as important links between the reservation and the rest of the world. Trading posts operated by non-Indian businessmen sprang up around the reservation selling dry goods and groceries while buying sheep, wool, rugs, silver jewelry, and baskets. Traders wrote and read letters, filled out forms, mediated problems, and improved markets for Navajo crafts. Moreover, it was usually traders who had the greatest influence on the styles of crafts made, a situation still partly true today.

The Navajo learned basketry skills from the Pueblo Indians (Tschopik 1940, 462). Like the baskets of the Anasazi and the Pueblo, their coiled pieces utilized a two-rod and bundle foundation. Later they switched to a three-rod foundation for most of their coilwork, although the earlier method continued to be used until the 1930s in the eastern Ramah Reservation area (Tschopik 1940, 445). It seems logical that the Navajo adopted the use of the three-rod method from the San Juan Paiute, who employ this type of foundation and with whom they lived in close proximity on the western side of the reservation around Navajo Mountain. The most commonly made form was a coiled tray (ts'aa'), twelve to fourteen inches in diameter and several inches deep. It was used in the household for serving and preparing foods or for various ceremonial rituals. A water jug (to'shjeeh) was also coiled, usually on a single-rod foundation, and was then coated with piñon pitch on the inside and outside for waterproofing. A third type of utilitarian basket (tsii'zis), used for transporting goods, was wicker plaited, semiconical in shape, and reinforced with two U-shaped rods. A coiled, cone-shaped burden basket was also used on the western portions of the reservation, but was probably only made by the San Juan Paiute.

All three types of utilitarian baskets were produced in 1868 at the end of the Bosque Redondo captivity. By 1910, the Franciscan fathers working at Saint Michaels, Arizona, reported only a few water baskets being produced and even fewer burden baskets. They described the burden baskets as being used for gathering yucca fruit for syrup, carried on the back or strapped on either side of a horse.

The development of Navajo basketry has gone through four phases. The first phase, before 1868, is represented by only a few baskets found at such locations as abandoned campsites, and there is little written information about this period of Navajo basketry. Several Spanish accounts in the first half of the eighteenth century mention the importance of Navajo baskets as items produced for trade with the Spanish and other Indians (Vivian 1957, 149). Moreover, it is known that both baskets and pottery were a part of everyday life, since they were the only containers available for food and water.

In the second phase after the Bosque Redondo relocation in 1868, metal containers, including buckets and pans, introduced by Euro-Americans replaced the need for utilitarian baskets used for preparing foods. Coiled trays, however, were still made for such ritualistic purposes as bathing with yucca suds; storing religious articles and medicine; serving sacred cornmeal; drumming; and as part of the mask for Nine-night ceremonies (Tschopik 1940, 447). As these baskets began to be made exclusively for ceremonial use, their forms, designs, construction, and production methods changed. In addition, the number of pieces being made decreased during this period, with rug weaving replacing basket production as the most profitable enterprise.

During the third phase in the early twentieth century, fewer and fewer wedding baskets were made by Navajo weavers, while the demand for these ceremonial baskets made by San Juan Paiute and Ute weavers increased. The taboos placed on Navajo basketmakers are considered by Tschopik to be the main factor in discouraging production of such baskets among the Navajo. Some of the many restrictions on Navajo weavers were the following: they had to always work on the concave side of the basket, since it was believed that if they turned the basket over they would lose their mind; they could never allow a child to place sumac on the head for fear of stunting his growth; they must not sleep with their husbands while working on a basket; and they could not work on a basket while menstruating (Tschopik 1940, 259). Weavers feared that failure to take into account any of these taboos could cause injury or make a basket unacceptable for ceremonial use.

Important figures in the basket market at this time were the Anglo traders, who facilitated the exchange of baskets among various types of people. To some degree, this situation still exists on the Navajo Reservation, with traders buying used wedding baskets and selling them to both Navajo and non-Indian buyers.

In the fourth phase, beginning in 1966, developments occurred within a period of a few years to dramatically increase the number of Navajo basketmakers. These developments include the establishment of basket-making classes at the Rough Rock Demonstration School in 1966, the support of traders who promoted the craft, and the creativity of Navajo weaver Mary Holiday Black.

Records at Navajo Mountain Trading Post in 1971 show only five weavers who regularly sold baskets to the store. In 1978, however, the total baskets sold at Navajo Mountain, Kayenta, and Oljeto trading posts totaled nine hundred, representing the work of 105 weavers (McGreevy 1989, 41). It appears that a plateau was reached at around one hundred basketmakers during the late 1970s, since the same figures are reported in 1984 (Mauldin 1984, 35).

Production accelerated in the 1990s. During the 1970s, five-rod foundations began to be used, and there was also a proliferation of different sizes and designs of baskets. Weavers watched the work of others closely and improvised to create their own original designs. Attitudes toward restrictive taboos began to change as the Indian art market expanded to include more non-Indians. Moreover, the demand for the new designs increased as collectors encouraged innovation and recognition of the basketmakers as artists, which had seldom occurred in the past. Basket making, which had always been regarded primarily as a source of income for weavers, was now also becoming an expression of the artists' creativity, skill, and knowledge.

This renaissance in Navajo basket making, which is based on the resiliency and creativity of the weavers, was promoted by traders and collectors. One of the early supporters was Virginia Smith, the daughter of Stokes Carson, a longtime trader on the reservation. She and her husband purchased the Oljeto Trading Post from her father in the late 1950s. Interested in basketry, she encouraged weavers by paying good prices for their work and by displaying their work in her museum room attached to the trading post. Her collection grew to several hundred pieces before her untimely death in 1985. Other traders who have been very supportive include Allen Townsend of Inscription House Trading Post, Richard Lee of Kayenta Trading Post and later Lee's Trading Company, Russell Foutz of the Foutz family of traders, and Rose and Duke Simpson of Blue Mountain Trading Post and Twin Rocks Trading Post. The most prominent individual in the renaissance of Navajo basket making, though, is Mary Holiday Black, who has been instrumental in teaching many family and extended family members as well as experimenting with dyes and new designs.

Perhaps the greatest contributors to the revitalization of basket making are the Ute and San Juan Paiute weavers living in the Monument Valley–Navajo Mountain area of the Navajo Indian Reservation or at White Mesa near Blanding, Utah, who helped preserve the art for most of the twentieth century. They not only continued to make baskets after most Navajo weavers had stopped, but they demonstrated considerable creativity in their use of new designs and helped the Navajo to see the demand for baskets in the Indian art market.

Sumac is the preferred material for both sewing splints and foundation rods among all three tribes. Sometimes willow is used by San Juan Paiute and Ute weavers for the foundation, but Navajo weavers still prefer using sumac, explaining this predilection with statements like, "You will go blind if you use willow." Apparently, some taboos are still adhered to by Navajo basketmakers. Yucca sewing splints are occasionally used by the San Juan Paiute on utilitarian pieces in combination with sumac splints and rods, although weavers say the yucca is more difficult to work with because of its sharp edges. The bowl shown on page 78 was made for me in this manner by Lilly Whiskers Duran in 1995. The work surface of the piece is on the exterior, as it is with all bowl-shaped baskets made by the San Juan Paiute. The coiling is from left to right rather than the usual right to left.

In 1938, informants of Omar C. Stewart said they could not remember using anything but aniline dyes. In recent years, Mary Holiday Black and her daughter Sally have experimented with natural dyes but found them to be too time-consuming and therefore unprofitable. Today Rit dyes are commonly employed with occasional use of natural additives, like soaking splints with sumac leaves and branches to increase the intensity of blacks. When sewing materials turn yellow with age, weavers sometimes use Rit white to bleach them, making the surface a pronounced whitish color rather than the light beige of the natural plant fibers.

Although Navajo baskets of the last century usually employed a foundation of two rods and a bundle, a method that produced a very fine coil, in the early 1980s only a few baskets with this type of foundation were made in the Blanco Canyon area (Whiteford 1988, 39). Barry Simpson showed me a 1995 basket by Navajo weaver Elsie Holiday made in this manner with two sumac rods and a bundle of sumac splints. In the vast majority of trays presently made by Ute, Paiute, and Navajo, however, combinations of three, five, and occasionally seven rods are employed for foundations. It has been suggested that the use of three-rod bunched foundations was learned from the Havasupai and Hualapai or the Western Apache (Whiteford 1988, 23). On the larger baskets and those coarsely made, the bark is left on the sumac rods, while on finer pieces the rods are smaller with the bark removed.

Four-rod foundations are employed by Ute and San Juan Paiute weavers predominately. For such baskets three rods are placed side by side with a smaller one behind, and when the sewing strands are applied the tray has a stepped appearance on the inside with a smooth flat surface on the exterior. In the past, this has been an identifying feature of Ute baskets, most of which came from White Mesa.

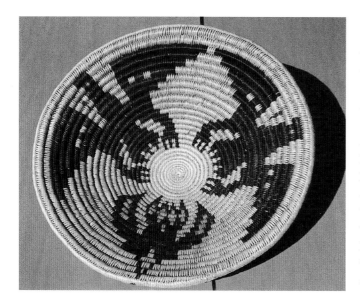

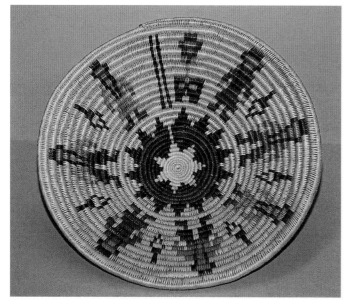

Water bottles and jugs are still produced in a variety of vase shapes and sizes. Most have horsehair handles attached and are waterproofed with piñon pitch applied in a very thin coat both on the outside and inside. They generally have either a two- or three-rod stacked, bundle, or combination foundation, and the stitches are spaced.

Weavers from all three tribes coil right to left from the work surface. The work surface is easily identified because of the regularity of its stitches and the smooth look and feel. On a good basket, this side does not have the split stitches and visible ends of cut stitches. When weaving, basketmakers hold the basket on edge in their lap with the work surface facing them. The left hand holds the rods in place, while the right hand holds an awl for punching a hole on the work surface. The sewing strand is then inserted in this opening and pulled through with the right hand. Occasionally a left-handed weaver works in the opposite direction. Several traders have said they set aside wedding baskets made in this manner since they are in demand by some Navajo medicine men. Moreover, Susan Brown McGreevy reports that baskets have historically been made in this manner for certain ceremonies. The baskets from these three tribes are made with noninterlocking stitches, which means the sewing splint passes through the lower cluster of coils between the two already existing stitches.

Basket rims can be finished in several different ways. In the past, pieces by these three tribes were usually completed with a false braid (herringbone) rim, which was also used by the Anasazi. This method of finishing rims is still commonly used, along with the method of using a "same stitch" or a combination of a same stitch plus overstitching with different colored strands. The herringbone finish is the most complex and time-consuming and forces the eye to focus on the design. The overstitched rim acts as a frame for the pattern and adds visual variety. The use of overstitching or same stitch has become very popular in recent years among San Juan Paiute weavers as they experiment with patterns other than the wedding design. Such treatment of rims is one fairly accurate identifying characteristic of recently made San Juan Paiute pieces.

The Navajo wedding design is by far the most frequently copied pattern on baskets. In this design, the center of the tray is always white and represents the earth or beginning of life. The

TOP: RACHAEL EYETOO'S CA. 1980S INTERPRETATION OF EAGLES—TWO FRONTAL POSES AND ONE FROM ABOVE. THE BEAKS ARE YELLOW, WITH SMALL AMOUNTS OF RED REPRESENTING FOOD. DIA. 21", H. 6". COURTESY OF THE BLUE MOUNTAIN AND TWIN ROCKS TRADING POSTS.

CENTER: PICTORIAL BASKET BY UTE/SAN JUAN PAIUTE WEAVER RACHAEL EYETOO, CA. EARLY 1980S. SHE USED ORANGES, REDS, YELLOWS, AND GREENS TO DEPICT UTE COUPLES ENGAGED IN A CIRCLE DANCE. NOTE THE BRAIDS ON THE FIGURES AND THE PATHWAY. DIA. 21", H. 5 1/2". COURTESY OF THE BLUE MOUNTAIN AND TWIN ROCKS TRADING POSTS.

RIGHT: BASKET BY UTE WEAVER MARY (WHITE) COLLINS. ONE OF THE EARLY WEAVERS TO BREAK AWAY FROM WEAVING ONLY MEDICINE DESIGNS (WEDDING), SHE USED THIS PATTERN ON SEVERAL OCCASIONS IN THE 1950S. DIA. APPROX. 13", H. 2". COURTESY OF THE BLUE MOUNTAIN AND TWIN ROCKS TRADING POSTS.

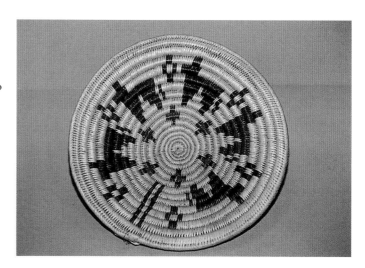

stepped black terraces denote the mountains or clouds, while the red band symbolizes the sun's rays or a rainbow. The break in the design (pathway) is related to the Emergence Myth, which describes the Navajo's evolution from previous worlds into the present one. The pathway is also an entrance and exit for the spirit, including that of the weaver (McGreevy 1989, 40).

⊕ U T E W E A V E R S Susan Whyte (1934–1994) was born in Allen Canyon to Mary Dutchie White and Okuma White. (Susan adopted this spelling of the family name.) Her great-grandmother on her mother's side was a Ute from northwestern Colorado who, along with other family members, fled south to San Juan County, Utah, after the Meeker Massacre. Her father was the son of Anson White (Mancos George), a truant and peace officer for the Indian school in Blanding. Born into a large family, she had two sisters and three brothers. One of her sisters, Rachael Eyetoo, is a basketmaker of considerable renown in the White Mesa community. As a child, Susan watched her mother, Mary White (also known as Mary Collins), make baskets while practicing on her own crude pieces. Her perseverance paid off when she was able to complete her first basket at age eight.

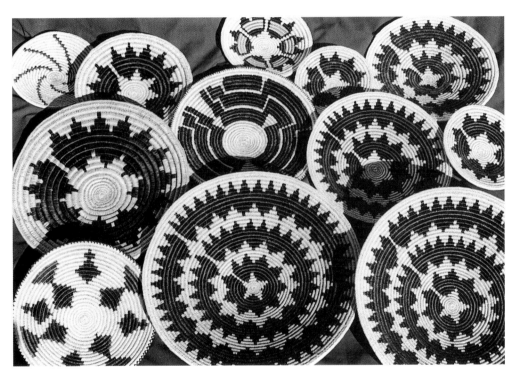

Baskets made by Ute/San Juan Paiute weaver Susan Whyte, ten of which were made in the 1990s. Copy of Navajo whirl design (upper left); yellow-and-black design with several pathways; copy of Anasazi design (middle); copy of Jicarilla design (bottom left). Baskets range in diameter from 9 3/4" to 20".

83

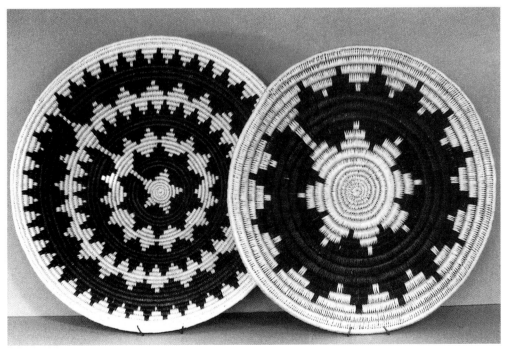

Medicine baskets by Susan Whyte. Tight-weave basket on left has a three-rod foundation, 1990. Dia. 20 1/4", H. 4 1/2". Rough-weave basket on right has a four-rod foundation, 1981. Dia. 18", H. 3 1/4".

During the late fall and before spring when the sumac was ready to be harvested, the family would travel from Allen Canyon high in the Blue Mountains down Cottonwood Canyon to Bluff, gathering sumac along the way. They often camped near Twin Rocks (now the site of Twin Rocks Trading Post) on the edge of town, where her mother would make baskets with the materials. Susan remembered how poor they were, one of the few sources of income being her mother's baskets. Each year the family moved several times between Allen Canyon, where they grew a garden during the summer, and White Mesa, where they wintered with their stock. Occasionally they lived in West Water for short periods of time because it was close to town (Blanding) and schools. When Susan was thirteen, they moved to White Mesa permanently, where a few years later, during the 1950s, the Bureau of Indian Affairs built houses.

Never married, Susan stopped weaving as an adult but continued spending summers in Allen Canyon, where she tended a garden and herded her sheep and goats. In the 1970s, she again took up basket making, and for the last twenty years of her life, Susan's skills as a basketmaker were unsurpassed in the area. She paid meticulous attention to the preparation of her materials, knowing precisely the best times to harvest plants for particular projects. She frequently used an exact formula for the design and structure of her pieces. According to this formula, the center red band was always three coils wide and the black step triangles on either side three coils wide, with the entire design totaling nine coils and ending two coils from the herringbone rim. While the size of the foundation coils varied, the nine-coil formula remained constant. She occasionally placed two or three sets of encircling designs on one basket but always kept the nine-coil formula.

Susan made two types of baskets that she called "rough" and "tight," the tight ones being her finest quality of work. Her designs always remained within the confines of what are termed Navajo ceremonial or wedding baskets; however, she frequently made some slight artistic variation. Like many other Ute weavers, she referred to them as medicine baskets.

Susan's rough-weave medicine baskets usually were made in two sizes—those with a diameter of eighteen to twenty inches and a smaller version about thirteen inches. The larger baskets started with a single-rod foundation and increased to four rods for the last two-thirds of the piece. The use of four rods on these pieces creates a stepped appearance on the inside surface of the baskets (page 83, bottom). This is an identifying characteristic of many Ute baskets produced at White Mesa. Susan's baskets are very sturdy. The bark was frequently left on the foundation rods of her rough baskets but was removed on her tight baskets.

Susan's tight baskets are of exceptional quality, with each coil perfectly rounded with the foundation rods scraped to the exact desired size and every stitch placed with precision. A typical basket by her with three sets of encircling design elements, twenty inches in diameter, has a total of thirty-four coils, with nine to ten stitches and three to four coils to the inch.

During the early 1990s, Susan made four baskets for me that were different from her other work: a water jug and three trays, including Navajo, Jicarilla Apache, and modified medicine basket designs (page 83, top). She was enthusiastic about this experimentation with new shapes and the placement of new designs on each piece.

Rachael Eyetoo (1926–1996) is the half sister of Susan Whyte. Her mother, Mary White, was Ute, and her father, George Eyetoo, was part San Juan Paiute and part Navajo. George's family migrated north to the Blanding area from Navajo Mountain on the Utah–Arizona border. While Rachael was born at White Mesa, she lived at different times of her life in West Water, Allen Canyon, White Mesa, and Blanding, where she attended school and graduated in the mid-1940s before marrying Harry Lang and raising three children.

Rachael, who learned to weave from her mother, completed her first basket when she was thirteen. She vividly remembers the basket, which was sold at the trading post in Allen Canyon for seventy-five cents. From an early age, Rachael used pictorial designs on her baskets. Her curiosity and artistic ability enabled her to remember images of humans, insects, and animals seen in schoolbooks and employ them in her weaving. Both she and her mother were early pioneers in the use of pictorial designs executed in bright colors. Pictorial baskets woven by Mary White have been dated to the 1960s, although she probably made others earlier. These baskets were quite popular among non-Indians. It is not clear which one was the originator, probably Mary. Rachael says her mother's designs (other than the wedding design) always consisted of horses or dogs. The three baskets by Mary that I have observed all had four or five horses with long tails surrounded by small crosses above and below with a pathway leading to the ending coil on the rim (page 82). While Ute and Paiute weavers made wedding baskets to be sold to the Navajo and the few interested tourists, these two women had begun experimenting with patterns that would not appear on Navajo-made pieces for another twenty or thirty years.

It is interesting that while Mary White's pictorial baskets do not look like Navajo ceremonial pieces, they always have a pathway.

Rachael started making baskets in the early 1940s but none of her early work can be identified and she cannot remember when she started using different designs. It is very likely that she started fairly early in her career. Frequently her designs cover almost the entire surface of the piece. They are expansive, pushing beyond the physical boundaries of the piece, and they reflect little of the controlled balance often seen in the work of others. She was not afraid to experiment with new dimensions or perspectives of her subjects and continually attempted to discover new ways of representing forms. This remained her primary interest, while the preparation of materials and attention to structural detail were of secondary importance.

FACING PAGE: SAN JUAN PAIUTE WEAVER ANNA WHISKERS, TUBA CITY, ARIZONA, OCTOBER 12, 1996. SHE HAD NOT SEEN THIS BASKET SINCE SHE SOLD IT TO STUART HATCH IN THE EARLY 1960S. THIS BASKET IS ALSO SHOWN ON PAGE 85.

84

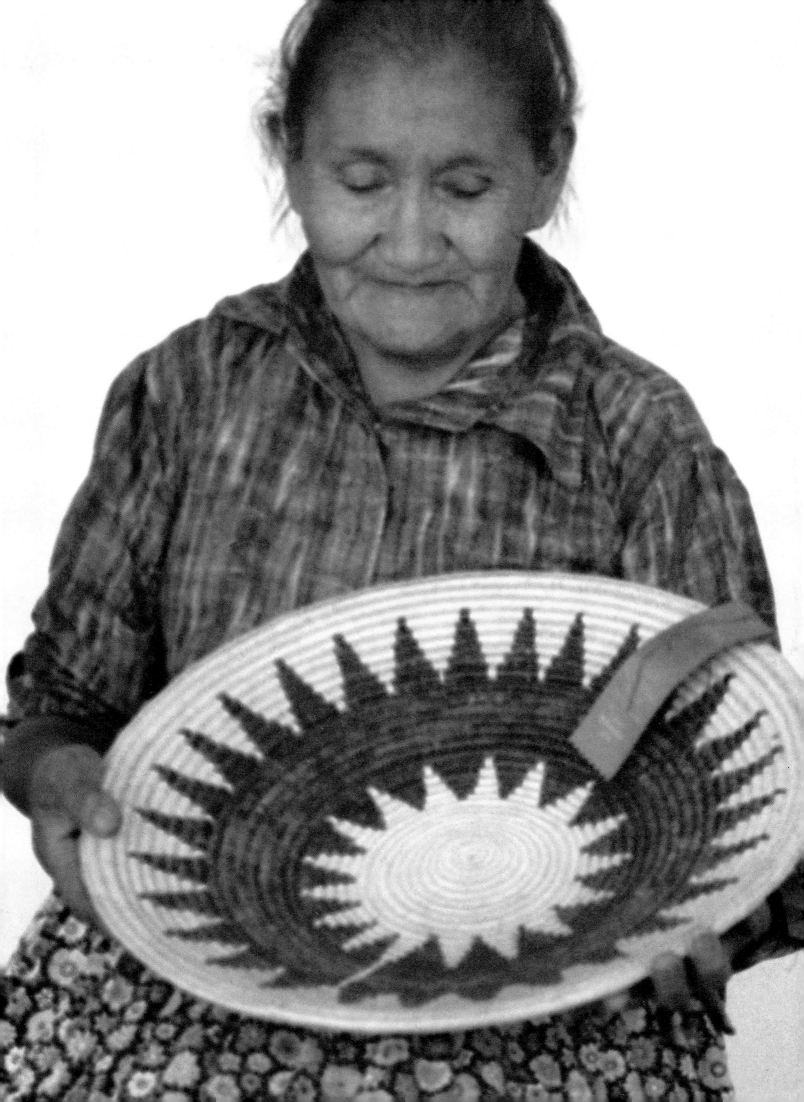

Located sixty miles apart, two distinct communities of San Juan Paiute live on the western portion of the Navajo Reservation. The most southerly location encompasses spring-fed lands along the Echo Cliffs and the town of Tuba City nearby. In recent years, many Paiute families have moved to Tuba City, where they live in modern mobile homes with all the conveniences of town life.

The second group continues to live in a very isolated area on the northeast side of Navajo Mountain, where they continue herding and farming.

The life-style of both groups has probably changed more in the last twenty years than in the previous one hundred. A 1985–86 exhibition at the Wheelwright Museum of the American Indian in Santa Fe helped bring attention to their plight as well as to their basketry, and federal recognition of the tribe in 1989 provided them with some financial help.

For most of the twentieth century, the sale of baskets has been the major source of income for the San Juan Paiute, and it continues to be important. Unlike the basketry of other tribes, during most of this century their weaving has been influenced more by other Indians than by non-Indians. The emphasis on different patterns other than the wedding design only began to evolve in the

1970s with the encouragement of trader William Beaver. Some of my favorite baskets are those made by the San Juan Paiute. Master weavers, they can make all types: traditional utilitarian pieces; large or small trays; pieces with four-rod foundations as well as three, five, and seven; and both old and new patterns.

Anna Whiskers, Helen Lehi, Grace Lehi, and Mabel Lehi were well taught by their mother, Marie Lehi. Anna Whiskers's daughters, Cecilia Long, Rose Ann Whiskers, and Evelyn James, also know how to weave, as does Helen's daughter Marilu Lehi.

An old basket made by Anna Whiskers in the early 1960s (page 85) has a wedding pattern that is eighteen coils wide with a slight convex center so it sits perfectly level. It has a three-rod foundation and fourteen stitches and five coils to the inch. The basket Grace Lehi is holding (below) is a copy of a design Rose Ann Whiskers made (opposite) on a smaller piece. Grace Lehi constructed hers with a foundation of four rods, whereas Rose Ann Whiskers employed three rods. One of the best ways to identify any type of coiled basket is to ascertain the structure of the foundation. It is interesting to note that San Juan Paiute and Ute weavers are the only ones who use a four-rod foundation. Navajo weavers use combinations of three, five, or seven. Rose Ann's small butterfly basket has twenty stitches to the inch and seven coils. Both she and Grace produce some of the finest work presently done.

The San Juan Paiute weavers living on Navajo Mountain also produce spectacular work, including Maryanne Owl and her daughter Susan Owl; and Bessie Owl, her daughter Edith King; and her grand-daughters Natalie King Edgewater and Ruth King. One of my favorite types made by this group is a three-inch-deep bowl made by Bessie Owl in 1986. The pattern, which appears to be rather old, was used earlier by another weaver on a basket in the Fred Harvey Collection. It is doubtful Bessie Owl saw this basket, but she must have seen others with the design.

In recent years, Natalie King Edgewater, a young woman, has emerged as a premier basketmaker. Not only does she pay careful attention to the preparation of her materials, but her stitches are consistently tight and even. Her designs, many of which have been used by other Paiute weavers, reflect innovative variations. Her work is readily recognizable because of her consistent fine stitching that creates clearly delineated patterns (opposite).

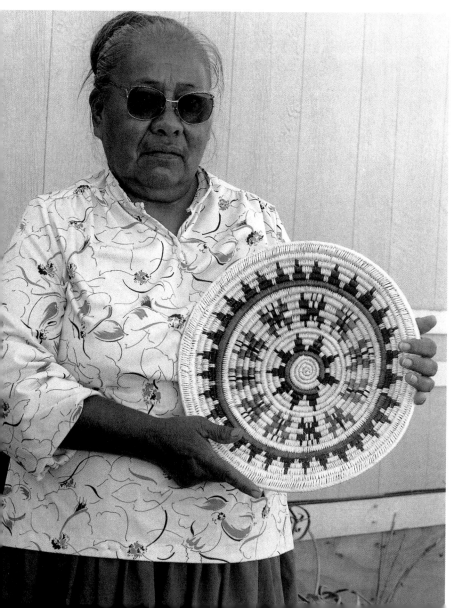

SAN JUAN PAIUTE WEAVER GRACE LEHI WITH A BASKET SHE MADE FOR THE AUTHOR, TUBA CITY, ARIZONA, NOVEMBER 21, 1995.

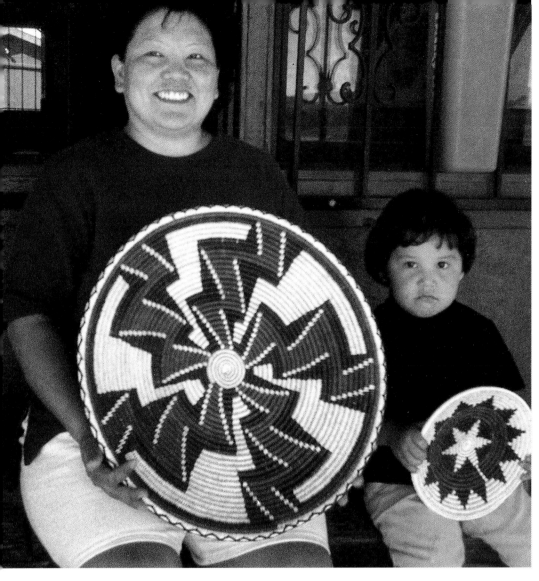

San Juan Paiute weaver Natalie King Edgewater at Sacred Mountain Trading Post. The very old design she used on this basket is one that has become synonymous with the weavers in her family. Made in 1998. Dia. 22", H. 4". Collection of William Beaver. Photograph by William Beaver.

Two San Juan Paiute baskets with the same design, the larger with a four-rod foundation and the smaller with a three-rod foundation. (from left) Rose Ann Whiskers, ca. 1990, Dia. 7 1/8", H. 1"; Grace Lehi, 1995, Dia. 13 1/2", H. 2 1/2".

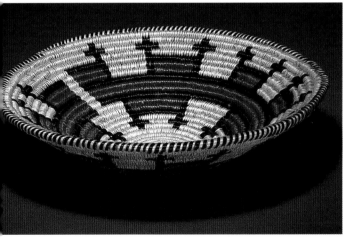

Basket made in 1986 by San Juan Paiute weaver Bessie Owl. This old design appears to be a modified wedding pattern with crosses added. Rose Ann Whiskers used a similar pattern on a basket in 1983. Note the same stitch rim finish alternating black and white. Dia. 15 1/2", H. 3".

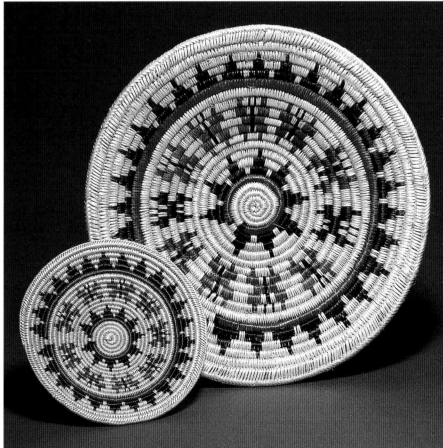

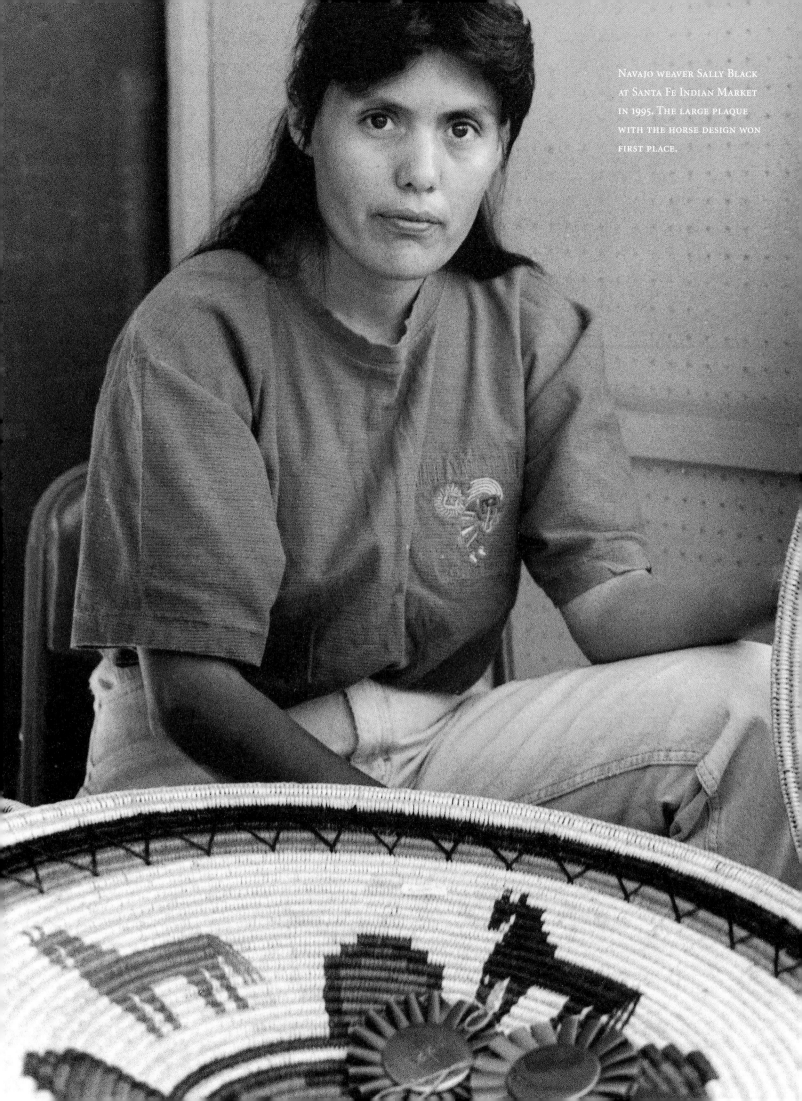

Navajo weaver Sally Black at Santa Fe Indian Market in 1995. The large plaque with the horse design won first place.

NAVAJO WEAVERS Mary Holiday Black has had a profound impact on the growing recognition of Navajo basket making and the revitalization of this art among the Navajo. Because she had a number of medicine men in her extended family, she learned to make *ts'aa'* (wedding baskets) to supply their ritual needs. She has taught nine of her eleven children to weave baskets. Her eldest daughter, Sally Black, was the first of her children to gain recognition for her work, and now others in the family are also being recognized for their artistry. Mary Black's creative genius and leadership have made it possible for other weavers in the area to sustain themselves economically in a region that provides little opportunity for work. Along with her daughter, Sally Black, she has demonstrated that a demand for baskets exists outside the Navajo community and that weaving can be profitable.

Virginia Smith of Oljeto Trading Post was one of the first to encourage Mary and Sally Black to weave baskets of different designs, shapes, and sizes (McGreevy 1989, 42). One of the earliest large pieces made by Mary Black, with a diameter of forty-six inches and a height of ten inches, was commissioned by Duke Simpson of Blue Mountain Trading Post (right). Made in the mid-1970s, the piece has a single wedding pattern. The basket pictured on page 90, made by Mary Black in early 1983, shows twelve yei-be-chei figures emerging from the traditional wedding pattern. Another basket made by Mary, almost identical to this one, was once on display at the Oljeto Trading Post Museum. She said these two baskets were the first ones she made with the yei design, and they are excellent examples of her early experimentation with patterns other than the traditional wedding design.

The images of these holy yei figures had been employed on rugs for years, but their use in conjunction with the sacred ceremonial design was frowned upon by many Navajo. The weaving of large wedding baskets not intended for ceremonial purposes, and the portrayal of holy people on a basket tray caused great concern among medicine men and traditional Navajo (McGreevy 1989, 43). Current-day designs depicting sandpainting and folktales on basketry trays are being criticized by many Navajo. It is not clear exactly what impact these attitudes have had on these early innovators, but the profit both Mary and Sally Black have received along with the popularity of their baskets have paved the way for more men and women to take up basket making.

The recipient of the Utah Governor's Award in 1993, Mary Black has acted as role model and innovator for over a dozen weavers in the Douglas Mesa area who are profiting while gaining recognition for their work. In addition, Mary Black's leadership has helped free basketmakers of many of the earlier restrictions placed on them by traditional Navajo society, causing this traditional art to explode with innovation.

In 1995, Mary was one of twelve recipients selected to receive a National Endowment for the Arts Fellowship (NEA). Jane

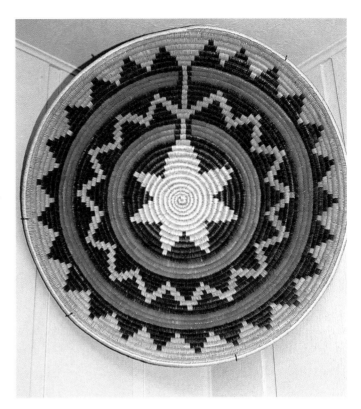

THIS HUGE BASKET DISPLAYED ON THE WALL AT THE BLUE MOUNTAIN TRADING POST WAS MADE BY MARY HOLIDAY BLACK, CA. 1975. DIA. 46", H. 10". COURTESY OF BARRY SIMPSON.

89

Alexander, director of the NEA, described the awards, saying, "Each of these extraordinary artists has tapped a great personal store of creativity to lead their communities in preserving and revitalizing traditions built by countless others"(Becenti 1995). This is exactly what Mary Black has done for basket making.

Sally Black was the first Navajo weaver to gain wider recognition by name among those involved in the Indian art market and collectors. Her prolific production and the size of her pieces combined with her unique yei and geometric designs all commanded public attention. She made her first basket when she was eight years old—a piñon-pitched water jug that sold for $15, which was an incentive for her to continue basket making. She explains that while her mother never directly encouraged her to weave when she was a child, she learned by watching her mother work.

In 1983, Sally Black participated in a symposium sponsored by the Museum of New Mexico comprised of basketmakers from throughout the Southwest, anthropologists, and others interested in basketry. Meeting other weavers, exposure to the Indian art market, and support from the symposium organizers helped her career as a basketmaker. In 1985, she was encouraged to sell her work at Santa Fe Indian Market, where her baskets were very unique among an array of artists selling pottery and jewelry. Consequently, she successfully sold all of them at premium prices, something that had never been accomplished by other Navajo basketmakers. She continues to participate in Indian Market and has encouraged other weavers to join her.

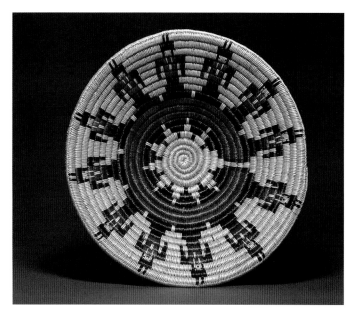

Always on the lookout for new challenging designs, Sally Black has employed a number of patterns usually associated with other tribes. Russell Foutz gave her photographs of his mother's collection of southwestern baskets, and the influence of Tohono O'odham, Akimel O'odham, and Western Apache designs was subsequently reflected in her work (McGreevy 1989, 42). She makes large plaques and ollas, frequently using both negative and positive areas of design on the same piece (below). Included in the patterns are people, dogs, horses, stars, frets, and squash blossoms. The sheer size of these pieces, combined with the stark contrast between black and white, creates a very dramatic artwork. Although baskets have always been used for decoration by collectors and others, Sally Black's baskets have been purchased as art, much the same as paintings. The interior design business with its focus on Southwest style has undoubtedly helped elevate basketry from a craft to an art in the eyes of the public.

Sally Black is part of a small but growing new generation of Navajo men and women who are professional basketmakers, talented artists who earn their living by their art. In addition to the coiled trays and plaques presently being produced, a lesser number of coiled vase-shaped baskets are also produced. Sally has made a number of these forms with designs, as have several other weavers, most notably Elsie Holiday. Three large extraordinary jars by Elsie were on display at the 1995 Gallup Inter-Tribal Indian Ceremonial.

Moreover, there has been a revival in the production of water bottles or water jugs made by the Navajo, types that almost disappeared among the Navajo for most of this century before again

BASKET WITH YEI FIGURES EMERGING FROM A WEDDING PATTERN BY NAVAJO WEAVER MARY HOLIDAY BLACK, CA. 1982. A SECOND ONE MADE BY BLACK WITH THE SAME PATTERN WAS IN THE OLJETO TRADING POST MUSEUM FOR MANY YEARS. DIA. 18", H. 5 1/2".

SALLY BLACK USED LARGE AREAS OF POSITIVE AND NEGATIVE IN THIS DESIGN, CREATING HER VERSION OF A PATTERN USED BY WESTERN APACHE BASKETMAKERS. (FROM LEFT) 1997, DIA. 21 3/8", H. 2 3/4"; 1995, DIA. 9 1/2", H. 9 1/2".

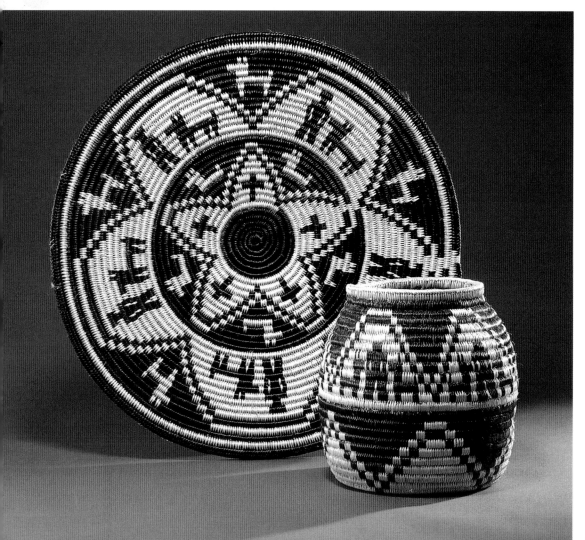

FACING PAGE: RENOWNED NAVAJO BASKETMAKER MARY HOLIDAY BLACK. SHE HAS BEEN THE CENTRAL FIGURE IN BRINGING ABOUT THE RENAISSANCE IN NAVAJO BASKET MAKING. PHOTOGRAPH BY EILEEN BENJAMIN.

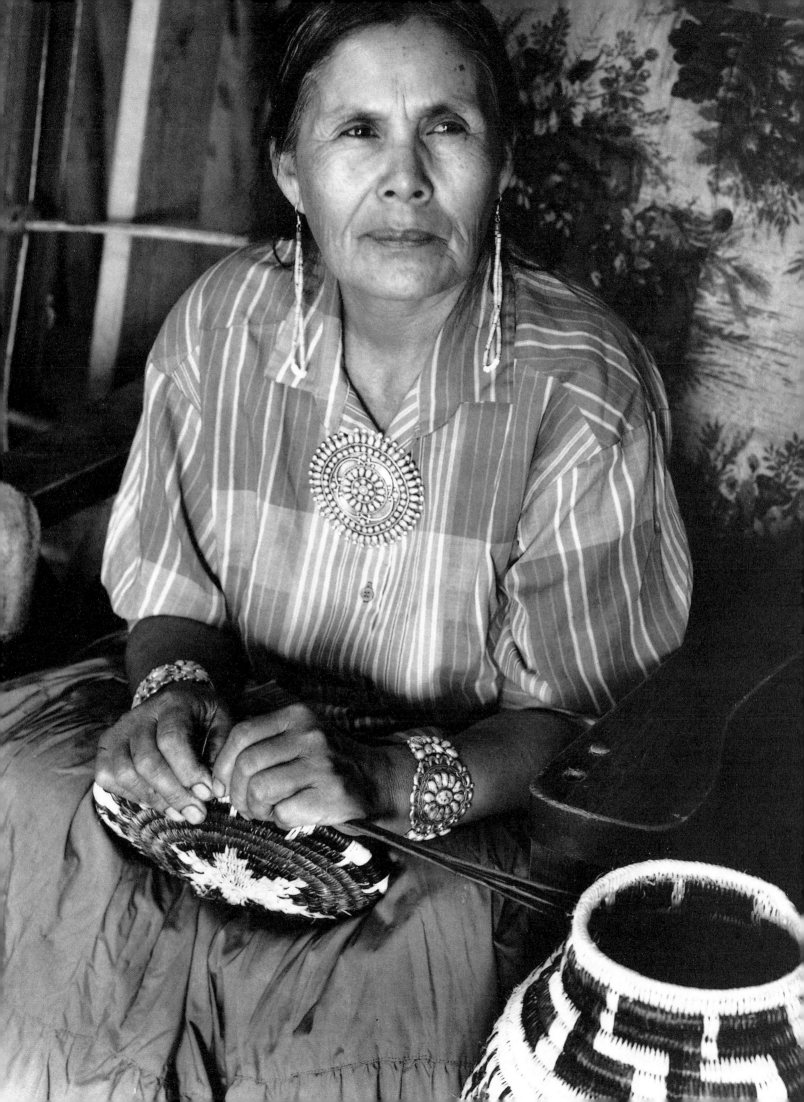

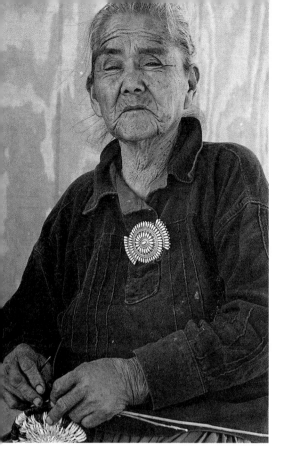

gaining popularity in the last twenty years. Relatively easy to produce, they are covered with hot piñon pitch. The only utilitarian baskets still made, although they are very different from the traditional pieces, many of them have a beautiful primitive quality. Their dark amber color, smooth glossy surface, piñon smell, and vase-shaped form combine to provide the collector and tourist with a piece of traditional folk art. Navajo weaver Etta Rock is the most prolific and enduring basketmaker who weaves this type of reproduction (above, right).

Fannie King is another contemporary Navajo basketmaker who is doing very fine work using traditional designs, including that of Spider Woman. Her bowl-shaped baskets are similar in shape to those made by Navajo weavers at the turn of the century. This shape complements the pattern because it adds a three-dimensional quality lacking in flatter pieces.

During the 1960s and 1970s, the Navajo Tribe promoted basket making by financially supporting several classes geared toward preserving the basketry tradition and giving participants a marketable skill. In 1964, the Economic Opportunity Act was passed, providing funds for demonstration projects in poverty areas. A proposal was presented to the Office of Economic Opportunity by the Navajo Tribe to implement a demonstration school run by a Navajo school board elected from the community. This was a revolutionary idea—a school run by the Navajo rather than BIA, the church, or a non-Indian public school district. In July 1965, the tribe received funds for the first year of operation of the school at Lukachukai, Arizona. The following year it was moved to Rough Rock, Arizona, where it has remained and is thus called the Rough Rock Demonstration School. One of the goals for the school was adult education, which included teaching English as a second language and implementing an arts and crafts program aimed at preserving traditional arts and training the Navajo to make a living

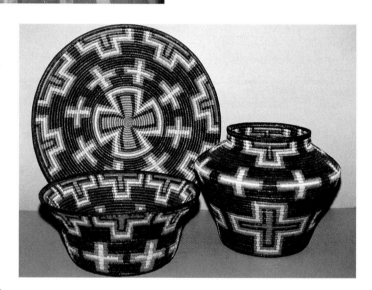

BASKETS BY ELSIE HOLIDAY DISPLAYING A CHIEF BLANKET DESIGN, CA. 1990S. TRAY: DIA. 21 1/4", H. 2 3/4"; BOWL: DIA. 15", H. 7"; OLLA: DIA. 14 1/2", H. 11 3/4". COLLECTION OF DR. AND MRS. E. DANIEL ALBRECHT.

producing them. Basket making was taught in addition to rug weaving, silversmithing, pottery making, sash weaving, and moccasin making. Trainees received a small salary while attending classes. Throughout 1969, the arts and crafts programs were very popular and extensive (Roessel 1977, 58). As Robert A. Roessel remarks: "During the first year, records kept on the graduates of the arts and crafts training program indicated that graduates more than doubled their income as a result of the training" (Roessel 1977, 11).

Bertha Austin (opposite), a Navajo woman from the Shonto area, and her daughter Mary Boone Martinez, were teachers at the school in the 1960s. They lived at Rough Rock while teaching the class, which was held six hours a day, five days a week, during the late fall and winter months. All of their students were Navajo women from around Rough Rock, who were taught how to gather and prepare materials and weave. Because of the scarcity of sumac in the area, students used colored yarn in place of sumac for sewing splints while they practiced.

The trading posts at Blanding and Bluff, originally operated by Rose and Duke Simpson and now by their children, are the center of a revival of Navajo basket making. The number of weavers participating continues to grow, with the majority coming from four families—the Rock, Black, Holiday, and Bitsinni families—that all have from one to several active weavers among them (see genealogy chart). This is in direct contrast to the 1970s and early 1980s, when, as Duke and Rose Simpson explain, the majority of baskets they were able to buy were made by Ute–San Juan Paiute weavers at White Mesa, with an occasional Navajo piece brought in by Mary or Sally Black. The wedding design was predominate on most early pieces, but gradually variations on it as well as new designs began to appear, including slightly modified wedding designs; wedding designs repeated two or three times on the same piece; wedding designs in combination with yei-be-chei figures; Western Apache and Pimian patterns; and images of rabbits, turtles, turkeys, deer, horses, dogs, eagles, and feathers. The sizes also began to vary, ranging from very small to very large. It is interesting to note that during this period as the number of baskets being produced by Navajo weavers increased the numbers made at White Mesa decreased.

The Simpsons encouraged creativity and quality from the weavers while providing payment for their work. They also established a demand for the craft by promoting it among the non-Indian public. Even though baskets had always been in great demand among the Navajo community, the inclusion of baskets as a part of the Indian art market was significant. Interested in all aspects of weaving, from gathering and preparing materials to construction and design, Barry Simpson and his brother, Steve, provided books, pictures, ideas, and the work of others to help stimulate the weavers' imagery. At the same time, it became obvious to them that Navajo basketry was also at a crossroads due to changes in Navajo society. No longer restricted to making ceremonial pieces or because of taboos, basketmakers were able to use their creativity and imagination in developing new designs, forms, and methods of construction rather than copying designs from other tribes.

Both Barry and Steve Simpson have encouraged basketmakers to continue to improve their art. Out of this partnership between artist and trader a unique concept has evolved—the idea that patterns on Navajo baskets should be both aesthetic and reflect the rich cultural heritage of the Navajo. Just as the wedding design on basketry provided considerable insight into Navajo culture, the depiction of Navajo creation stories on baskets opens up a whole realm of possibilities for basketmakers, allowing artists to express

their Navajo worldview through their creative imagery and therefore make products that are both culturally meaningful and salable.

In this new climate of creativity, the difficult technical challenge is converting an idea or legend into a design that can be placed on a circular surface. Because of the structural limitations of coiling, the weaver must conceptually develop new perspectives. To address this problem, in 1995 Barry Simpson hired a young Navajo artist, Damian Jim, to help develop designs for the weavers. Jim sketches designs based on Barry and Steve Simpson's research into Navajo legends and then scans the color image into the computer. The results are then printed on a laser printer with modifications suggested by the weavers. Then the printout is given to basketmakers for use as patterns, with individual weavers developing their own interpretations. Agnes Grey used one of these designs to win the Best of Category at the Gallup Inter-Tribal Indian Ceremonial in 1997.

The Navajo creation stories, which have been passed down through the centuries by oral tradition, have many different interpretations, depending on who is telling them, although the moral is usually constant. They explain the creation of the earth and the

Elsie Holiday is a very talented Navajo weaver who is willing to try new designs, forms, and methods of construction in her work. Photograph by Eileen Benjamin, November 7, 1998.

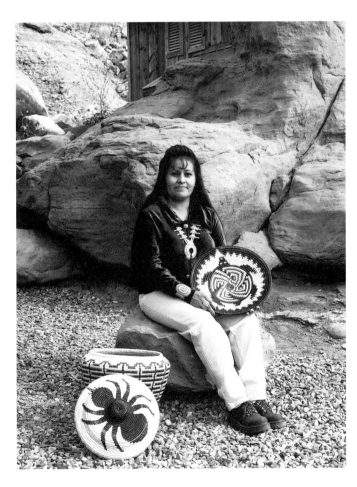

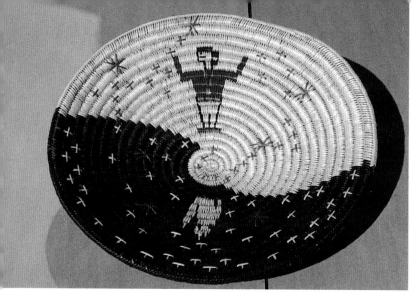

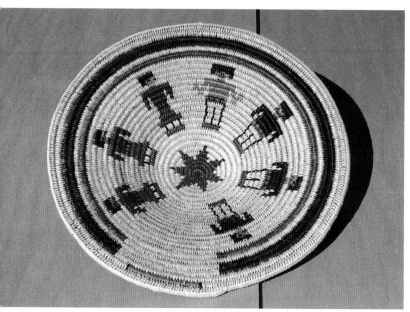

heavens, the Navajo's journey from past worlds into the present one, the relationships between men and women, and the triumph of good over evil. The designs on the baskets on this page and opposite are visual representations of some of these stories.

The design at left shows the creation of the universe. The light and dark portions represent day and night and also the positive and negative forces at work in human nature, which must be controlled to bring about a balance. First Man is shown carefully placing the constellations in the heavens in an orderly fashion, while Coyote does the same with three red stars before becoming impatient and blowing the remaining ones into the night sky. The heavens that we observe every night have this organized quality to them in addition to a chaotic quality that can be seen in the haphazard organization of the Milky Way.

The traditional Navajo house, the hogan, is the sacred center of the family unit. The design at left shows a red central star, which represents the hearth. The opening in the outer circle is the doorway, which always faces east. A short yellow line in the doorway is the winter sun; life begins each day with the rising of the sun.

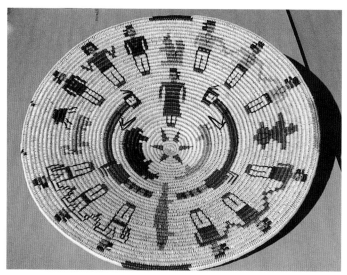

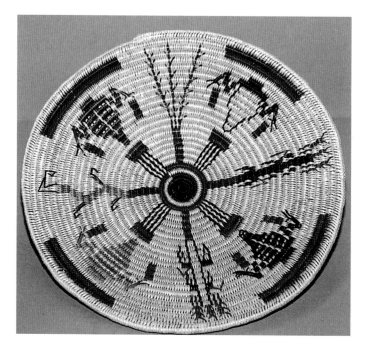

TOP LEFT: BASKET BY NAVAJO WEAVER PEGGY ROCK BLACK WITH A DESIGN THAT EXPLAINS HOW THE STARS WERE PLACED IN THE HEAVENS, 1993. DIA. 17", H. 3 3/4". COURTESY OF THE BLUE MOUNTAIN AND TWIN ROCKS TRADING POSTS.

BOTTOM LEFT: BASKET BY NAVAJO WEAVER MARY HOLIDAY BLACK WITH A DESIGN SHOWING THE TRADITIONAL SEATING ARRANGEMENT OF MEN AND WOMEN AND OF THE RESPECTED ELDER OR STORYTELLER INSIDE THE HOGAN, 1995. DIA. 19", H. 1 3/4". COURTESY OF THE BLUE MOUNTAIN AND TWIN ROCKS TRADING POSTS.

TOP RIGHT: SALLY BLACK HAS MADE SEVERAL BASKETS WITH THIS DESIGN DEPICTING THE LEGEND OF CHANGING BEAR WOMAN, 1993. DIA. 26", H. 1". COURTESY OF THE BLUE MOUNTAIN AND TWIN ROCKS TRADING POSTS.

BOTTOM RIGHT: NAVAJO BASKET DEPICTING A SANDPAINTING DESIGN USED FOR A CURING CEREMONY. MADE BY LORRAINE BLACK IN 1995. DIA. 17 3/4", H. 2 1/2". COURTESY OF THE BLUE MOUNTAIN AND TWIN ROCKS TRADING POSTS.

Opposite the door on the west is the position occupied by the respected elder or storyteller (certain stories could only be told in the winter). The south side of the hogan is reserved for the women, while the north is for the men. According to legend, the walls of the hogan include four essential elements: turquoise, white shell, jet, and abalone. The outer circles surrounding the figures are representative of these elements.

The basket below combines design elements from those on page 94. The story of First Man and Coyote creating the heavens is being told within the hogan. The storyteller is seated in the position of a respected elder in a yellow shirt (the sacred color of the west); the women wear blue, representing the south; the men are dressed in black, signifying the north; and the doorway is white for the color of the east. This design was the culmination of several baskets made by two weavers, with input by Barry and Steve Simpson and their brother-in-law, Amer Tumeh. In this design, the story about the creation of the universe is being told within a traditional hogan by an elderly man, a scene that could easily take place on a cold winter night around a bright warm fire, with a rapt audience of children.

The basket opposite (top right) relates the story of Changing Bear Woman. One of the most fascinating of all Navajo legends, it is a lengthy story of the triumph of good over evil. Changing Bear Woman is shown in the middle in a red skirt surrounded by the yei-be-cheis, her twelve brothers, and many of the animals who play an important role in the story.

Changing attitudes in the Navajo community in recent years have also allowed Navajo artists to begin using the sacred healing images of sandpaintings on baskets. Sandpaintings, which are used as part of a healing ceremony in traditional Navajo medicine, are usually executed on the earthen floor of the hogan by the medicine man using different colors of sand and minerals. After the ceremony, or sing, which frequently lasts several days, the design is destroyed. These religious designs have been passed down by medicine men from generation to generation either orally or in a book of drawings. The designs are now executed in colored sand on pressed wood, painted on muslin cloth and paper, or woven on rugs and baskets. The basket on page 94 (bottom) is one of the first pieces made with such an extensive healing design. In this design, used for healing rheumatism and arthritis, the dark center represents the emergence of the Navajo from the fourth world. Forced to escape the fourth world because of a flood, the four oblong designs radiating from the center represent logs caught in the vortex of a whirlpool. Four sacred plants are shown between the logs, representing corn, beans, squash, and tobacco. The four frogs between the plants are representative of water creatures, who play an important role in the creation story. The recent use of all these designs based on Navajo oral tradition has helped increase the range of creative expression in Navajo basketry

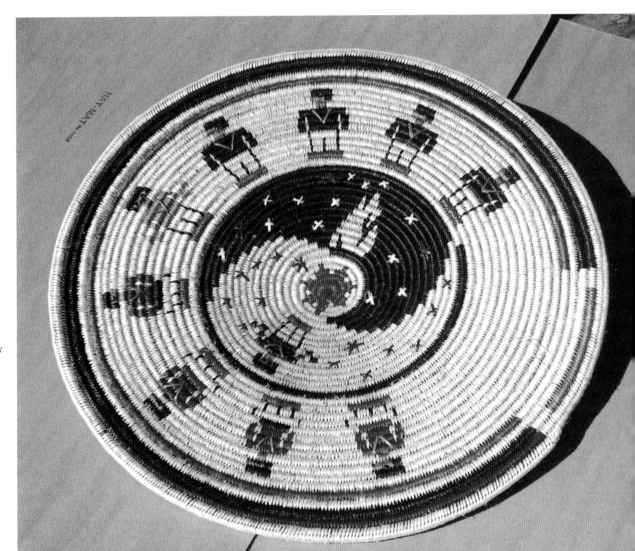

Basket made in 1995 by Peggy Rock Black. Dia. 25", H. 2 1/2". Courtesy of the Blue Mountain and Twin Rocks Trading Posts.

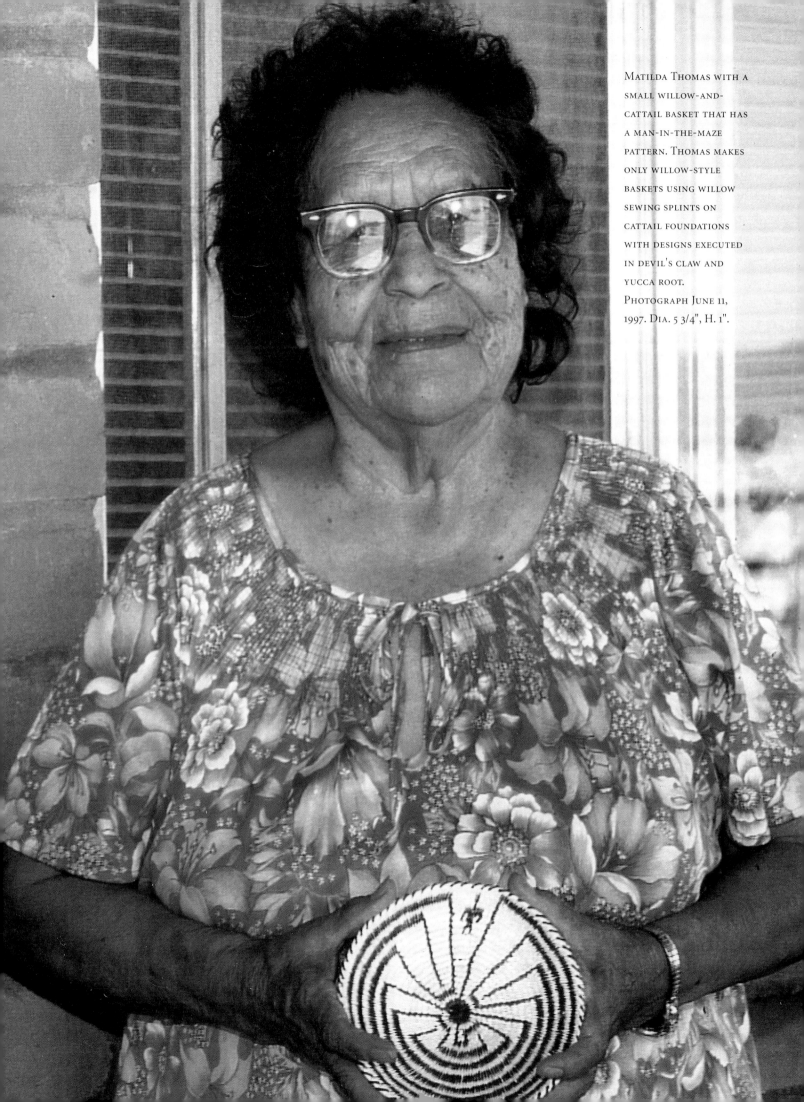

MATILDA THOMAS WITH A
SMALL WILLOW-AND-
CATTAIL BASKET THAT HAS
A MAN-IN-THE-MAZE
PATTERN. THOMAS MAKES
ONLY WILLOW-STYLE
BASKETS USING WILLOW
SEWING SPLINTS ON
CATTAIL FOUNDATIONS
WITH DESIGNS EXECUTED
IN DEVIL'S CLAW AND
YUCCA ROOT.
PHOTOGRAPH JUNE 11,
1997. DIA. 5 3/4", H. 1".

THE TOHONO O'ODHAM have several hundred weavers who produce more baskets every year than any other tribe in the western United States. Although these coiled baskets are made in a variety of sizes and have different types of construction, the majority of them are small plaques or shallow bowls that have been woven with spaced stitches in combination with other techniques that allow the bear grass foundation to be seen. While many of them are very intricately made, displaying a lacelike quality, others are quickly woven with greater distances between the stitches. A smaller group of basketmakers produces close-work coiled trays with squash blossoms, fret, and elder brother designs, along with new patterns. Moreover, the Tohono O'odham continue to make miniature yucca and willow pieces, as well as intricate horsehair baskets.

By contrast, the Akimel O'odham produce very few pieces, but the quality continues to be very good. The outlook for this group is, however, somewhat positive in that there are probably more Akimel O'odham weavers now than a few years ago.

HISTORY The Piman-speaking O'odham peoples of southwestern Arizona and northern Mexico have historically been referred to as the Pima and Papago. The Pima have always called themselves the Akimel O'odham (River People), whereas the Papago identify themselves as the Tohono O'odham (Desert People). Today, both tribes have officially chosen these traditional Piman names to identify themselves.

The prehistory of the O'odham peoples is vague, although they appear to be descendants of the Hohokam, who had thrived in the area earlier. There is conjecture between scholars as to what happened between the classical period of the Hohokam (A.D. 1450) and the arrival of the Spanish in the late seventeenth century. Several theories have been advanced regarding the decline of the Hohokam, including environmental deterioration and disease (Ezell 1983, 149–50). The information that we do have on the O'odham peoples dates from the arrival of

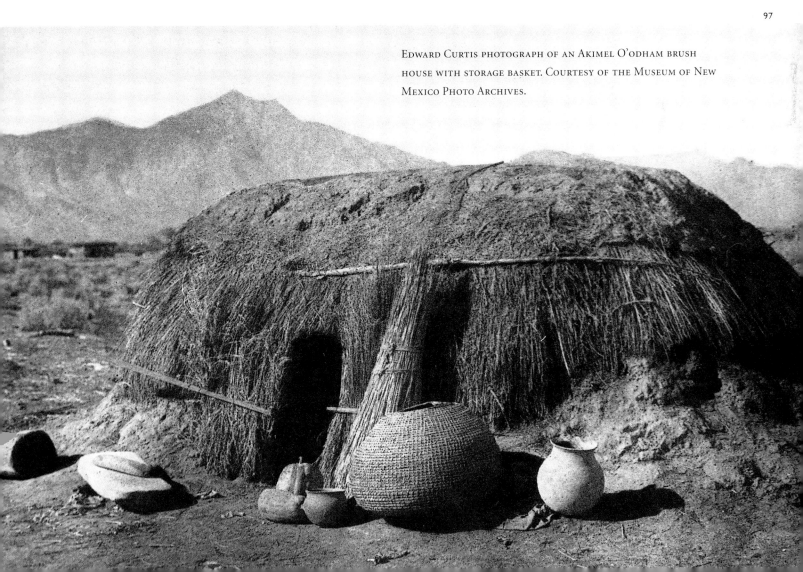

EDWARD CURTIS PHOTOGRAPH OF AN AKIMEL O'ODHAM BRUSH HOUSE WITH STORAGE BASKET. COURTESY OF THE MUSEUM OF NEW MEXICO PHOTO ARCHIVES.

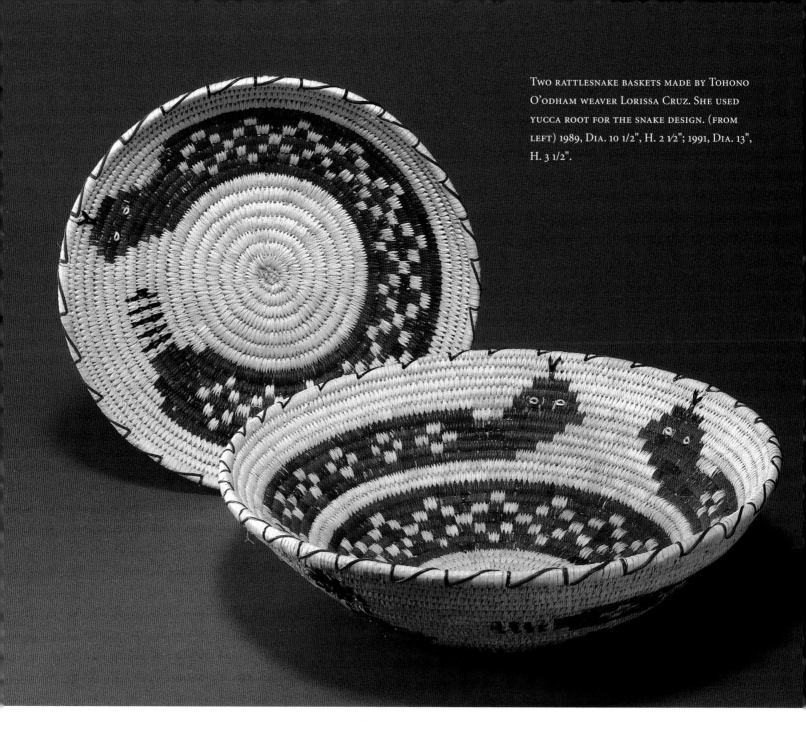

the Spanish. With the exception of the Pueblo Indians to the north and east, the O'odham lived in close proximity to Euro-Americans for more than 150 years before other tribes in the Southwest.

When the Jesuit missionaries led by Father Eusebio Kino arrived in southern Arizona in 1687, the Akimel O'odham lived in several large permanent villages along the Gila, Salt, and Santa Cruz rivers. They practiced floodplain and irrigation farming in areas adjacent to the river, along with hunting and gathering wild foods. Surrounded by the vast reaches of the Sonoran Desert, their riverine communities maintained a delicate balance with nature. By contrast, the Tohono O'odham lived in drier regions of the Sonoran Desert to the south and west. Lacking permanent water sources in the western regions, they were nomadic hunters and gatherers. In eastern areas where there was greater rainfall, they maintained winter villages in the mountains. During summers they moved to lower elevations near alluvial plains, where they could practice dry farming to augment their livelihood.

More than two dozen Spanish missions and stations were eventually established on O'odham lands (Fontana 1983, 137–39). The Akimel O'odham settlements along the Gila River were the first to experience changes introduced by the Jesuit missionaries, while those in desert regions had less contact with the mission outposts. While the O'odham people frequently resisted Spanish intrusions, they also became their allies in fighting the Apache. The acculturation that resulted from contact with the Spanish was gradual compared to the abrupt changes that occurred with the arrival of American settlers in the mid-nineteenth century.

The economy of the O'odham people was enhanced considerably with the introduction of wheat by the Spanish. With this new crop, the Akimel O'odham were able to produce a surplus that could be traded or sold. Moreover, the O'odham were introduced to wage labor through the establishment of ranching and mining activities in the region and their participation as scouts in the Apache wars.

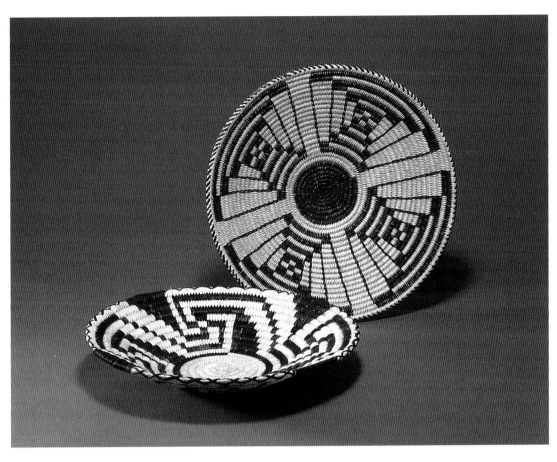

YUCCA-AND-BEAR GRASS
BASKET (LEFT) WITH
FRET DESIGN
INCORPORATING THE
ANCIENT SWASTIKA
MOTIF. IN OLDER WILLOW
BASKETS THE CENTER
WOULD BE DARK.
WILLOW-AND-CATTAIL
BASKET (RIGHT) WITH A
TURTLEBACK DESIGN.
THE MATERIALS USED IN
THIS PIECE WEIGH LESS
THAN THOSE IN THE
OTHER BASKET. (FROM
LEFT) 1983, DIA. 12 1/2",
H. 2 1/2"; 1986, DIA. 13",
H. 2 1/2". WEAVERS
UNKNOWN.

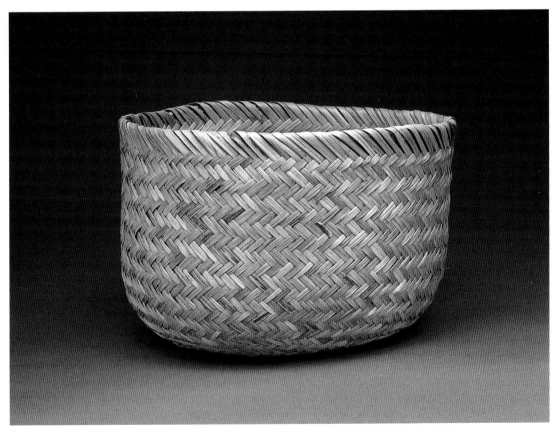

PIMIAN PLAITED BOWL
FROM NORTHERN
MEXICO BY MARGARITA
ROMERO. PALMILLA
SPLINTS WERE WOVEN IN
A DOUBLE THICKNESS
WITH A THREE OVER AND
UNDER METHOD. DIA.
11 7/8", H. 7 7/8".
COLLECTION OF THE
MUSEUM OF INDIAN
ARTS AND CULTURE/
LABORATORY OF
ANTHROPOLOGY.

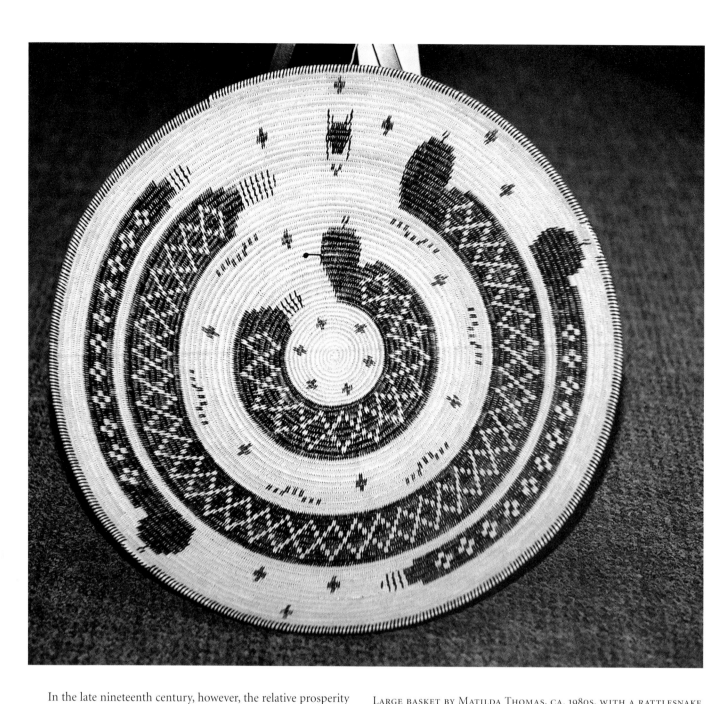

In the late nineteenth century, however, the relative prosperity that had come from wheat farming ceased as the O'odham began losing the precious water needed to irrigate their farms. This occurred after the Mexican-American War in 1849 and the Gadsden Purchase in 1853, when the United States gained control of most of their lands and large numbers of settlers began moving into the newly established Arizona Territory. By 1871, newly built canals and dams had diverted all the irrigation water used by Indian farmers to non-Indian farms, undermining the O'odham's ability to compete with non-Indian farmers and forcing them to become wage laborers (Ezell 1983, 159).

The result was catastrophic for the Akimel O'odham economy and the cooperation that had previously existed between their communities. When comparing the lush green suburbs of such localities as Phoenix and Chandler with the nearby Gila River and Salt River Indian Reservations, the most casual observer can recognize the boundary line between the barren Indian lands and the surrounding green farms and towns. A current exception to this situation is Ak-Chin Indian Community, which in 1988 settled

LARGE BASKET BY MATILDA THOMAS, CA. 1980S, WITH A RATTLESNAKE MOTIF. SEVERAL SMALL SNAKES CAN BE SEEN IN THE CENTRAL AREA. DIA. APPROX. 22", H. APPROX. 3". PRIVATE COLLECTION OF DENNIS AND NEVA KIRKLAND OF CASA GRANDE, ARIZONA.

a lengthy case with the United States government guaranteeing delivery of 75,000 acre-feet of water. After just a few years, thousands of acres of green fields have now replaced the once-arid terrain.

In the late nineteenth and early twentieth centuries, six reservations were established for the Pimans: the San Xavier, Gila Bend, Ak-Chin, and Tohono O'odham Reservation for predominately Tohono O'odham; the Salt River Reservation for Akimel O'odham; and the Gila River Reservation, which the Akimel O'odham occupy with the Maricopa.

SMALL CULTIVATED GARDEN OF DEVIL'S CLAW AT THE VILLAGE OF CHUICHU ON THE TOHONO O'ODHAM RESERVATION. THE PODS FROM THE PLANT ARE HARVESTED IN THE FALL.

Unlike the basketry of most tribes in the western United States, that of the O'odham has undergone two rather thorough fieldwork studies in the twentieth century. Mary Lois Kissell conducted research in 1910–11 and Margaret Shreve in 1941–42. During the intervening period, there were a number of changes in materials, methods of construction, and forms of baskets produced.

Kissell reports that while plaiting is one of the simplest techniques it is also one of the most important, ranking in production with coiling. The method provides mats for sleeping, eating, and drying foods and head rings for carrying ollas and loaded baskets. Plaiting was also used to fashion the headband and back mat required for carrying the *kiaha* (collapsible burden basket) and in the production of trinkets, clothing, medicine, and ritual items (Kissell 1916, 150).

The types of coiled pieces fell into three categories: crude, coarse, and close. Crude coiling was used on large baskets for storing wheat, corn, and mesquite beans, which, lacking a base, were placed on roofs or on the ground. Construction involved a bundle of twigs in a spiral technique with one element of the bundle encircling the whole, thus attaching it to the lower bundle.

Coarse coiling was used for large granary baskets by both tribes. They were made with a bundle foundation (warp) and sewing strands (weft), as is all coilwork. Stitches were sewn at periodic intervals, exposing the foundation, a method later described by Shreve as open-stitch. Wheat straw was used for the foundation, as was some bear grass and ocotillo. The sewing splints were willow, sotol, or occasionally other materials. These baskets were kept either in the house or in a storage shed. Close-coiled bowls and trays were important items in all types of food preparation and consequently were made in large numbers. They were made of tightly woven willow and cattail, and their hallmark was the dramatic contrast between a white background and an intricate black design that swirled outward from a central black vortex.

When Margaret Shreve conducted her study on basketry of the Tohono O'odham, she found that considerable changes had occurred in the thirty years since Kissell's fieldwork. Most households continued to use willow baskets, but those woven for sale were made of yucca. A few women were producing miniature baskets between two and four inches in diameter, and one weaver was making miniature horsehair pieces.

Plaited mats, which had been so important in households for such activities as eating and sleeping, were no longer used, having been replaced by manufactured dishes and beds. Although these pieces had comprised 50 percent of the total basket production in 1910, they now only represented 1 percent (Shreve 1943, 13). Only five women continued to make them for sale rather than for utilitarian purposes. The materials they used had also changed from the traditional sotol to yucca. Shreve's assessment that the technique of plaiting would probably not last much longer even though it was an old tradition in southern regions among the Tohono O'odham proved to be accurate. The New Mexico Museum of Indian Arts and Culture has one piece that was made in the 1950s by a Piman woman living in Mexico (page 99, bottom).

Shreve also discovered that the crude-coiled granary baskets used outside and discussed by Kissell were no longer being made, with the exception of a small replica produced for the Tohono O'odham Fair in 1941 (Shreve 1943, 13).

Shreve divided coiling techniques still in use into three categories: (1) spaced-stitch (with gaps between each stitch, exposing the foundation); (2) split-stitch (with a stitch in the above coil penetrating the stitch below), usually used in conjunction with spaced-stitch; and (3) close-stitch (with stitches buttressing each other and totally covering the foundation). The space-stitch indoor granary baskets, referred to by Kissell as coarsely coiled pieces, were no longer made. However, small spaced-stitch baskets used in households of the northern Tohono O'odham Reservation were made of willow sewing splints and cattail foundations. Although Kissell had not mentioned these, informants said they had always been made.

When women from this area started to make baskets for sale, they used these materials and this sewing method, in addition to the technique of intentionally splitting the wrap in the previous coil. The resulting patterns were more attractive to buyers. When weavers on the southern part of the Tohono O'odham Reservation began to make these baskets, they used a bear grass foundation and yucca sewing splints.

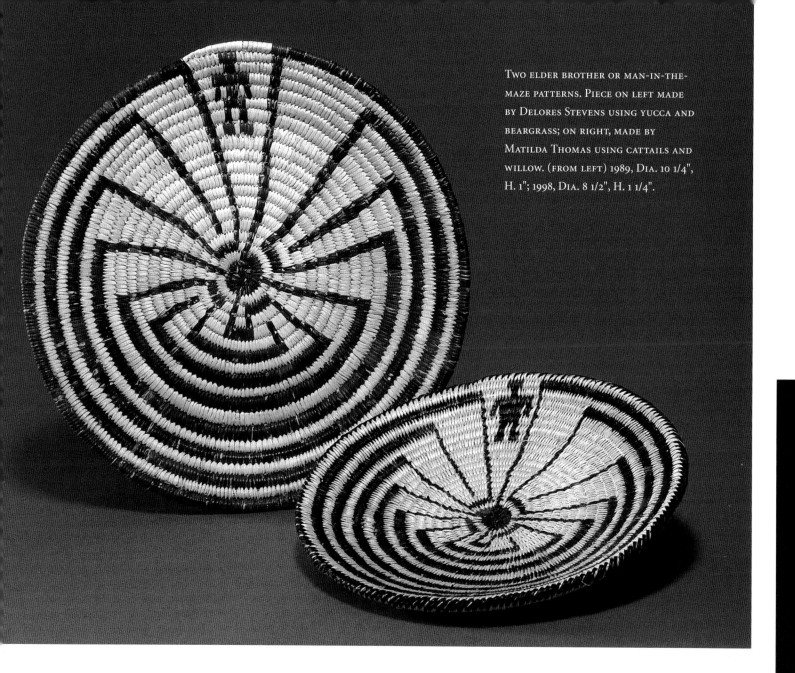

⊕ MATERIALS AND CONSTRUCTION

In the almost sixty years since Margaret Shreve's fieldwork, the technique of plaiting has been completely abandoned by O'odham weavers in the United States and possibly by those living in Mexico. Coiled baskets using a close-stitch of bleached yucca with designs of devil's claw, yucca root, and unbleached yucca are made with less frequency. Baskets employing a spaced-stitch in combination with a split-stitch and the addition of one stitch added to the right are now the most common type made (opposite). The split-stitch with the additional stitch on the right is called a wheat-stitch. The number of miniature horsehair pieces being made has increased dramatically since there is a ready market for them. Natural colors of horsehair, including black, brown, white, and red, are used, and both the warp and the weft of these pieces are made from the mane and tail.

Moreover, miniature yucca and willow pieces are still produced but with less frequency than those of horsehair. Such small baskets are not a recent innovation but have been made for hundreds of years. Mary Cruz has been among the most prolific weavers of these small yucca ollas and plaques, frequently using a rattlesnake pattern, while Rikki Francisco and Matilda Thomas make miniature ones using willow and cattail.

The gradual change from the use of willow to yucca that took place in the years between Kissell's and Shreve's studies occurred as a result of the increased market for baskets. However, the shift to the use of yucca probably began at an even earlier date in the southern regions of the Tohono O'odham Reservation. When sturdy willow baskets were no longer necessary for preparing foods, there was less need to make them. Additionally, yucca was readily available whereas willow was scarce on Tohono O'odham lands and had to be obtained from the Akimel O'odham. Thus, yucca baskets, while not as strong as willow baskets, were a practical substitute for the tourist trade. Foundation materials changed very little as the Tohono O'odham weavers had always tended to use more bear grass and yucca than cattail due to availability (Cain 1977, 32).

The use of a bundle foundation for coiled baskets is a technique that the O'odham people share with the Hopi. This type of foundation is far less common in the Southwest than the use of several willow, cottonwood, or sumac rods. Tribes in California and Alaska also use bundles of grasses for their foundations. The bear grass strips used by the Tohono O'odham are in some ways more difficult to work with because they are bulky and sharp edged. These baskets have flat coils rather than the round ones seen on others with bundle foundations because weavers pound the finished works between two stones to flatten the coils and produce smooth, attractive surfaces.

A variety of designs are used on contemporary close-stitch baskets made by both tribes, including friendship rings, the harvesting of saguaro fruit, landscapes, rattlesnakes, black widows and other insects, gila monsters, squash blossoms, the elder brother's house motif, and geometric patterns. While there is considerable creative energy being expended on the development of new patterns, there are fewer and fewer weavers who do the old fret, spiral, and squash blossom designs, designs characteristic of traditional O'odham basketry and that also occur on Hohokam pottery from an earlier time.

Tohono O'Odham basket by Barbara Havier using bear grass and yucca splints. The delicate floral design was created by using a combination of split-, wheat-, and close-stitching. 1982. Dia. 14 1/8", H. 3 1/8". Collection of the Museum of Arts and Culture/Laboratory of Anthropology.

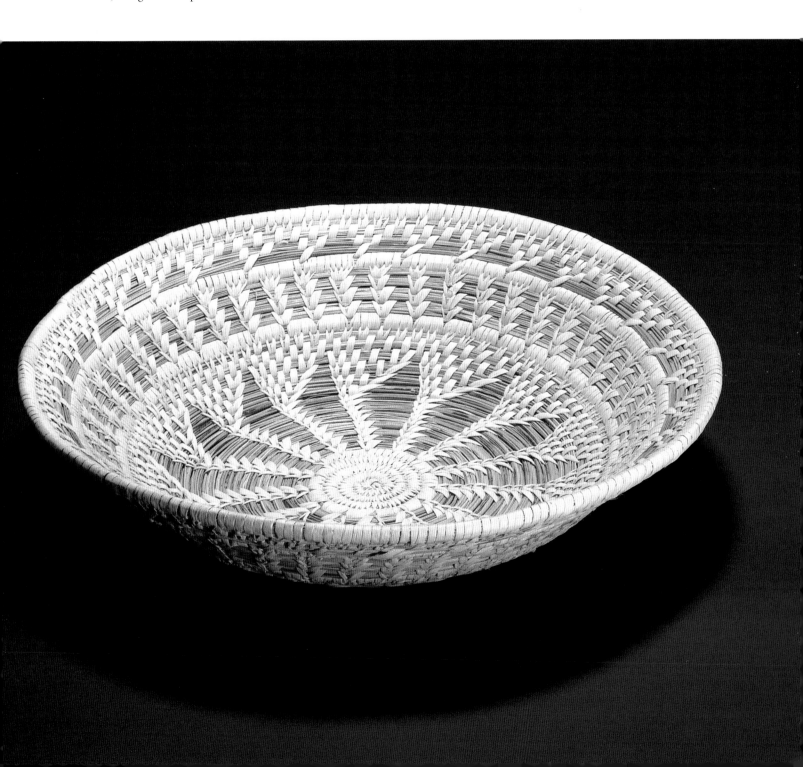

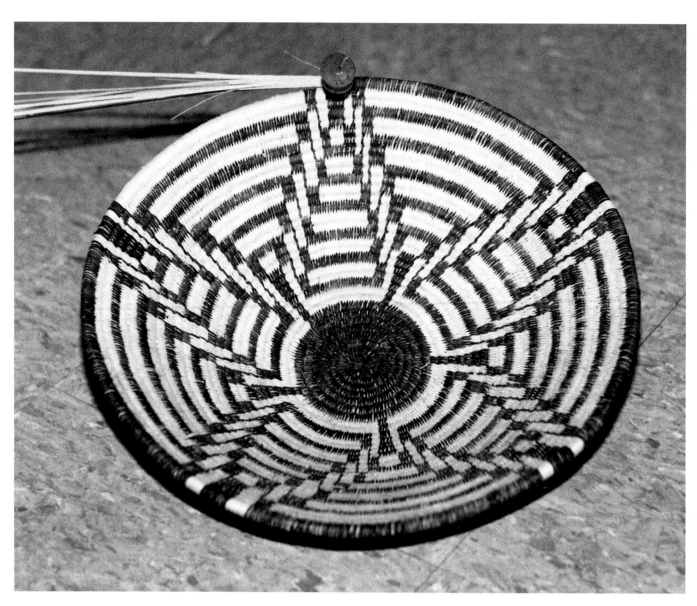

BASKET BY MATILDA THOMAS. NOTE
THE BUNDLE OF CATTAILS USED FOR
THE FOUNDATION (ABOUT TWENTY
SMALL STRANDS), AS WELL AS THE
DEVIL'S CLAW FOR THE CIRCLE IN THE
CENTER AND YUCCA ROOT FOR THE
REST OF THE PATTERN, APRIL 23, 1997.
DIA. APPROX. 14", H. APPROX. 3".

BASKET BY TOHONO O'ODHAM WEAVER
MARY ROMERO SHOWING A FRET
PATTERN EMERGING FROM A WHIRLING
VORTEX. SHE USED YUCCA AND DEVIL'S
CLAW ON THE PIECE, MADE CA. 1993.

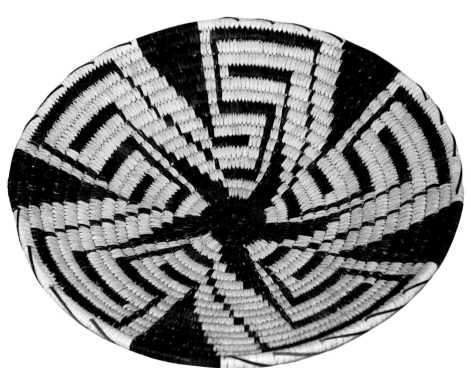

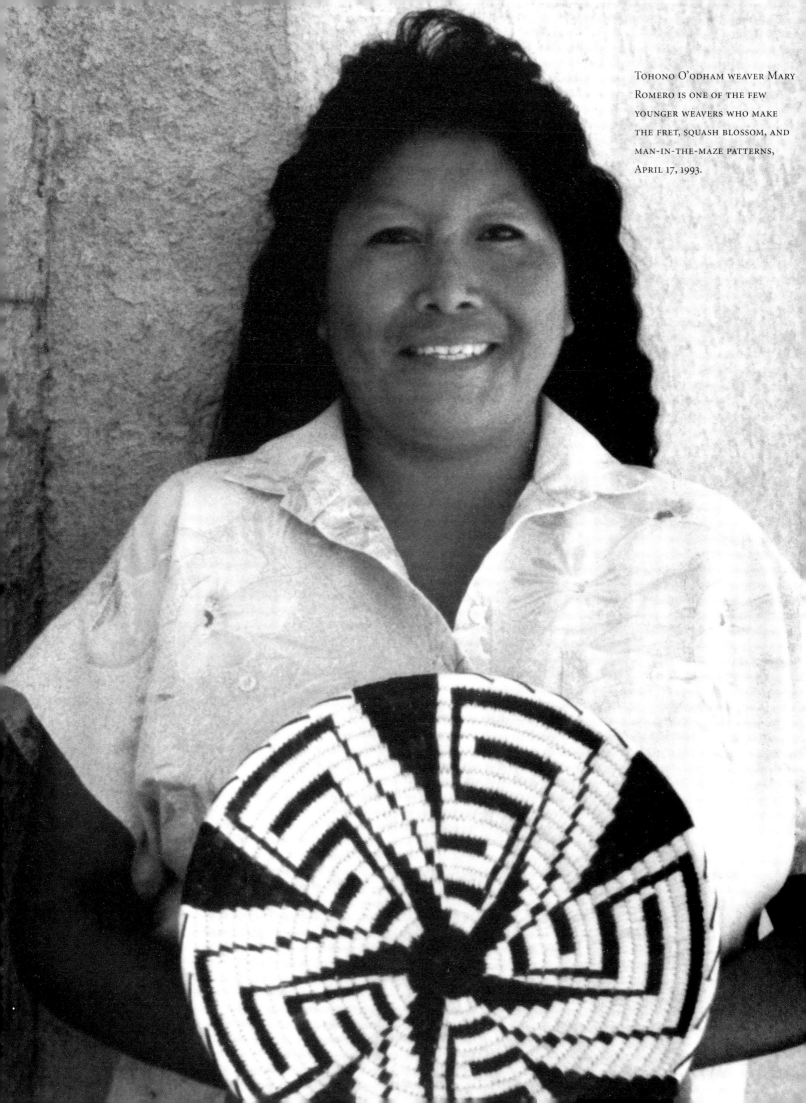

TOHONO O'ODHAM WEAVER MARY
ROMERO IS ONE OF THE FEW
YOUNGER WEAVERS WHO MAKE
THE FRET, SQUASH BLOSSOM, AND
MAN-IN-THE-MAZE PATTERNS,
APRIL 17, 1993.

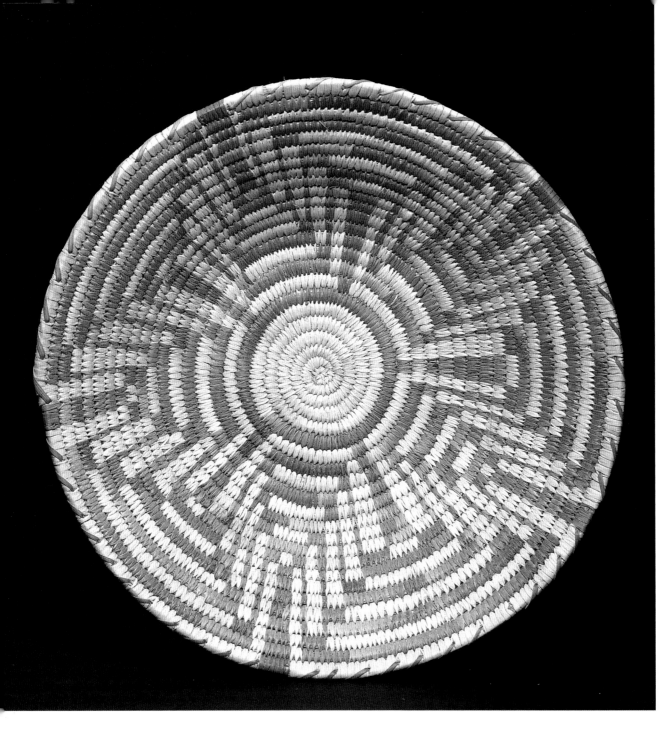

Five-petal squash blossom executed with bleached and unbleached yucca sewing splints by Tohono O'odham weaver Mildred Lewis, ca. 1989. The variation between the white background and light green pattern is very subtle. Dia. 11 1/2", H. 2 1/2".

BEAUTIFUL RATTLESNAKE BASKET WITH A PATTERN REMINISCENT OF
TURN-OF-THE-CENTURY MISSION PIECES FROM SOUTHERN CALIFORNIA.
MADE BY DELORES STEVENS, THE BASKET WAS DISPLAYED AT THE
ARIZONA INDIAN BASKETWEAVER'S ASSOCIATION GATHERING HELD AT
THE SONORAN DESERT MUSEUM IN 1998. DIA. APPROX. 14".

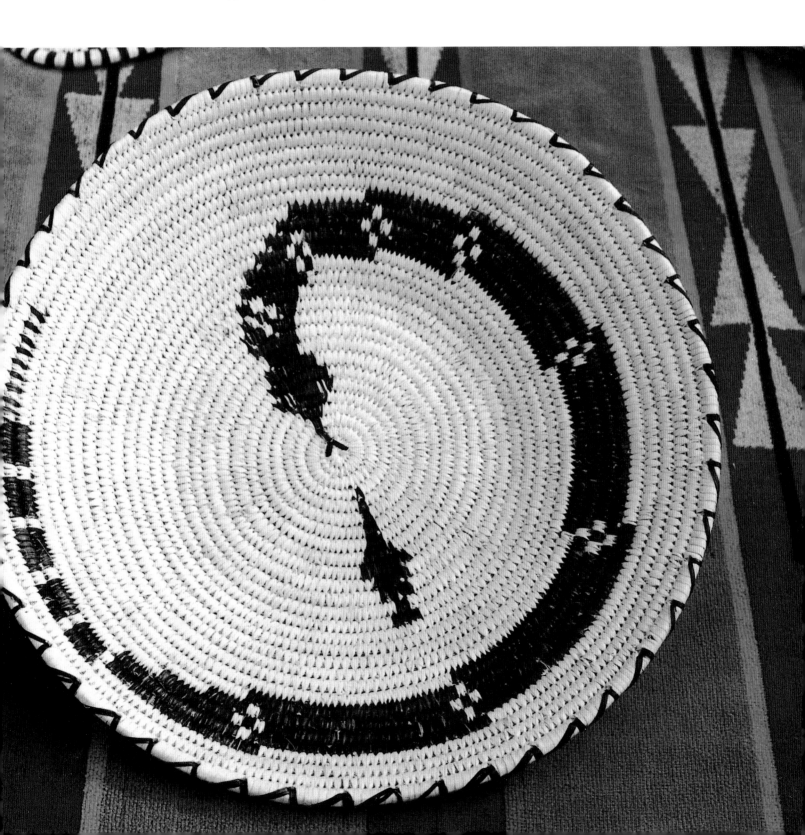

A few willow and cattail baskets are still made on the Salt River and Gila River Reservations, as well as on the northern part of the Tohono O'odham Reservation. They are identified as made by the Akimel O'odham or as "willow" baskets; however, it is not always clear whether these contemporary pieces are of Akimel or Tohono origin, and it is probably a mute point to attempt to identify them as one or the other for several reasons. During this century baskets made by the Tohono O'odham have been more innovative in form and construction than those of the Akimel O'odham, but weaving traditions have also continued to play a significant role in the types of baskets produced. For example, in the small community of Chuichu the production of innovative horsehair baskets has existed for many years concurrently with the making of more conservative close-stitch willow and cattail pieces. The continued use of these traditional materials at Chuichu could suggest that the identification by tribal origin of contemporary pieces is no longer applicable. Intermarriage has also introduced a homogeneity that justifies the terms "Piman willow" or "O'odham willow" for contemporary willow and cattail pieces.

Matilda Thomas (1918) lives in the small community of Chuichu in the northern part of the Tohono O'odham Reservation. Like many other women of her generation, she learned to weave at a young age. Her mother, Grace Thomas, who died when Matilda was very young, was a basketmaker who sold her work at the trading post in Sacaton.

Matilda Thomas makes beautiful coiled trays and shallow bowls using willow sewing splints over a bundle of finely split cattails. She has never attempted to make a basket of yucca and bear grass because she prefers to employ the same materials her mother used. During the winter of 1996–97, she produced baskets ranging in size from six to twenty-four inches and using yucca root and devil's claw either separately or in combination for several designs: squash blossom, fret, man in the maze, and friendship ring.

Over the years, Matilda has received recognition for her work at various shows, including the O'odham Tash in Casa Grande, the Gallup Inter-Tribal Indian Ceremonial, and an exhibition at the Heard Museum in Phoenix. Her impressive array of ribbons is displayed on the front room wall of her house.

She won blue ribbons at O'odham Tash in 1993 and 1994 with baskets more than twenty inches in diameter that had twelve-point squash blossom patterns (opposite). In late 1997, she discontinued making these large pieces, explaining that they were "too hard to make." Today, her baskets are smaller and include miniatures and ones ranging in size from eight and one-half to twelve inches.

Currently, materials are difficult to obtain, according to Matilda, who purchases her cattails and yucca root but grows her own willow and devil's claw in her yard. She taught me how and when to gather cattails and the process of cleaning, drying, and splitting them. Since I gathered them in northern Utah, I was not confronted with rattlesnakes, which, according to Rikki Francisco, are rather common in stands closer to the reservation.

There are also a number of other Tohono and Akimel O'odham basketmakers who are doing extraordinary work. Rikki Francisco (Akimel) and Annie Antone (Tohono) had several pieces in the "Deep Roots, New Growth" show of contemporary basketry at the Wheelwright Museum of the American Indian in 1998. Francisco's willow pieces were tightly stitched with red yucca root on a white background and had designs reminiscent of those used on Hohokam pottery. The yucca baskets made by Antone had motifs of an eagle and a desert landscape that included ocotillo and a gila monster. Her yucca sewing splints are so finely split that her designs have a circular look to them rather than the square appearance of patterns with a lesser stitch count.

Sadie Marks, who is a Hopi married to a Tohono O'odham man, weaves in the Tohono style, creating imaginative pieces that include open-work and close-work in combination with a variety of patterns and materials. The weaving of small figurines and animals has long been a hallmark of Tohono O'odham weavers, and these designs have never been better than those currently made by Delora Cruz and Ena Lopez. In addition, Tohono O'odham basketmakers Virginia Lopez, Edith Lopez, Delores Stevens, Christine Johnson, and Francis Stevens produce beautiful pieces in a variety of shapes, stitches, and patterns.

In recent years, an organization for marketing Tohono O'odham baskets has been established on the Tohono O'odham Reservation. Terrol Dew Johnson, a young man who is also a weaver, has been successfully directing the Tohono O'odham Basketweaver's Organization (TOBO). While the goals of TOBO are to revitalize and teach basketry, it also has the objective of helping weavers market their creations, since many parts of the reservation are very isolated. To promote sales and get better prices for weavers, TOBO either takes baskets on consignment or buys pieces before retailing them at various shows and functions.

In 1995, the Arizona Indian Basketweaver's Association was organized with goals similar to the California Indian Basketweaver's Association established in 1991. Weavers throughout Arizona as well as from Baja California, Mexico, attended the 1998 meeting of the organization at the Sonoran Desert Museum, with the majority of weavers present being Tohono O'odham and Akimel O'odham. At the event, a sales booth did a brisk business, and approximately twenty-five high-quality contemporary baskets that had been entered in a competition were displayed. Such events not only promote the art of basket making but also help dispel the myth that only old baskets possess quality or are collectible.

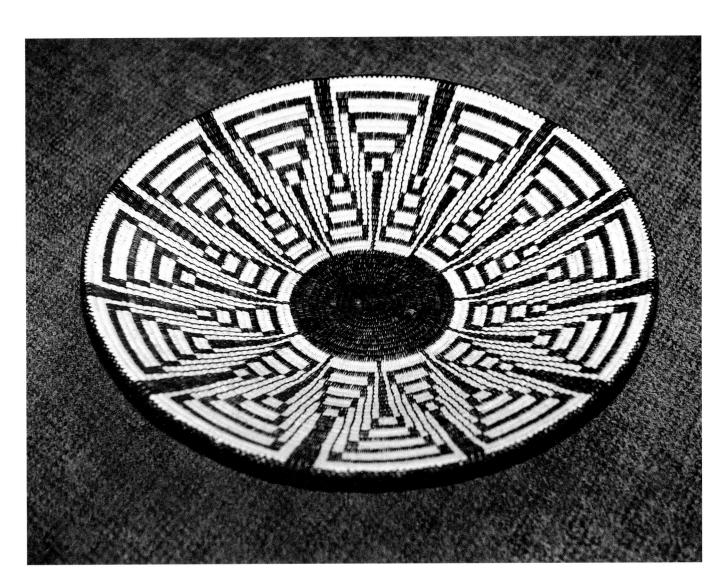

Large tray by Matilda Thomas that won a blue ribbon at the Casa
Grande O'odham Tash Show in 1994. The pattern is a twelve-point
squash blossom. Dia. 22", H. 3 1/2". Private collection of Dennis and
Neva Kirkland of Casa Grande, Arizona.

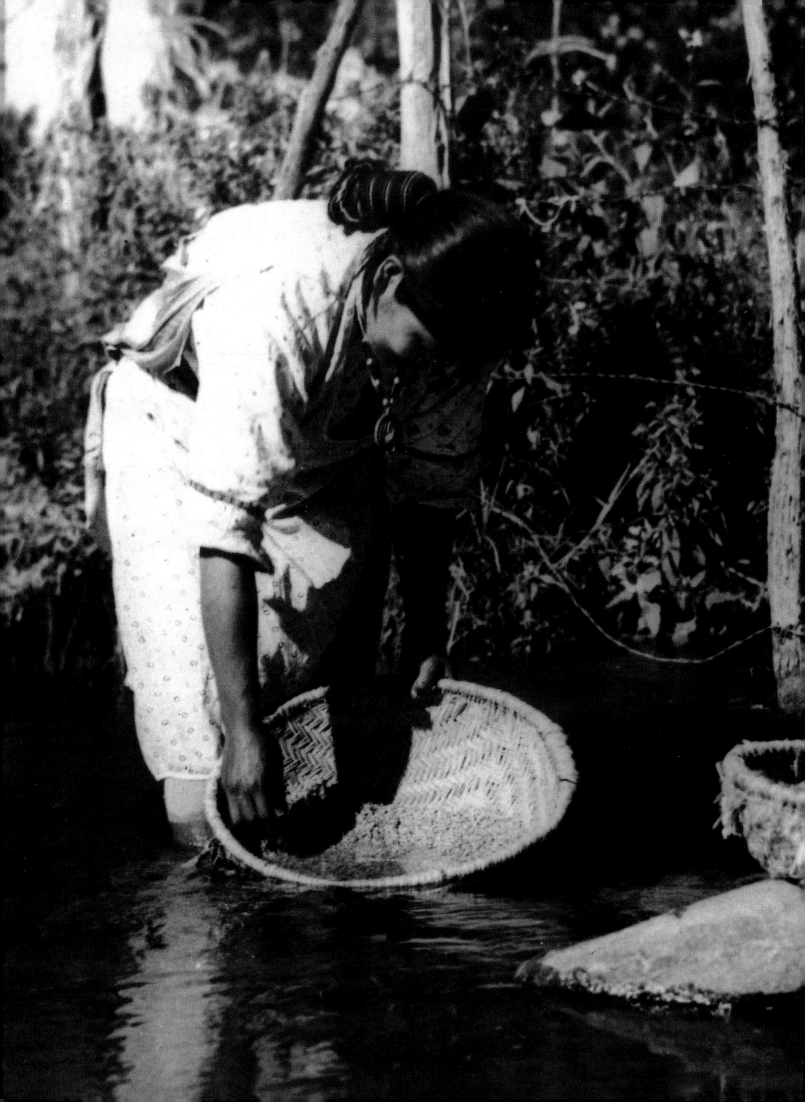

A T THE END OF THE TWENTIETH CENTURY basket making is seldom practiced among the Pueblo peoples of New Mexico. A few plaited wicker pieces continue to be made by male weavers and the yucca-ring sifter is still made at Jemez Pueblo and occasionally at one or two others. Coiled baskets are no longer manufactured. At the Hopi villages in Arizona, however, coiled and plaited basket making is actively pursued by many women, with the quality of the work equal to or surpassing that of turn-of-the-century weavers.

⊕ H I S T O R Y Unlike most Indian tribes in the western United States, Pueblo people of the Southwest have lived under the domination of Euro-Americans for more than four centuries. The first Spaniards to travel north from New Spain (Mexico) were led by Fray Marcos de Niza in 1593. They visited Zuni, claimed possession of the lands for the king of Spain, and quickly retreated, taking with them tales of the great wealth of the area. The next year Francisco Vásquez de Coronado's expedition left New Spain with an army of three hundred men and six Franciscan friars in search of the reported wealth of Cibola. They traveled first to the Zuni area, where a party was dispatched to Hopi, before continuing east to the Tiwa pueblos along the Rio Grande and to the Pueblo of Cicuye (Pecos). Although no gold was found, as a result of the expedition the horse was introduced to the area, ultimately transforming the life-style of many tribes.

In 1598, Juan de Oñate led a group of colonists to northern New Mexico, where they established themselves among the Tewa of San Juan Pueblo. In 1610, the colony was moved by Pedro de Peralta to the site of present-day Santa Fe. For the next seventy years, the Pueblo people lived under a repressive Spanish yoke. Especially repugnant to them was the Spanish attempt to replace their religion with Catholicism.

Enmity toward the Spanish finally resulted in the Pueblo Revolt of 1680, when the Spanish were forced to withdraw from the region. The victory of the Pueblo people was short lived, however; in 1692, Don Diego de Vargas led his army in the reconquest of New Mexico. When hearing of the return of the Spanish, many Pueblo people abandoned their villages and sought refuge with other tribes and neighboring pueblos to avoid reprisal.

In the ensuing century and a half, Comanche, Apache, and Navajo raids on Pueblo and Spanish settlements increased. The Comanche, who now had more mobility since they had domesticated horses introduced by the Spanish, forced the Apache from the Plains and controlled the eastern boundaries of Pueblo lands. Meanwhile, mounted Ute war parties increased their attacks from the north, and the Navajo used horses to steal sheep and cattle from Indian and Spanish settlements. Frequently, the Pueblo and the Spanish were forced to combine forces to combat these invaders.

Among all the Pueblo people there was a gradual assimilation of Hispanic culture, including the celebration of Roman Catholic feast days, and the use of the Spanish language, the *horno* (oven), and even some styles of dress. During the twentieth century, there has been a shift toward Anglo culture (Simmons 1979, 221).

111

COILED TRAY MADE IN 1965 BY ALCARIO GACHUPIN OF JEMEZ PUEBLO. HE LEARNED TO WEAVE FROM A JICARILLA APACHE WEAVER. DIA. 13 1/2", H. 3 1/4". COLLECTION OF RICHARD HOWARD.

FACING PAGE: PERFECTITIA BACA TOYA, OF JEMEZ, WASHING WHEAT IN A LARGE YUCCA RING BASKET, SEPTEMBER 15, 1936. PHOTOGRAPH BY TEN BROECK WILLIAMSON, COURTESY OF THE MUSEUM OF NEW MEXICO.

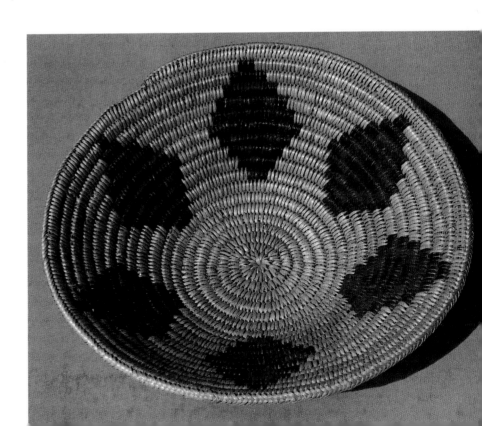

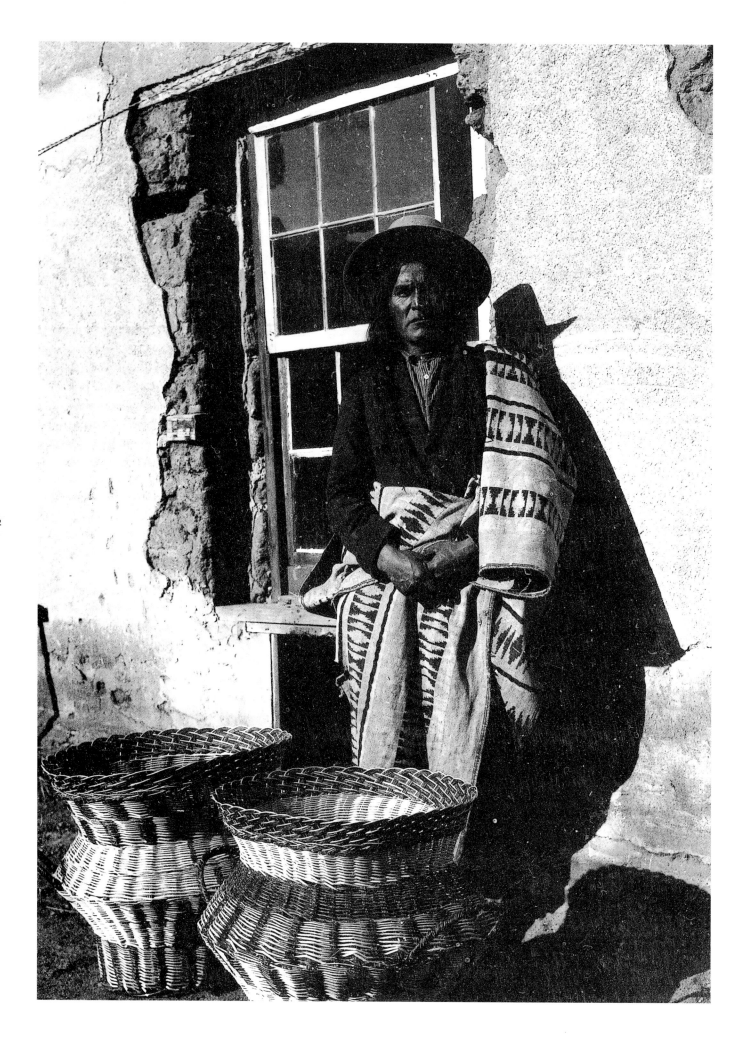

More information exists about baskets made by prehistoric
Pueblo people than about those made in more recent historic
times (Whiteford 1988, 143). The ancestors of the Pueblo, the
Anasazi, produced both plaited and coiled baskets. They made the
first yucca-ring sifter and two types of coiled baskets, one with one
rod and a bundle foundation and another with two rods and a
bundle foundation. Basketry items made by them were so finely
executed that today archaeologists refer to the period in which
they lived as Basketmaker. Basket making began in the area, how-
ever, long before the Anasazi, with the Archaic people of the
region. Items made by them found near Navajo Mountain,
Arizona, date between 6000 and 5000 B.C. (Williams 1979, 37).

While the use of baskets for preparing foods predates that of
pottery, archaeologists have noted an increase in the production
and use of pottery after A.D. 700, a practice that continued into his-
toric times. There continued to be a need for baskets, though, and
their production continued to flourish. Somewhere around the
year A.D. 1200 a third foundation technique came into use for
coiled pieces, which consisted of three bunched rods (Whiteford
1988, 144). All three foundation types continued to be made, but
beginning in the historic period there was a constant decline in
production of coiled basketry in the New Mexico pueblos until it
was no longer produced in any of these locations.

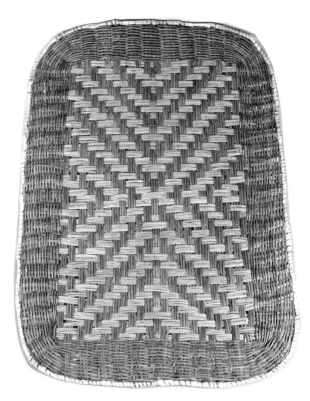

113

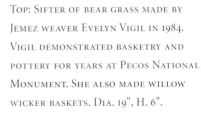

TOP: SIFTER OF BEAR GRASS MADE BY
JEMEZ WEAVER EVELYN VIGIL IN 1984.
VIGIL DEMONSTRATED BASKETRY AND
POTTERY FOR YEARS AT PECOS NATIONAL
MONUMENT. SHE ALSO MADE WILLOW
WICKER BASKETS. DIA. 19", H. 6".

CENTER: PLAITED PIKI TRAY BY DORA
TAWAHONGVA. THE TRAY WON A BLUE
RIBBON AT THE MUSEUM OF NORTHERN
ARIZONA ART SHOW IN 1986. L. 22 1/2",
W. 16 1/2".

LEFT: TYPES OF BASKETS STILL
PRODUCED AT SEVERAL PUEBLO
VILLAGES. (REAR, FROM LEFT) THOMAS
GARCIA, SANTO DOMINGO; LORENZO
ARMIJO, PEÑA BLANCA. (FRONT, FROM
LEFT) CHESTER AQUINO, SAN JUAN;
THOMAS STONE, SANTA CLARA; AND
CORINA YEPA WAQUIE, JEMEZ.

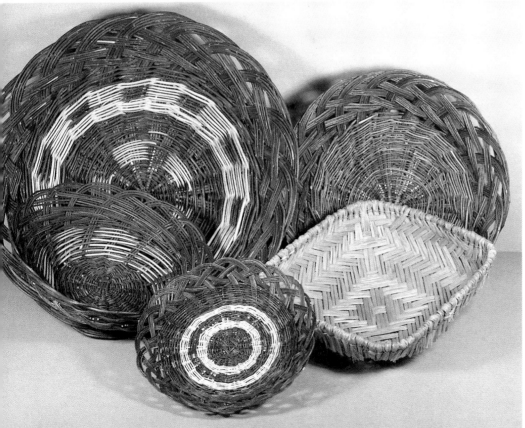

Hopi wicker-plaited carrying basket worn by katsina dancers. Made of scrub sumac with two large U-shaped support branches, ca. 1930. W. 9", H. 9". Collection of the Museum of Indian Arts and Culture/Laboratory of Anthropology.

Facing page, bottom: Hopi deep-coiled basket with a galleta grass foundation and yucca sewing splints. The encircling diamond design around the top and the bottom frame four sets of katsina faces, ca. 1930. Dia. 14 3/4", H. 13 1/2". Collection of the Museum of Indian Arts and Culture/Laboratory of Anthropology.

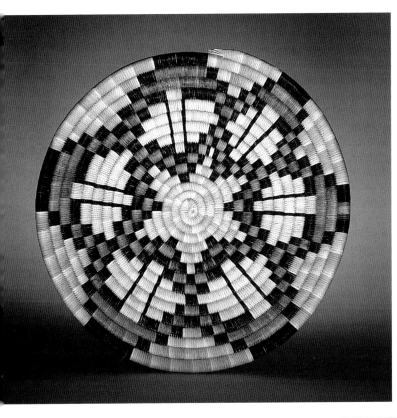

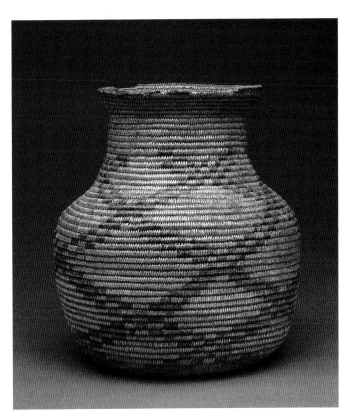

Top left: Man's wedding plaque by Hopi weaver Joyce Ann Soufkie, 1998. Traditionally, the basket is made by the bride's family and is presented to the groom. Note the unfinished rim, which represents the groom's future. 1998, Dia. 14", H. 1 3/4".

Top right: Pueblo Bottle, probably of two-rod and bundle foundation, similar to ones collected at several Pueblo villages before the nineteenth century. Dia. 13 3/4", H. 11". Collection of the Museum of Indian Arts and Culture/Laboratory of Anthropology.

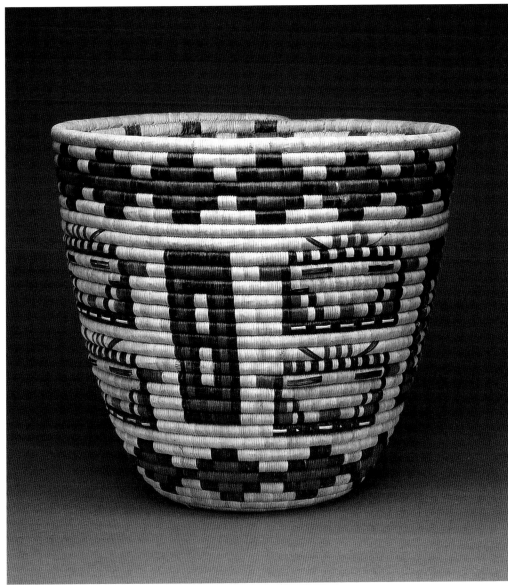

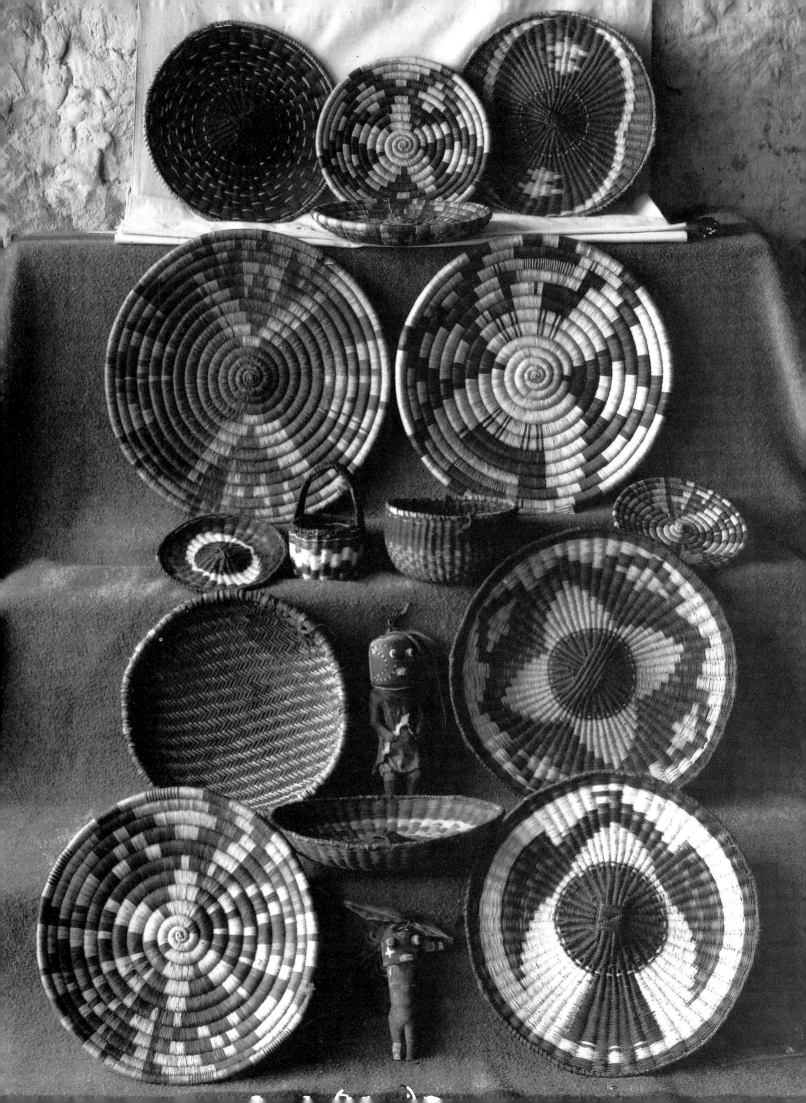

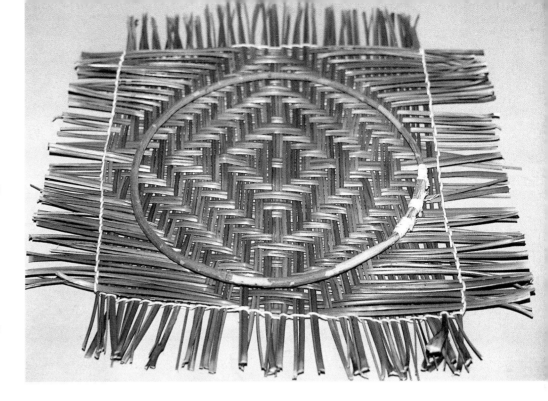

FACING PAGE: COILED AND PLAITED HOPI
BASKETS IN 1890. THIS PHOTOGRAPH
DEMONSTRATES THAT THE QUALITY OF
BASKETS BEING MADE TODAY AT HOPI IS
EQUAL TO THAT OF BASKETS MADE A
CENTURY AGO. PHOTOGRAPH BY BEN
WITTICK, 1890, COURTESY OF THE MUSEUM
OF NEW MEXICO.

THE FINISHED YUCCA MAT WILL BE PLACED
ON TOP OF THE SUMAC HOOP BEFORE IT IS
GENTLY PUSHED THROUGH THE HOOP TO
CREATE A DEEP BOWL. IT IS THEN SECURED
AROUND THE RIM AND TRIMMED. MADE BY
JEMEZ PUEBLO WEAVER CORINA WAQUIE IN
1998.

Very few coiled baskets have been made in any of the New Mexican pueblos during this century. In recent years, Rosendo Gachupin of Jemez Pueblo, who was taught by his father, Alcario Gachupin, has made coiled baskets, but he has stated that his father learned to weave from a Jicarilla Apache (Whiteford 1988, 168). Because of health problems Rosendo is unable to gather materials, although he still makes baskets using a wire frame and colored strips of plastic leather lacing.

The only eastern pueblo where yucca baskets are still made is Jemez Pueblo. These pieces, which are usually larger and considerably deeper than those produced by the Hopi, look like sturdy utilitarian pieces made to be used, and in some households still are. Until recent times they were employed for winnowing wheat, washing grains, and sifting flour. In addition to round shapes, they are presently made in square forms, with a heavy wire rim rather than the willow or sumac branch used earlier (page 113, bottom).

Open-work, plaited wicker pieces now made at Santa Clara, San Juan, and Santo Domingo Pueblos are usually smaller than previously. They are used for storing or serving foods. They have an especially important roll to play during ceremonies when the women carry foods in them for the dancers. In earlier times they were much larger in size, resembling those manufactured in several European countries for carrying and storing large quantities of foodstuffs. Because of this similarity, it has been suggested that the art was learned from early Spanish settlers, who made or imported similar types; however, it seems likely that the Pueblo people could have developed the technique independently.

Today, the status of basketry among the Hopi is very different. Yucca-ring baskets are still made at all three Hopi mesas (First, Second, and Third), just as they have been for fifteen centuries (Teiwes 1996, 59). Such baskets are still important utensils in Hopi households, where they are used for winnowing corn, sifting debris from various foods, and for storing fruits, beans, and corn. They are made for sale, for gifts, or to be used in the Basket Dance by young girls who have not learned to make plaited wicker plaques (Teiwes 1996, 61).

The Hopi continue to make four additional types of wicker-plaited baskets: cradle baskets, piki trays, carrying pieces or burden baskets, and plaques. The cradle basket is made with a frame consisting of a sturdy oak branch bent in a U-shape. Scrub sumac branches with the bark intact are then used for the warp and weft and are plaited around the frame. Finally, a plaited curved piece is attached near the opening at the top to protect the baby's head and to provide shade and warmth. Small miniature baby baskets are also made for dolls from commercial materials.

The piki tray (page 113) is a large rectangular mat used for serving piki bread, one of the traditional delicacies made by Hopi women for special occasions and ceremonies. The bread is made of a thin blue-corn gruel, which is spread sparingly over a hot stone griddle, cooked quickly, and rolled and placed on the tray. Piki trays are made for use within the Indian community and are infrequently for sale. The central part of the mat is plaited using dune broom for the warp and weft, while the plaited wicker border is made of scrub sumac or a commercial material to make the form rigid. These materials are then bent to one side to be included in the rim, which is finished with a wrap of yucca splints.

Two types of burden baskets are still occasionally made by the Hopi but are now used only for ceremonies. These types, which were made by both men and women in the past, are rectangular with a U-shaped oak rod at each end. Unsplit scrub sumac branches or commercial materials are now used for the warp and weft to build the sides, creating deep baskets. The oak rods are left exposed above the rim so they can be used as handles for lifting and securing the pieces on the back or on a burro. Smaller versions are also made—with a split sumac or dune broom plaited bottoms executed like the centers of piki trays. The ends are then bent upward to be plaited with unsplit sumac or commercial material, while the rims are lashed with strips of split sumac. These pieces are referred to as fruit or peach baskets since they were utilized to carry fruit from the orchards located below the village; they are also used by men being initiated into the Wuwuchim Society and carried on the backs of Katsinas in the Powamuya Ceremony (Teiwes 1996, 172).

Finally, the baskets currently most frequently made by the Hopi are plaited wicker plaques, which are round and flat, measuring from a few inches in diameter to approximately sixteen inches. A variety of designs, both traditional and innovative, are executed in bright colors on these pieces. Made at five villages on Third Mesa, the majority of them come from Oraibi, Kykotsmovi, and Hotevilla, with fewer made at Lower Moenkopi and Upper Moenkopi (Teiwes 1996, 32).

While many of these plaques are made for sale, a greater number are produced for use within the Hopi community—as gifts, payment for work, prizes for footraces, and as ceremonial items employed in the kiva or in the Basket Dance of women's societies. As Helga Teiwes observes, they are frequently used for what the Hopi call payback in social circumstances. For example, in a traditional Hopi wedding, the groom's parents make the wedding robes for the bride, and

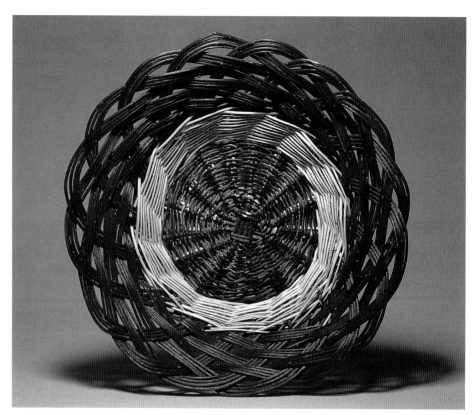

in return the bride's family will make the appropriate number of plaques used as a payback to the groom's family. The payback requires that three special styles of baskets are included: a large wedding plaque for the groom filled with white cornmeal that he will keep for his lifetime; a second smaller one with a similar design filled with sweet cornmeal; and a piki tray filled with piki bread. The rest can be any size or design. On Third Mesa up to one hundred plaques can be required for a wedding payback (Teiwes 1996, 57–59). After receiving a plaque for whatever reason, the recipient can keep it, give it away, or sell it. Frequently, pieces that are sold to traders are those given to young men by an aunt, the relationship between aunt and nephew being a very special one in Hopi society.

Hopi coiling is constructed very differently from the method once used in New Mexican pueblos or by the Navajo, Havasupai, San Juan Paiute, or Yavapai. Instead of having a rod foundation, Hopi coiled baskets have a bundle foundation and thus resemble baskets currently made by the Tohono and Akimel O'odham of southern Arizona. It is likely that the Hopi use of a bundle foundation was influenced by the Hohokam (Whiteford 1988, 144), who are the probable ancestors of the O'odham. Some older pieces dating to the late nineteenth and early twentieth centuries have thick foundation coils that measure up to an inch in diameter, while the coiled plaques and bowls currently made in the villages on Second Mesa have smaller coils. Many designs used are the same employed a hundred years ago, including Katsina masks and figures, and star and floral patterns. Such coiled pieces are used in the same way within the Hopi community as the wicker plaques, except for large deep pieces made specifically for sale. Many of these baskets take up to a year or more to complete and are commissioned by traders or collectors.

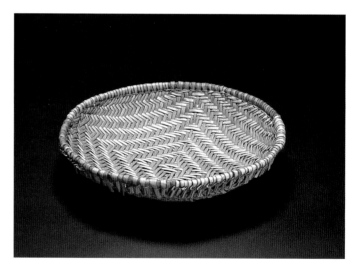

TOP: OPEN-WORK WILLOW BOWL BY SAN JUAN PUEBLO WEAVER STEPHEN TRUJILLO. HE WAS IN HIS EIGHTIES WHEN HE MADE THIS PIECE IN 1984. DIA. 13 1/4", H. 3".

BOTTOM: THE GEOMETRIC PATTERN ON THIS HOPI SIFTER WAS MADE BY USING THE WHITE INSIDE AND GREEN OUTSIDE OF THE YUCCA LEAF. NOTICE HOW SHALLOW THE TRAY IS COMPARED TO THOSE MADE AT JEMEZ PUEBLO. WEAVER UNKNOWN, CA. 1983. DIA. 11 1/2", H. 2".

FACING PAGE, BOTTOM: THIS UNUSUALLY SHAPED WICKER PLAQUE IS CALLED A FLAT KACHINA, OR WATER MAIDEN. HOPI WEAVER JOAN MONONGYE MADE IT FOR THE AUTHOR IN 1997. L. 13 1/4".

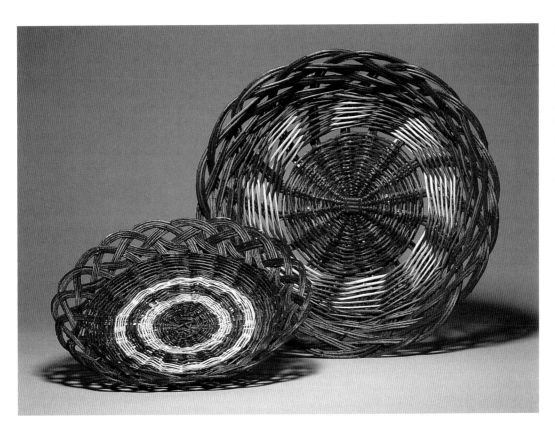

Open-work wicker bowls made by Thomas Stone, who married a Santa Clara Pueblo woman. Basket on right is by Chester Aquino of San Juan Pueblo. (from left) 1998, Dia. 10 1/2", H. 2"; 1992, Dia. 13", H. 4".

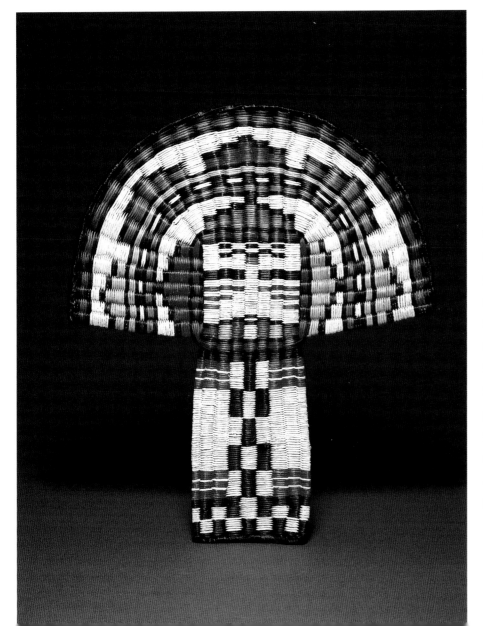

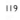 **MATERIALS AND CONSTRUCTION** A wide variety of plants are used by Pueblo weavers for coiling their baskets. Hopi coiled pieces are made with a galleta grass foundation and sewn with carefully prepared and dyed yucca splints. Only five colors are used on coiled baskets: white, yellow, green, red, and black. The white, yellow, and green are all natural colors. For white sewing splints, the center leaves of the yucca plant are gathered in late summer and allowed to bleach in the sun. Yellow splints come from leaves that have been exposed to freezing temperatures before being gathered and placed in the sun and the rain, where they turn yellow. The green comes from the outside leaves of the yucca that are gathered throughout the year. The red and black colors are commercially dyed in most cases but can be colored using plant dyes.

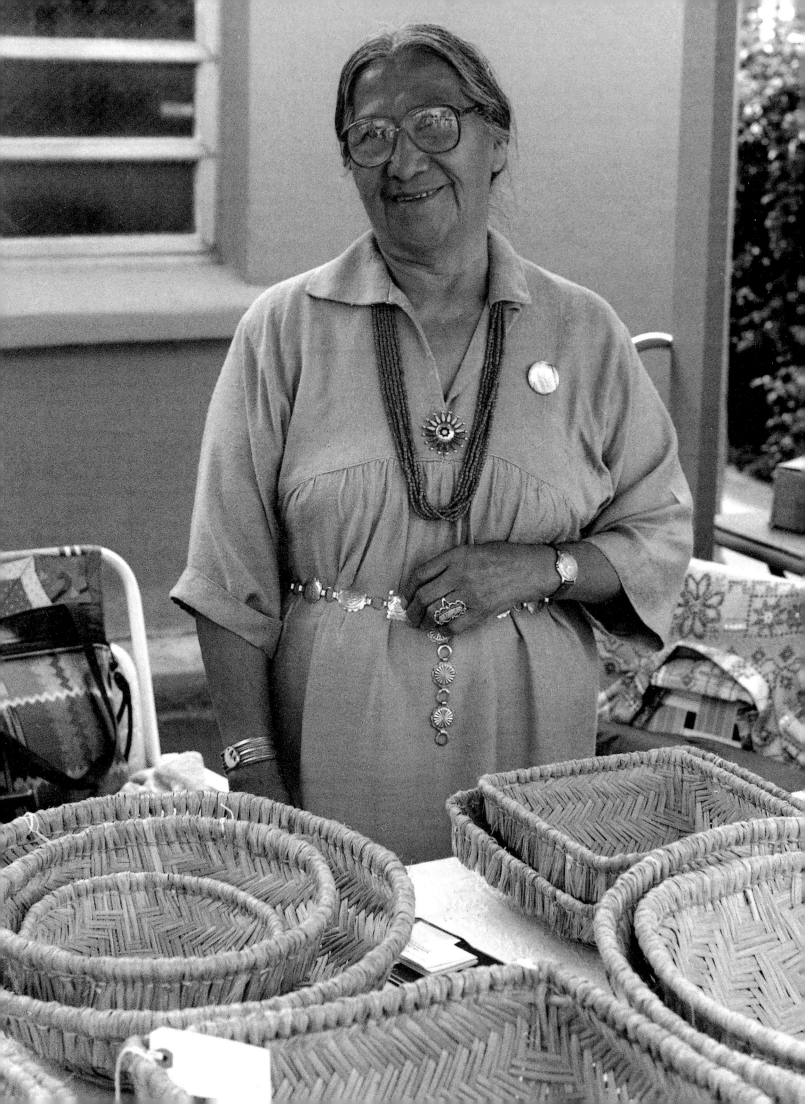

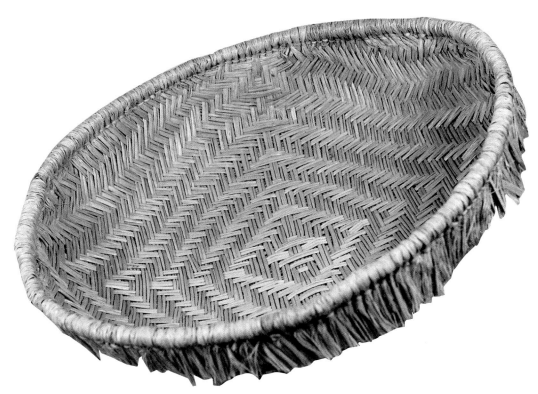

The yucca leaves employed in Hopi coiled pieces cannot be gathered until mid- to late July after the Niman Ceremony. Basketmakers carefully select the white leaves from the center of the plant or outer green leaves for use as sewing splints. The leaves are then split lengthwise and the center elevated portions removed with an awl before the sides are scraped. The removed fibers can be used in combination with galleta grass for the foundation. After the splints are divided into several smaller splints, depending on the size of the basket to be made, they are then placed in the sun to bleach and dry. The galleta grass used for the foundation, which is gathered about the same time as the yucca, grows along the highway, attaining a height of twelve inches. It requires no preparation and is best collected early in the season before it becomes too dry.

Different styles of plaited baskets can be produced by using either flexible (yucca) or rigid materials (unpeeled willow, dune broom, or rabbitbrush). In plaiting, the warp and weft elements are frequently the same and are passed over and under each other, as in textile weaving. Designs, however, can be created by altering the sequencing of warp and weft or by using different colors. In the Southwest, the only basketmakers who still plait baskets are those at Hopi and at Jemez, San Juan, Santa Clara, and Santo Domingo Pueblos in New Mexico.

The brightly colored Hopi plaited wicker plaques are made with a rigid foundation and rigid weft of dune broom and a weft of rabbitbrush, or chamisa. The weft strands for the most part are colored with synthetic dyes, but a few weavers continue the arduous task of making and using natural plant dyes.

Hopi plaited wicker plaques are executed with a dune broom warp of approximately twelve sticks or more placed parallel to each other and then divided into three equal parts by colored weft elements of rabbitbrush bent around them. A second group of the same number of sticks is then bound with weft elements before being placed on top of the first one at a ninety-degree angle. The weaver then begins to add additional warp materials in the empty spaces while plaiting around the whole in a circular fashion. When the desired diameter is achieved, usually from a few to sixteen inches, some of the warp sticks are cut while about a third of them are bent to one side to be lashed together with a dyed strip of yucca as part of the rim.

Because of the scarcity of scrub sumac, many weavers are forced to use commercial materials for several types of rigid plaited baskets, including oval-shaped fruit baskets, piki trays, and miniature cradle baskets. In recent years, the use of these commercial materials has become popular among many weavers. Such materials are difficult to detect in coiled baskets since the sewing strands cover the material used for the foundation, but they are easier to identify in plaited pieces because of their color and smooth surface. I have seen commercial materials on replicas of old utilitarian pieces and cradle baskets made by the Hopi but never on wicker plaques from the villages of Third Mesa. It is extremely important that commercial materials be identified when they are used. My experience has been that weavers are usually willing to share this information, but this is not always the case with others in the Indian arts business. In recent years, many collectors have paid premium prices for coiled Pomo baskets without being aware that commercial materials were used for the foundations.

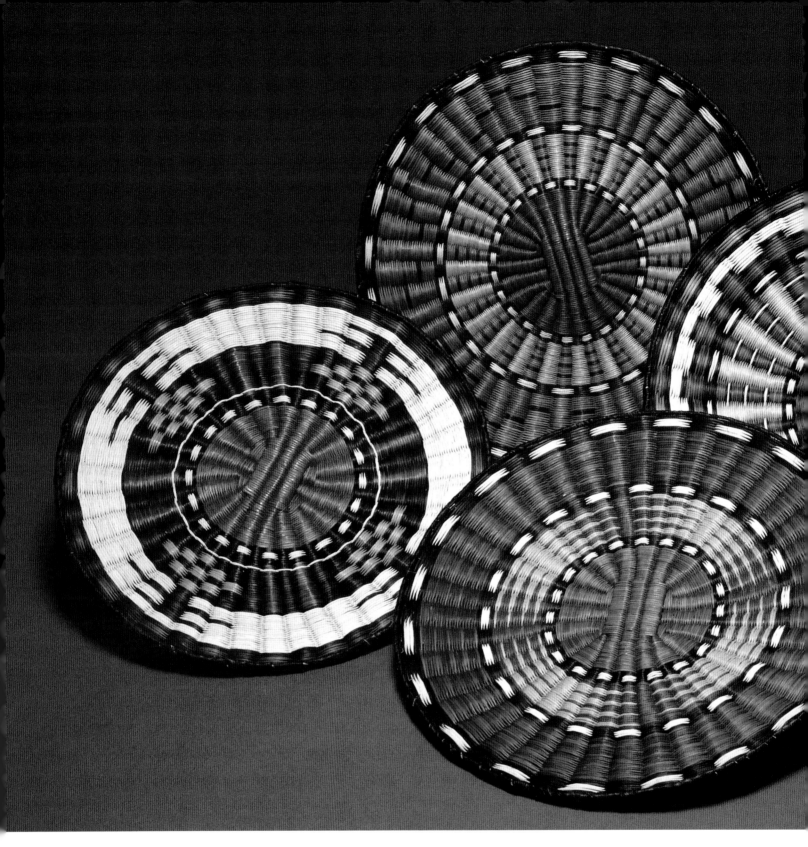

An array of Hopi wicker plaques made between 1988 and 1994. (from left) Embroidered robe design, weaver unknown, Dia. 11 1/2"; (rear) Dora Tawahongva, Dia. 12 1/4"; (front) Katherine Hoyungowa, Dia. 12"; (rear) corncob design, Joan Monongye, Dia. 12 1/2"; (front) old-style plaque start, Joan Monongye, Dia. 9".

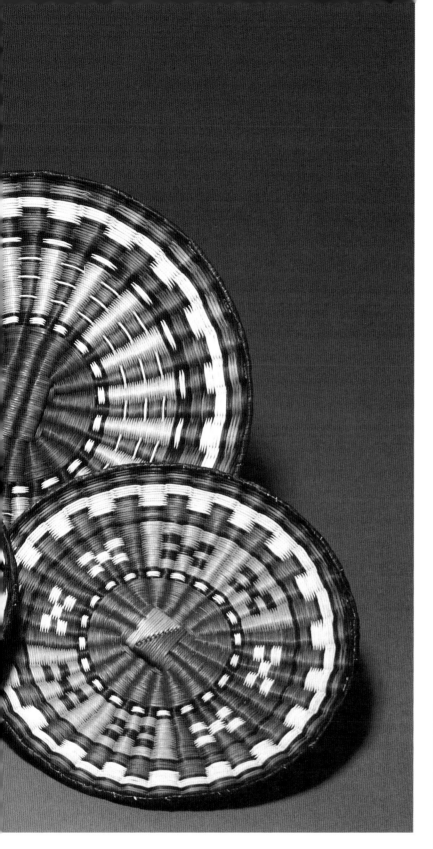

Hopi wicker plaque by Clara Sekayesva
of Hotevilla, made in 1991. Dia. 12".

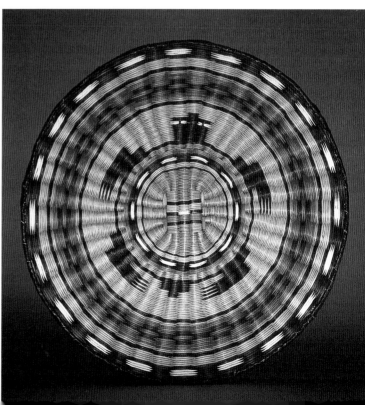

The final type of plaited baskets produced are those made of flexible materials, which are referred to as yucca-ring sifters. Yucca is the only plant used for this type of basket by the Hopi, but bear grass is also used by Jemez weavers for very large pieces. Hopi weavers prepare narrowleaf yucca splits by removing the ridge that runs down the center of the leaf. Some of the splints are then placed in the sun to bleach them white, while others are left green or occasionally colored with aniline dyes. A variety of geometric patterns can be developed by using the white, green, or dyed yucca leaves. Next, the splints are plaited with combinations crossing over or under two or three splints to create various patterns. When a square or rectangular mat is desired, a sumac or wire rim is placed over it; then the mat is brought up through the inside of the rim and bent over the outside. Finally, two yucca strands are used to attach the mat to the frame just below the rim, and the fringe is trimmed.

While in other tribes basketry has always been an art practiced by women, this was not the case among the New Mexico Pueblo, where men usually produced the wicker ware. Coiled pieces were also made by the men, while yucca-ring sifters were plaited by women. Such traditional roles, though, are changing among many of the Pueblo people.

⊕ WEAVERS AND THEIR BASKETS

Before 1945, yucca-ring sifters from Jemez were in great demand by the Acoma and Laguna people, who traded them for mutton, grain, beads, and blankets. Residents around Jemez Pueblo also used them for wood baskets (Williamson 1937, 39). The only woman still consistently making yucca-ring sifters, Corina Yepa Waquie, lives at Jemez Pueblo. When she was young, Corina watched her mother, Margarita C. Yepa, and her two aunts weave. Her aunt, Anna Maria Toya, was featured on the cover of the Museum of New Mexico's *El Palacio* in 1937 (Williamson 1937). Corina produces perfectly executed baskets in round, square, or rectangular shapes; these baskets are various sizes but all are four to six inches deep—generally much larger and deeper than those made by the Hopi. For the square and rectangular pieces, Corina uses wire rims while for her round pieces she employs sumac branches, which she gathers near Jemez Pueblo. Sometimes she uses bear grass on her larger pieces because of its additional length. The designs on her sifters are created by placement of the splints but not by using different-colored splints. She always utilizes the same design, which consists of a small square in the center surrounded by increasingly larger ones.

Corina, who gathers her own materials, says that yucca is best when collected in the early spring since it is easier to work with. Further, she states that the leaves that come from the center of the plant are thinner than those cut from the outer portions, but the outer leaves make a stronger basket. No preparation is needed for yucca splints.

According to Corina, Lucas Toledo, who died a few years ago, was the last man at Jemez to make willow-plaited wicker baskets. A San Juan Pueblo man, Stephen Trujillo (1899–1986), was very influential in teaching and preserving the art of open-work willow baskets. The results of his efforts can be seen in the work of two of his students, Joe Val Gutierrez and the late Thomas Stone of Santa Clara Pueblo. Stone's daughter took a high school basket-making class from Trujillo in the early 1980s. Watching her weave at home, Thomas became interested and started experimenting.

Since then, Thomas has continued to perfect his craft. One of two identifying characteristics of his work is the beautiful red color of his pieces. This color is achieved because of his experience with the optimal time to harvest his materials. For example, while willow is usually harvested in the fall, to collect them when their color is best it is important to wait until after the first good frost when the willows begin to turn a rich reddish brown color, a color they retain only briefly before becoming a dull brown or gray.

A second characteristic of Thomas Stone's work is his use of branches with a small circumference. Most contemporary basketmakers doing open-work use much larger branches. In earlier years, these were needed to make sturdy utilitarian pieces. Since baskets are now made for sale, however, Thomas has elected to use smaller ones that allow him to do much finer plaiting. Some of his work is in the Smithsonian Institution in Washington, D.C., and in the Museum of Indian Arts and Culture in Santa Fe, New Mexico.

A contemporary of Stephen Trujillo who also lived at San Juan Pueblo was Marcus Cata. Cata made open-work plaited baskets and taught his grandson, Chester Aquino. Chester is the only one still making them at San Juan Pueblo in 1999. His pieces, like those of Trujillo, have a start consisting of four or five withers lashed diagonally over the same number. This makes a very uniform and clean center with either sixteen or twenty rods radiating outward. The bark is removed from some of the moving elements, allowing for the development of a design. Sometimes willows with different-colored bark will be used for the same purpose.

Thomas Garcia of Santo Domingo Pueblo was a prolific weaver of plaited wicker baskets. In the 1980s his baskets could be found in many Indian arts and crafts stores in Santa Fe or Albuquerque. A small energetic man, he frequently could be seen in Santa Fe with a stack of baskets to sell. The willow basket shown opposite was made in 1984 when he was in his eighties. Thomas started his baskets with three large willow rods lashed diagonally over two. The center rod of the three was straight, while the ones on either side were partially cut so they flared outward at a forty-five-degree angle. The two rods on the bottom were also angled at approximately ten degrees. This method of construction produced foundations of only ten elements rather than the sixteen or twenty employed by Stephen Trujillo, Chester Aquino, and Thomas Stone.

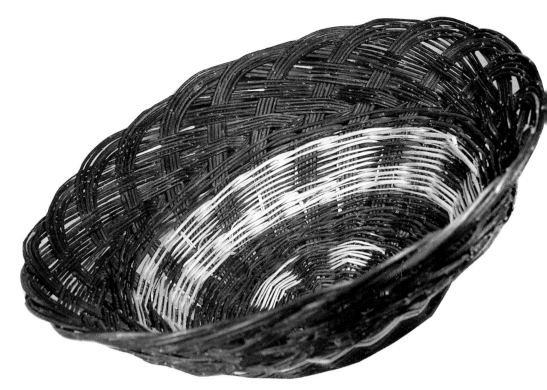

WILLOW BOWL BY THOMAS GARCIA OF
SANTO DOMINGO PUEBLO. SOME OF THE
WILLOW BRANCHES WERE PEELED TO
CREATE THE WHITE DESIGN, CA. 1984.
DIA. 20 1/2", H. 8".

In constructing the sides of baskets, Garcia plaited several rows of extra-large branches approximately halfway up the sides. This provided added strength to his larger pieces, which, when loaded, had considerable stress in this area. These branches can be seen as the four rows just above the design on his basket shown at right.

Lorenzo Armijo, a Hispanic man from Peña Blanca, taught himself to plait willow baskets by looking at others work and by trial and error. He initially became interested when he found some that his grandmother had made. He has lived close to Santo Domingo and Cochiti Pueblos his entire life and frequently sells his baskets to people from Santo Domingo, where they are popular for use in ceremonies in which foods and fruits are served. Armijo employs the same methods for reinforcing his pieces that Thomas Garcia did.

While the quality of work among many tribes has generally deteriorated over much of this century, the quality of Hopi baskets is equal to or surpasses those made at an earlier time. The workmanship is consistent and precise, and they are some of the most colorful baskets made today. A tremendous number of baskets are produced every year, most of which are used in the Hopi communities. They play a major role among women's societies and in religious ceremonies in addition to being needed for weddings or as paybacks, gifts, and prizes. Because many of these are sold to non-Indians after their initial use and others are specifically made for sale, it is sometimes difficult to differentiate between those made for sale and others. The majority of Hopi baskets currently made are wicker or coiled pieces. For the most part, Hopi basketmakers have not attempted to create new forms to attract the non-Indian market, as have other tribes.

Over the past twenty years, I have talked with many Hopi weavers at Hotevilla on Third Mesa and bought baskets from them. A common practice in basket making at Hotevilla is for a group of women to gather at one house to work for several days until each has completed a piece. The baskets are then given to one of the women, who can sell them or keep them. Thus, one of the women will have several for sale, and the others will refer buyers to her house. It was under such circumstances that I first met Joan Monongye and Clara Sekayesva in March 1988. They were working at Clara's house along with three other women. The basket Joan made with a corncob design shown on page 123 was collected at that time.

Dora Tawahongva and Katherine Hoyungowa also live at Hotevilla. Dora's piki tray (page 113) is superbly executed using natural materials of dune broom, sumac, and yucca wrapping splints. It won a blue ribbon at the Museum of Northern Arizona Art Show in 1986. Katherine's plaque (page 122) combines her technical expertise and artistry with a variety of color combinations.

One of the best-known Hopi weavers of coiled baskets is Joyce Ann Saufkie of Shungopovi on Second Mesa. Although she only began weaving in 1980, she has gained considerable expertise and recognition for her work, receiving first prize in the Hopi Craftsman's Exhibition in 1982 and Best of Show in 1990 (Teiwes 1996, 96). She participated in the 1983 symposium sponsored by the Museum of New Mexico's Laboratory of Anthropology, which brought together for the first time weavers from all over the Southwest, including Sally Black, Lydia Pesata, and Elnora Mapatis. This event and accompanying catalogue (Mauldin 1984) were instrumental in focusing increased attention on basket making, which for so long has been overshadowed by Native American jewelry, pottery, and rugs.

Overall, the state of Hopi basket making continues to be healthy because of the vital roles it plays in many aspects of Hopi society. By contrast, Pueblo basketry is in a precarious state. The Pueblo people lost most basket-making traditions long ago because of the demand for their pottery by Indians and non-Indians alike. While basketry continues to be important for ceremonial use, this does not appear to be enough incentive for continuance of the craft.

DURING THE LAST TWENTY YEARS many people have helped in bringing this project to fruition. Several traders have played significant roles in helping me achieve a comprehensive understanding of the status of contemporary basket making. Special recognition needs to be given to Stuart Hatch, of Hatch Brothers Trading Post, in Fruitland, New Mexico, a friend and fellow historian who provided me with innumerable names, places, events, and dates based on his sixty years of trading experience with the Utes, Paiutes, and Navajos. Melvin and Joyce Montgomery of Globe, Arizona, were an invaluable resource on basket making at San Carlos. Joyce arranged photo sessions with weavers and took me around the reservation to meet others.

A longtime friend, Barry Simpson, of Blue Mountain Trading Post in Blanding, Utah, was responsible for introducing me to Susan Whyte and helping me assemble a history of basket making at White Mesa. Our shared interest in basketry provided for many enjoyable conversations over the years. His brother, Steve Simpson, of Twin Rocks Trading Post in Bluff, Utah, has also been of great help on contemporary trends in Navajo basketry and on genealogical data. Thanks also to his parents, Duke and Rose Simpson, who so graciously shared information about weavers at White Mesa and about Mary Holiday Black.

William Beaver has played a pivotal role in the contemporary basketry of the Navajos and San Juan Paiutes from his Sacred Mountain Trading Post north of Flagstaff, Arizona. He generously provided me with the information I requested, including photographs of weavers, while engaging me in stimulating conversation. Fred Carson, Jr., of Carson's Trading Post in Farmington, New Mexico, and Joe and Mary Gene Brooks, who ran the Big D in Dulce, shared their trading experiences, as did the late Ray Hunt of Hunt's Silver Smith Shop in Blanding.

I am indeed grateful to Diane Dittemore, curator of ethnographic collections at the Arizona State Museum at the University of Arizona, for giving me access to the museum's collections and assisting in finding those special baskets. At the Museum of Indian Arts and Culture in Santa Fe, New Mexico, I was ably assisted by Louise Stiver, curator of fiber arts and jewelry, in my search for baskets to be included in this book, and archivist Diane Bird provided the photos I requested.

Over the years Carol Edison of the Utah Arts Council has willingly provided photographs while patiently answering all my questions, and for this I thank her. Lawrence E. Dawson, formerly of the Lowie Museum, read my manuscript and offered invaluable suggestions and encouragement. Susan Brown McGreevy read the entire manuscript and offered valuable insights. Thanks also to Dennis Kirkland of Casa Grande for allowing me to photograph some of his Akimel O'odham masterpieces.

Eileen Benjamin generously made available photographs of Mary Holiday Black and Elsie Holiday.

Most of the recognition for all aspects of this book must go to the basketmakers, the women and men who shared with me their love of the art and their concerns for its future. The passing of many of these extraordinary weavers in large part provided the impetus for a book that would preserve their work and something about their lives. Two women who have been very helpful are Evalena Henry and Brenda Julian. Evalena helped with the Henry genealogy of Western Apache weavers and with the information about her mother, Cecilia. Brenda, director of the Jicarilla Arts and Crafts Program, allowed me to photograph baskets in the museum's collection and answered many questions on the history of the program.

A special thanks to Steve, who frequently acted as a second ear and note taker, allowing me to enjoy the many and varied conversations with weavers, and to Paulette and Chris, who joined me on collecting expeditions that took us to many out-of-the-way places in California, Nevada, and the Southwest.

Many thanks to Carol Haralson, of Sedona, for her sensitive handling of the material in her design of this book.

Lastly, I want to thank Mary Wachs of the Museum of New Mexico Press, who, from the very beginning, has shown enthusiastic support for this project

JAMES ROCK

MADALINE ROCK

BETTY BITSINNIE

Jack Rock

GORDON BITSINNIE

JEFFREY ROCK

LORRAINE BLACK

JEANNE BITSINNIE

ARDAWN BITSINNIE

Herman Begay

CHARLENE ROCK

FERGUS BITSINNIE

KEE BITSINNIE

IRENE EDDIE

CABRA BITSINNIE

LOUISE BITSINNIE

KAREN ROCK

SOPHIA BITSINNIE

Harry Rock

Monty Rock

128

Helen Bitsinnie

BURMAN BITSINNIE

GLADYS KATSO,
B. 1927

Harrison Rock

BENNY BITSINNIE

BYRON BITSINNIE

Begay Bitsinnie

BONNIE BURBANK

BERENDA BITSINNIE

Larry Bitsinnie

Vicky Benally

GARY BITSINNIE

EVA BLACKWATER

JERRY BITSINNIE

KENNETH BITSINNIE

JACKIE MARTINEZ

HERBERT BITSINNIE

CLARA ATENE

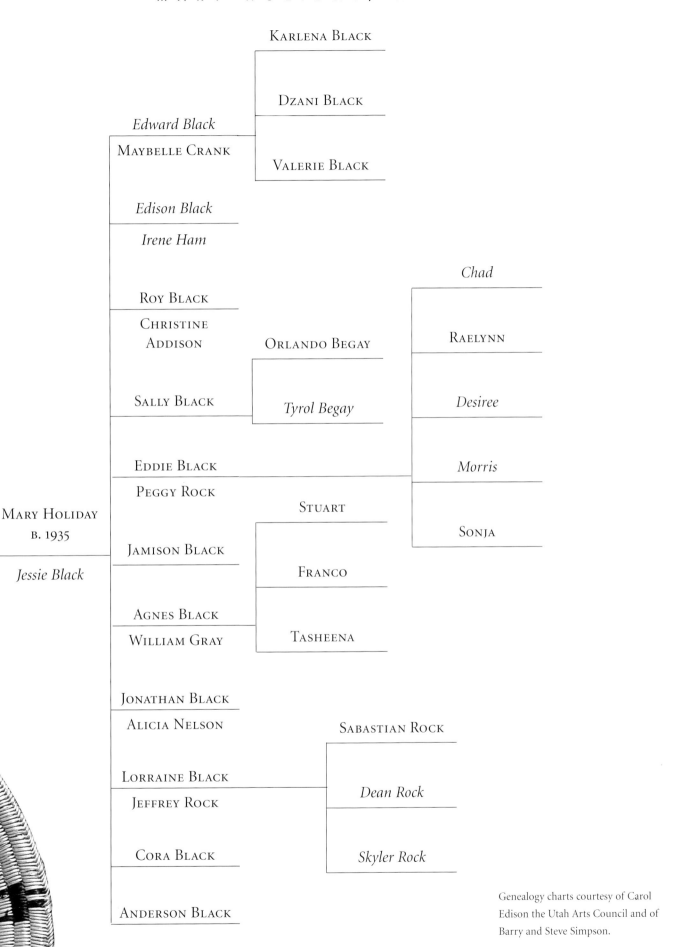

KARLENA BLACK

DZANI BLACK

Edward Black

MAYBELLE CRANK

VALERIE BLACK

Edison Black

Irene Ham

Chad

ROY BLACK

CHRISTINE
ADDISON

RAELYNN

ORLANDO BEGAY

SALLY BLACK

Desiree

Tyrol Begay

Morris

EDDIE BLACK

PEGGY ROCK

STUART

SONJA

MARY HOLIDAY
B. 1935

JAMISON BLACK

FRANCO

Jessie Black

AGNES BLACK

WILLIAM GRAY

TASHEENA

JONATHAN BLACK

ALICIA NELSON

SABASTIAN ROCK

LORRAINE BLACK

JEFFREY ROCK

Dean Rock

CORA BLACK

Skyler Rock

ANDERSON BLACK

129

Genealogy charts courtesy of Carol
Edison the Utah Arts Council and of
Barry and Steve Simpson.

Capitalized names refer to weavers.

JACKSON ROCK

ETTA CHEE

JAMES ROCK

MARY ROCK

MADELINE ROCK

Samuel Holiday

JEFFERY ROCK

Jack Rock

CHARLENE ROCK

BETTY BITSINNIE

Sally Rock

Robert Chief

Amber Johnson

BETTY ROCK

GENE JOHNSON

Joe Johnson

JOANN JOHNSON

Harry Rock

MARY JEAN JOHNSON

Tom Rock

VERNA C. JOHNSON

Jean Rock

NELSON CLY

BENJAMIN S. JOHNSON

Kee Y. Cly

130 GRACE BIGMAN
B. 1919

THURDINA YAZZIE

CHRIS JOHNSON

JENNY ROCK

HERMAN

RAMONA J. JOHNSON

Yazzie Rock

Gary Rock

CHRISTINE ROCK

LARRY ROCK

ELEANOR CLY

DAVID ROCK

PHOEBE ROCK

ANNIE ATCITTY

MARTINA

EVELYN ROCK

Chad

Marcus

RAELYNN

NELLIE ROCK

THEODORE

Desiree

Albert Tohtsonie

Morris

PEGGY ROCK

SONJA

EDDIE BLACK

LENA

MARY ROSE

Raymond

Nancy

WILSON

Richard

Ricky

Randall

RITA

CHARLISSA

LOUISE

Adrian

AARON

Brian

Darwin

Dorran

Kelsey

SISSY

Clinton Henry NOVINA COBB ELISA COBB

ALISHA COBB

MELISSA COBB

CELINA HENRY MARY BETH CAOOSE

VIOLA HENRY TAYLOR *Anthony Henry, Sr.*

CAROLINE HENRY

PHOENICIA PADILLA

VELMA PADILLA

JESSICA PADILLA

Jackson Henry CAROL SALAZAR

EVELYN STEELE HENRY MARY JANE DUDLEY

VELDA PEAPOT

CECILIA NELSON,
1902–1996

Robert Henry

VELVETTA VOLENTE

131

Robert Henry, Jr.

KATIE KOZIE

EVALENA HENRY

LOREENA UPSHAW

BERNADETTE TAYLOR

JOANN HENRY TAYLOR ELIZABETH TAYLOR

MARY LOU COULLE

VERONICA TAYLOR

LORENA HENRY COBB

Ambrose Henry

BUTT END The thicker cut end of a branch.

CLOSE-STITCH In coiling, each stitch closely buttresses against its neighbor, completely covering the foundation.

COILING Coiling is a technique in which a spiral foundation of materials circles outward from the center to the rim. The successive circles are sewn together with pliable sewing splints of sumac, cottonwood, willow, or yucca. These methods are employed by the Navajo, San Juan Paiute, Havasupai, Jicarilla Apache, Yavapai, Western Apache, Hopi, Tohono O'odham, and Akimel O'odham.

DIAGONAL/TWILL TWINING A method in which two moving elements are woven around two stationary elements.

FAG END In coiling, the tail end of the new sewing splint being introduced, which will be cut or anchored between coils or under stitches.

HERRINGBONE Also called false braid, it refers to the rim finish on Navajo, San Juan Paiute, and Jicarilla coiled baskets.

INTERLOCKING STITCH Least common type of sewing on coiled baskets, in which the sewing splint always hooks through the stitch below it.

MOVING END In coiling, the front end of a new sewing splint that is pulled through the hole made by the awl.

NONINTERLOCKING STITCH Common type of sewing used on coiled baskets; the sewing splint passes through the lower coil between the preceding stitches.

OLLA Any basket that is vase shaped.

OPEN-WORK refers to twined pieces in which open areas exist between warp and weft elements.

PLAIN/SIMPLE TWINING A method in which two moving elements are twisted around one stationary element.

PLAITING The plaiting technique employs single elements or sets of elements that pass over and under each other. The method is similar to that of textile weaving. Flexible materials (yucca) or rigid materials (willow

132

TWO-ROD AND BUNDLE COILING

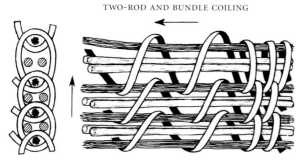

BUNDLE COILING

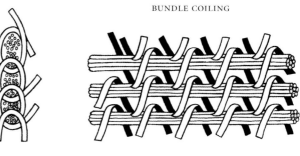

THREE-ROD STACKED COILING

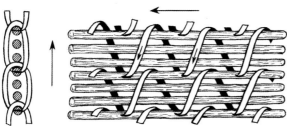

THREE-ROD BUNCH COILING

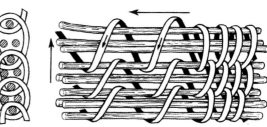

SINGLE-ROD WITH INTERLOCKING STITCHES

branches, rabbitbrush, sumac, and dune broom) are used to make different types of baskets. Patterns can be created by varying the sequence of the weave or by using colored materials. Rio Grande Pueblo and Hopi basket-makers continue to use this method.

SPACED-STITCH On a coiled basket, stitches are spaced wide apart, exposing the foundation.

SPLINT The pliable sewing material that wraps around the bundle in coiled baskets or around the warp in twined baskets.

SPLIT-STITCH In coiled basketry, the sewing strand that pierces the stitch in the previous coil.

TICKING Pattern treatment, usually on the rim, in which alternating stitches in a coiled basket are different colors.

TWINING In this method, the warp is the rigid elements (foundation) around which two or three flexible elements, called the weft, are twisted. Different patterns are created by varying the number of foundation elements the weft elements are woven around; by twisting the weft elements to expose their lighter or darker sides; or by using one weft element to overlay another. In the Southwest, the Havasupai, Hualapai, Western Apache, and San Juan Paiute use these methods.

WARP The foundation of a basket. In coiling it is made up of a bundle, one or more branches, or a combination of both; in twining it is the rigid sticks around which the pliable splints are woven.

WEFT Refers to the pliable sewing strands that are wrapped around the foundation in a coiled basket; in a twined basket it is the two or three strands passing over and under the rigid foundation.

WHEAT-STITCH A two-stitch technique used in Tohono O'odham coiled baskets. The first stitch is used in a spaced-stitch method that splits the lower coil stitch. A second stitch is then added to the right of it.

WICKER A type of plaiting in which rigid materials (willow branches, dune broom, or rabbit-brush) are used for the warp and the weft.

TWISTED (SIMPLE) TWINING

PLAIN (SIMPLE) TWINING

THREE-STRAND TWINING

DIAGONAL (TWILL) TWINING

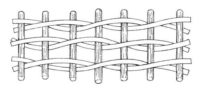

RIGID MATERIAL PLAITING

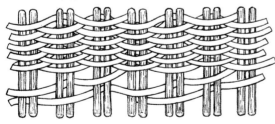

DIFFERENT-COLORED WEFT PLAITING WITH RIGID MATERIAL

FLEXIBLE MATERIAL PLAITING

BASKET START

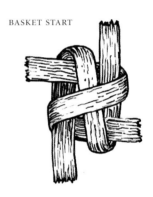

Several types of basket starts are used by O'odham weavers, including spiral starts, four-square knots, and plaited squares.

The four-square knot shown here is one Matilda Thomas employs. She uses two sewing splints of devil's claw, given that the central part of her pattern is typically black.

133

PULLED TIGHT

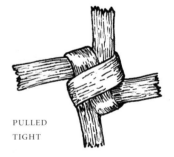

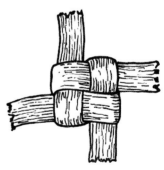

REVERSE SIDE: THE FOUR ENDS ARE THEN BENT TO THE LEFT AND SEWN INTO A STARTING KNOT BEFORE SMALL AMOUNTS OF FOUNDATION MATERIALS ARE ADDED.

Apache plume *(Fallugia paradoxa)* is an attractive shrub used by Havasupai weavers for the rim on twined baskets and cradle baskets.

Arrowweed *(Pluchea sericea)* grows in thick stands along Havasu Creek and is employed for the rim on Havasupai twined pieces.

Bear grass *(Nolina microcarpa)* is a member of the lily family, it grows in thick clumps with long, narrow, razor-sharp leaves. The Tohono O'odham weavers shred the leaves for use in the bundle foundation of their coiled baskets. Corina Waquie of Jemez Pueblo uses it in her large ring sifters.

Catclaw Acacia *(Acacia greggii)* is a small thorny tree reaching twenty feet in height; it is the preferred material of Havasupai weavers for the weft in their twined pieces.

Cattail *(Typha agustifolia)* is utilized by O'odham weavers for the bundle foundations in their willow-sewn coiled baskets.

Cottonwood *(Populus* spp.*)* provides materials for both coiled and some twined baskets made by the Pai and Apache.

Devil's claw *(Martynia proboscidea parviflora)* splints from this clawlike pod are used for the black designs on Pai and Apache twined and coiled pieces and on O'odham coiled baskets.

Dune broom *(Parryella filifolia)* branches are employed on Hopi plaited wicker plaques for the foundation warp.

Galleta grass *(Hilaria jamesii)* Bundles of this tall, stiff grass are used for the foundation in Hopi coiled baskets.

Mountain mahogany *(Cercocarpus montanus)* Before the common use of aniline dye, the root of this plant made orange dye for the sewing strands found on Navajo wedding baskets.

Mulberry *(Morus microphylla)* branches are a preferred material of Cibecue weavers for the warp and weft in twined baskets.

Ocotillo *(Fouquieria splendens)* was used as a foundation material on old storage–granary baskets of the O'odham.

Piñon pine *(Pinus edulis)* resin is still utilized for waterproofing replicas of old-style Apache, Pai, and Navajo water jugs.

Rabbitbrush or chamisa *(Chrysothamnus nauseosus)* The slender stems of this plant are peeled and dyed before being plaited over and under the warp of Hopi wicker plaques.

Soaproot *(Chlorogalum pomeridiaun)* paste was made from the roasted bulb of this plant to seal utilitarian baskets used by California Indians.

Sotol *(Dasylirium wheeleri)* historically was used for sewing splints on old storage–granary baskets and plaited baskets of the O'odham. Sometimes used today by Tohono O'odham weavers as a yucca substitute for sewing splints.

Sumac (scrub, squaw bush, or lemonberry; *Rhus* spp.*)* is one of the plants most frequently used in the Southwest by Hualapai, Havasupai, Apache, Ute, San Juan Paiute, Hopi, and Navajo weavers for coil or twine baskets.

Tamarisk *(Tamarix spp.)* bush stems are occasionally used for the warp and rims of twined pieces by Western Apache weavers.

Willow *(Salix* spp.*)* Several varieties are utilized by southwestern weavers in one capacity or another for coiling or twining; found in Akimel O'odham coiled baskets and Western Apache burden baskets in particular.

Yucca *(Yucca* spp.*)* Several varieties of this plant including broadleaf and narrowleaf, are used for sewing splints on Hopi and Tohono O'odham coiled baskets and plaited yucca-ring sifters of the Hopi and Pueblo. The Spanish bayonet root is employed for the brown designs in O'odham coiled baskets. Yucca splints are used to bind the rim of Hopi plaited wicker plaques.

134

ADAVISIO, J. M.
1977. *Basketry Technology: A Guide to Identification and Analysis.* Chicago: Aldine Publishing.

AQUINO, CHESTER.
1998. Personal communication with Larry Dalrymple.

ASHCROFT, JIM, AND ZONA.
1995. Personal communication with Larry Dalrymple.

AUSTIN, BERTHA.
1995. Personal communication with Larry Dalrymple, October 19.

BAILEY, GARRICK, AND ROBERTA GLENN BAILEY.
1986. *A History of the Navajos.* Santa Fe, N.Mex.: School of American Research Press.

BARNETT, FRANKLIN.
1968. *Viola Jimulla: The Indian Chieftess.* Yuma, Ariz.: Southwest Printers.

BASSO, KEITH H.
1983. "Western Apache." In *Handbook of North American Indians.* Vol. 10, edited by Alfonso Ortiz. Washington, D. C.: Smithsonian Institution.

BATEMAN, PAUL.
1972. "Cultural Change and Revival in Pai Basketry." Master's thesis, Northern Arizona University.

BEAVER, WILLIAM.
1995–1999. Personal communication with Larry Dalrymple.

BECENTI, DEENISE.
1995. "Utah Navajo Basket Weaver Receives Grant from NEA." *Salt Lake City Tribune:* "Arts," June 18.

BLACK, E. Z.
1936. "Basket Making Among the Utes." In *Indians at Work.* Washington, D.C.: U.S. Government, April 15.

BLACK, SALLY.
1995–1998. Personal communication with Larry Dalrymple.

BREAZEALE, J. F.
1923. *The Pima and His Basket.* Tucson: Arizona Archaeological and Historical Society.

BROOKS, JOE, AND MARY GENE BROOKS.
1994. Personal communication with Larry Dalrymple.

BRUGGE, DAVID M.
1983. "Navajo Prehistory and History to 1850." In *Handbook of North American Indians.* Vol. 10, edited by Alfonso Ortiz. Washington, D.C.: Smithsonian Institution.

BUNTE, PAMELA A.
1985. "Ethnohistory of the San Juan Paiute Tribe." In *Translating Tradition: Basketry Arts of the San Juan Paiute.* Santa Fe, N.Mex.: Wheelwright Museum of the American Indian.

CAIN, THOMAS H.
1977. *Pima Indian Basketry.* Phoenix, Ariz.: McGrew Printing and Lithographing Co.

COX, BARTON.
1994. Personal communication with Larry Dalrymple.

DAWSON, LAWRENCE E., AND JAMES DEETZ.
1965. *A Corpus of Chumash Basketry.* Los Angles: University of California Press.

DAWSON, LAWRENCE E.
1998. Personal communication with Larry Dalrymple, September 14–15.

DICKSON, LOLA.
1987–1993. Personal communication with Larry Dalrymple.

DUTTON, BERTHA P.
1976. *The Rancheria, Ute, and Southern Paiute Peoples.* Englewood Cliffs, N.J.: Prentice-Hall.

EDISON, CAROL A., ED.
1996. *Willow Stories: Utah Navajo Baskets.* Salt Lake City: Utah Arts Council.

ELLIS, FLORENCE H., AND MARY WALPOLE.
1959. "Possible Pueblo, Navajo, and Jicarilla Basketry Relationships." *El Palacio* 66: 181–198.

EYETOO, RACHAEL.
1995–1996. Personal communication with Larry Dalrymple.

EZELL, PAUL H.
1983. "History of the Pima." In *Handbook of North American Indians.* Vol. 10, edited by Alfonso Ortiz. Washington, D.C.: Smithsonian Institution.

FERG, ALAN, ED.
1987. *Western Apache Material Culture: The Goodwin and Gunther Collections.* Tucson: University of Arizona Press.

FONTANA, BERNARD L.
1983. "History of the Papago." In *Handbook of North American Indians.* Vol. 10, edited by Alfonso Ortiz. Washington, D.C.: Smithsonian Institution.

FOWLER, CATHERINE S., AND LAWRENCE E. DAWSON.
1986. "Ethnographic Basketry." In *Handbook of North American Indians.* Vol. 11, edited by Warren L. D'Azevedo. Washington, D.C.: Smithsonian Institution.

FRANKLIN, ROBERT J., AND PAMELA A. BUNTE.
1990. *Indians of North America: The Paiute.* New York: Chelsea House Publishers.

GOODY, BERNADETTE.
1996. Personal communication with Larry Dalrymple, September 20.

GUY, HUBERT.
1977. "Baskets, Beads and Buckskin." *Arizona Highways* (July): 10–19.

HATCH, STUART.
1987–1998. Personal communication with Larry Dalrymple.

HENRY, EVALENA.
1996–1998. Personal communication with Larry Dalrymple.

HEROLD, JOYCE.
1978. "Tanzanita Pesata." *American Indian Art* 3, no. 2: 26–94.

1982. "One Hundred Years of Havasupai Basketry." *The Basket Weavers: Artisans of the Southwest. Plateau.* 53, no. 4: 14–21.

HIRST, STEPHEN.
1976. *Life in a Narrow Place: The Havasupai of Grand Canyon.* New York: David McKay Co.

HURST, WINSTON.
1992. "Historical Background on San Juan County Utes." *Blue Mountain Shadows* 11: (Winter): 4–5.

JAMES, GEORGE W.
1972. *Indian Basketry.* Reprint of 1909 edition. New York: Dover Publications.

JULIAN, BRENDA.
1994–1999. Personal communication with Larry Dalrymple.

KELLY, ISABEL T., AND CATHERINE S. FOWLER.
1986. "Southern Paiute." In *Handbook of North American Indians.* Vol. 11, edited by Warren L. D'Azevedo. Washington, D.C.: Smithsonian Institution.

135

KHERA, SIGRID, AND PATRICIA S. MARIELLA.
1983. "Yavapai." In *Handbook of North American Indians*. Vol. 10, edited by Alfonso Ortiz. Washington, D.C.: Smithsonian Institution.

KISSELL, MARY LOIS.
1916. "Basketry of the Papago and Pima." *Anthropological Papers of the American Museum of Natural History* 17, no. 4: 150–254.

KROEBER, ALFRED L., ED.
1935. "Walapai Ethnography." *American Anthropological Association: Memoirs* no. 42. Menaska, Wis.

McGREEVY, SUSAN BROWN.
1985. "Translating Tradition: Contemporary Basketry Arts." In *Translating Tradition: Basketry Arts of the San Juan Paiute*. Santa Fe, N.M.: Wheelwright Museum of the American Indian.

1989. "What Makes Sally Weave? Survival and Innovation in Navajo Basketry Trays." *American Indian Art* 14, no. 3 (Summer): 38–45.

McGUIRE, THOMAS R.
1983. "Walapai." In *Handbook of North American Indians*. Vol. 10, edited by Alfonso Ortiz. Washington, D.C.: Smithsonian Institution.

McKEE, BARBARA, EDWIN McKEE, AND JOYCE HEROLD.
1975. *Havasupai Baskets and Their Makers: 1930–1940*. Flagstaff, Ariz.: Northland Press.

McNITT, FRANK.
1972. *Navajo Wars: Military Campaigns, Slave Raids, and Reprisals*. Albuquerque: University of New Mexico Press.

McPHERSON, ROBERT.
1989. "Paiute Posey and the Last White Uprising." *Blue Mountain Shadows* 4 (Spring): 7–13.

MAPATIS, ELNORA.
1981–1983. Written correspondence with Larry Dalrymple.

MARTINEZ, MARY.
1995. Personal communication with Larry Dalrymple, October 18.

MASON, OTIS TUFTON.
1976. *Aboriginal American Indian Basketry*. Reprint of 1902 publication. Santa Barbara, Calif.: Peregrine Smith.

MATTHEWS, WASHINGTON.
1894. "The Basket Drum." *The American Anthropologist* 7, no. 2: 202–208.

MAULDIN, BARBARA.
1984. *Traditions in Transition*. Santa Fe, N. Mex.: Museum of New Mexico Press.

MILLER, WICK R.
1986. "Numic Languages." In *Handbook of North American Indians*. Vol. 10, edited by Alfonso Ortiz. Washington, D.C.: Smithsonian Institution.

MONONGYE, JOAN.
1991–1998. Personal communication with Larry Dalrymple.

MONTGOMERY, JOYCE; AND MELVIN MONTGOMERY.
1980–1996. Personal communication with Larry Dalrymple.

MORRIS, EARL H., AND ROBERT F. BURGH.
1941. *Anasazi Basketry: Basketmaker II through Pueblo III: A Study Based on Specimens from the San Juan River Country*. No. 533. Washington, D.C.: Carnegie Institution of Washington.

OPLER, MORRIS E.
1983. "The Apachean Culture Pattern and Its Origins." In *Handbook of North American Indians*. Vol. 10, edited by Alsonso Ortiz. Washington D.C.: Smithsonain Institution.

PESATA, LYDIA.
1984–1995. Personal communication with Larry Dalrymple.

QUADE, MAJORIE.
1996. Personal communication with Larry Dalrymple.

ROBERTS, HELEN HEFFRON.
1985. *Basketry of the San Carlos Apache Indians*. Reprint of 1929 publication. Glorieta, N. Mex.: Rio Grande Press.

ROBINSON, BERT.
1954. *The Basket Weavers of Arizona*. Albuquerque: University of New Mexico Press.

ROESSEL, ROBERT A., JR.
1977. *Navajo Education in Action: The Rough Rock Demonstration School*. Chinle, Ariz.: Rough Rock Demonstration School.

1983a. *Dine'tah: Navajo History*. Vol. 2. Rough Rock, Ariz.: Rough Rock Demonstration School.

1983b. "Navajo History, 1850–1923." In *Handbook of North American Indians*. Vol. 10, edited by Alfonso Ortiz. Washington, D.C.: Smithsonian Institution.

SCHROEDER, ALBERT H.
1974. "A Study of Yavapai History." In *American Indian Ethnohistory: Indians of the Southwest*. New York: Garland Press.

SCHWARTZ, DOUGLAS W.
1983. "Havasupai." In *Handbook of North American Indians*. Vol. 10, edited by Alfonso Ortiz. Washington, D.C.: Smithsonian Institution.

SHREVE, MARGARET.
1943. "Modern Papago Basketry." *The Kiva* 8, no. 2: 10–16.

SIMMONS, MARC.
1979. "History of the Pueblos Since 1821." In *Handbook of North American Indians*. Vol. 9, edited by Alfonso Ortiz. Washington, D.C.: Smithsonian Institution.

SIMPSON, BARRY.
1989–1998. Personal communication with Larry Dalrymple.

SIMPSON, STEVE.
1992–1999. Personal communication with Larry Dalrymple.

SMITH, ANNE M.
1974. *Ethnography of the Northern Utes*. Santa Fe, N. Mex.: Museum of New Mexico Press.

STEWART, OMAR C.
1938a. "The Navajo Wedding Basket." *Museum Notes: Museum of Northern Arizona* 10, no. 9: 25–28.

1938b. "Navajo Basketry as Made by Ute and Paiute." *American Anthropologist* 40: 758–759.

1978. "Litigation and Its Effects." In *Handbook of North American Indians*. Vol. 8, edited by Robert F. Heizer. Washington, D.C.: Smithsonian Institution.

1982b. *Apache Indian Baskets*. Tucson: University of Arizona Press.

1983. *Indian Baskets of the Southwest*. Tucson: University of Arizona Press.

TEIWES, HELGA.
1996. *Hopi Basket Weaving: Artistry in Natural Fibers*. Tucson: University of Arizona Press.

Tiller, Veronica E.
1983. "Jicarilla Apache." In *Handbook of North American Indians.* Vol. 10, edited by Alfonso Ortiz. Washington, D.C.: Smithsonian Institution.

1992. *The Jicarilla Apache Tribe: A History* (rev. ed.). Lincoln, Nebr.: University of Nebraska Press.

Tschopik, Harry, Jr.
1938. "Taboo as a Possible Factor Involved in the Obsolescence of Navajo Pottery and Basketry." *American Anthropologist* 40, no. 2: 257–262.

1940. "Navaho Basketry: A Study of Culture Change." *American Anthropologist* 42, no. 3: 444–462.

Vivian, Gordon.
1957. "Two Navajo Baskets." *El Palacio* 64, nos. 5–6: 145–155.

Waquie, Corina.
1985–1998. Personal communication with Larry Dalrymple.

Wauneka, Beth.
1989–1998. Personal communication with Larry Dalrymple.

Whiteford, Andrew Hunter.
1988. *Southwestern Indian Baskets: Their History and Their Makers.* Santa Fe, N. Mex.: School of American Research Press.

Whiteford, Andrew Hunter, and Kate McGraw.
1994. "A Guide to Southwest Indian Baskets." *Indian Art Magazine:* Santa Fe, N. Mex.: Southwest Association for Indian Arts, 33–59.

Williams, Cynthia-Irwin.
1979. "Post-Pleistocene Archeology, 7000–2000 B.C." In *Handbook of North American Indians.* Vol. 9, edited by Alfonso Ortiz. Washington, D.C.: Smithsonian Institution.

Williamson, Ten Broeck.
1937. "The Jemez Yucca Ring Basket." *El Palacio* 42, nos. 7, 8, 9: 37–39.

I N D E X

138